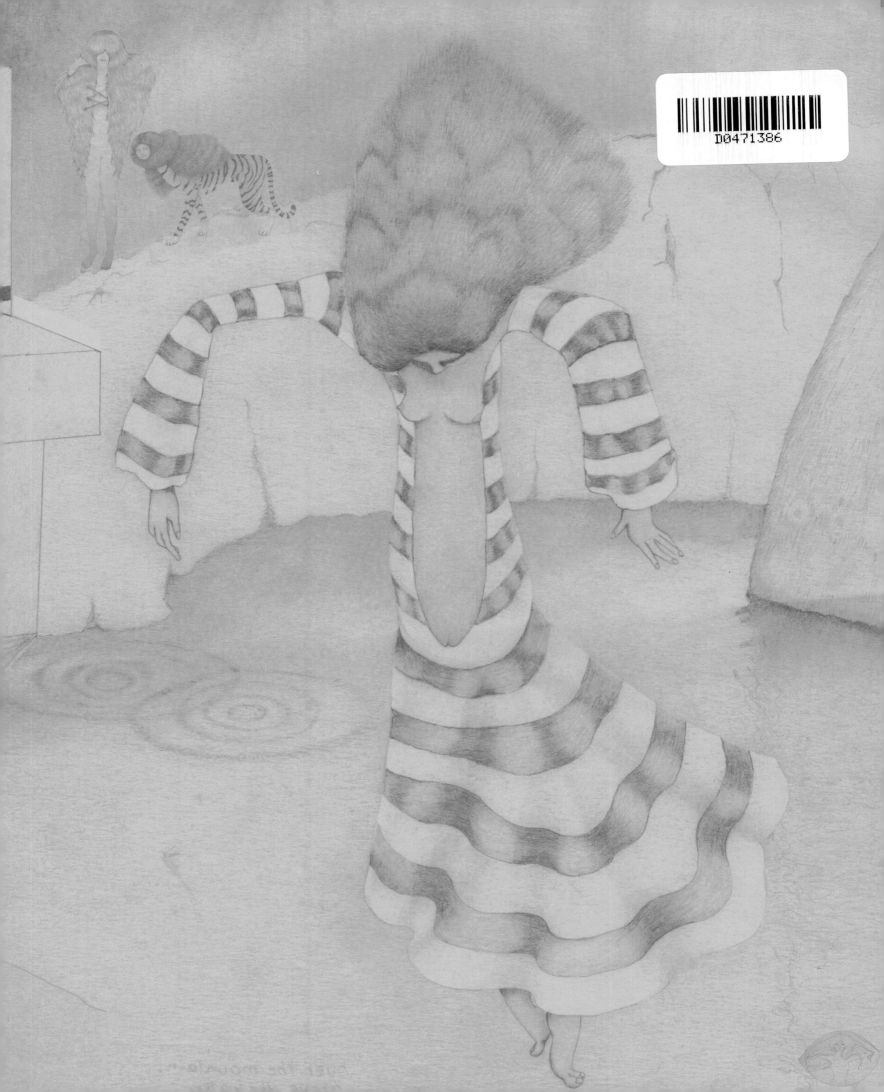

Object
that
Dreams

zoren gold & minori

A REFLECTION OF THEIR COMBINED UNCONSCIOUS THOUGHTS AND DESIRES, THIS IS A BOOK ABOUT THE DREAMS OF THE OBJECT.

ACCORDINGLY, THE STORY OF ZOREN GOLD & MINORI IS ONE OF DISTANCE AND PROXIMITY, OF INTIMACY AND ALIENATION, OF SYNERGY AND INDIVIDUALITY, OF SUBJECT, OBJECT AND THE MYSTERIES THAT LIE BETWEEN.

Don't be deceived – although the luscious images of Minori Murakami, slipping in and out of character from gothic to angelic, from synthetic to decidedly human, and photographed by Zoren Gold in a variety of poses and settings, might suggest something akin to the traditional relationship between the painter and his model, between the artist and his trusted muse, 'Object That Dreams' is the collaboration of two artists in their own right – viewed through the eye of Zoren's camera and expressed by Minori, body and mind.

A 'creative photography unit' since 2000, both artists left their native countries – and continents – during the mid-90s. Trading Europe and Japan for America, both initially made their own way across the United States: while Zoren got hooked on photography more or less by chance (after discovering a copy of Photoshop on his used Macintosh), Minori studied art and design, and followed a career as a graphic designer and freelance illustrator.

Not exactly love at first sight, it should take until 1997 for their paths to cross. Minori was asked to give Zoren a ride, but uncomfortable silence prevailed – "it was a long 20-minute drive home." Their second encounter seemed equally ill-fated, when Gold turned up empty-handed at Minori's birthday party. And yet, this meeting was about to unlock a new side to their relationship: "To make up for the missing present, he promised to take a portrait of me and my dog. We went through my closet, picked out some clothes and ended up shooting at my apartment. It was the beginning of our photographic relationship." Soon after, Gold and Minori embarked on their first creative collaboration, eager to explore the world of fashion. Stymied by the fact that neither of them actually knew how to sew, they decided to try something closer to home – mixing photography and graphic design.

The result: a sometimes precarious, but always fruitful relationship that lasts to this day. Joining forces in every respect, they soon took their work and life to Tokyo, Minori's home and fertile ground for their unsettling blend of photography, illustrations, collages, hand-made props and computer graphics.

Aware of the inherent pitfalls of such a close-knit personal and professional symbiosis, their work and life has drawn them both closer together – and further apart. "It might sound paradoxical, but our closeness has brought out our individuality, has revealed that there are some things that cannot be shared. Sometimes we get lost in disagreements rooted in our different cultures and upbringings, things we might never understand about each other. And yet, these frustrations and differences keep the mystery alive and supply us with a fresh point of view."

Skirting the boundaries between personal and professional, between spontaneous art and commissioned work, Zoren Gold and Minori treat their pictures as a stage to be fitted and filled with their own ideas and creations. With a keen eye for all the elements that will shape the final image – setting, style, props, model, background, media – their works display an ingenious mix of painstaking planning and spontaneous expression. Whether experimental imagery destined to undergo later treatment, or meticulously orchestrated photo shoot – the final outcome invariably exudes a sense of detached perfectionism.

United in their exceptionally formal approach to layout and composition, these images emphasise and redefine vanishing lines, surface structures and transitions through the clever use of illustration, patterns and ornaments. In this, the duo diverges from traditional photographic perception and displays a marked affinity to the rules and tools of graphic design. Their sometimes eerie depth of field and razor sharp focus only adds to the impression of artificial flatness and simultaneity of all pictorial elements – hybrid landscapes, frozen in time and space.

Stark, moody and untouchably glamourous, their fashion images carry a hint of Helmut Newton's stylised glamour circa mid-70s to mid-80s, yet Zoren Gold and Minori's visual language is far harder to grasp and define. While stylistic devices help shape and create their distinctive reality, their images are very much surreal. "Ever since I was a child, I have carried a sense of foreignness or alienation. When faced with surrealist art, I feel at home. The boundaries between my external and internal reality seem to blur more and more. In the end, what is reality anyway?"

With a strangely focussed detachment Zoren Gold and Minori tweak and twist their reality – or body parts – into unexpected permutations. Toying with artificiality, their images rip humans out of their natural surroundings, like autonomous units untouched by their environment, to create new associative, yet deliberate combinations of isolated elements and de- and relocated parts. This story of creation out of destruction is an ancient one, yet with the help of modern technology, Zoren and Minori adapt the genre's recurring themes and techniques – subject and object, Eros and desire, injury and mutilation, dolls, artificiality, superimposition and modulations of reality (by means of overexposure, solarisation, etc.) – to their very own vision of contemporary surrealist expression. Paying homage to the paragons of fantastic realism and surrealist photography, from Man Ray and Raoul Ubac to the likes of Dora Maar, Jacques-André Boiffard and Eli Lotar, even René Magritte, Hans Bellmer or Brassaï, they also find kindred spirits in surrealist artist duo Claude Cahun and Marcel Moore who pursue a remarkably similar approach in their art and the form of their artistic collaboration.

Soft, subtle, playful, bold, stylised, stark, dark and addictive, Zoren Gold and Minori's unapproachable, unattainable, yet desirable work carries a personal secret we can never hope to share, yet that continues to exert its fascination.

Doll-like in appearance, Minori becomes fetish, stereotype and enigma in one, offering herself up as the perfect blank slate for an endless string of different characters. The subject becomes the object – but then again "being the subject is part of artistic expression. I become the subject with objectivity, and cherish the chance to feel free in a photograph."

By subjecting the model to objectification, yet awarding her complete subjective control, Zoren Gold and Minori have turned the tables on their audience – so who is the object after all?

ROBERT KLANTEN

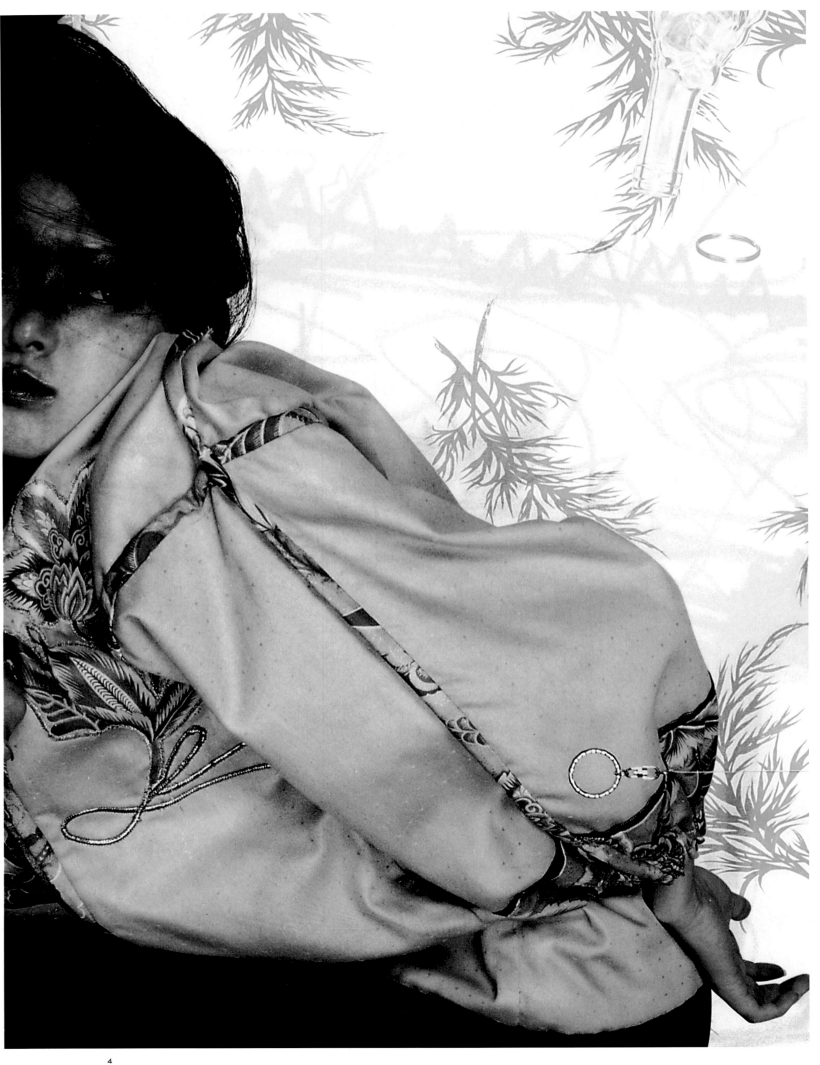

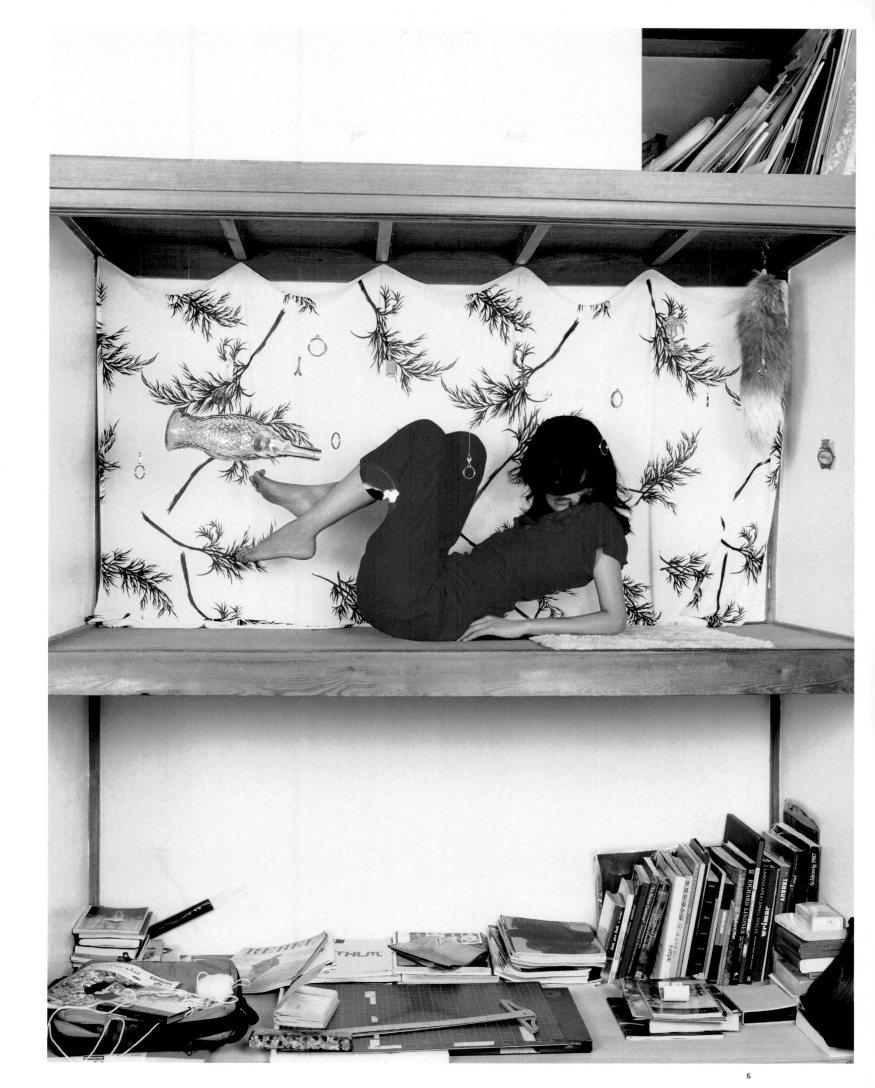

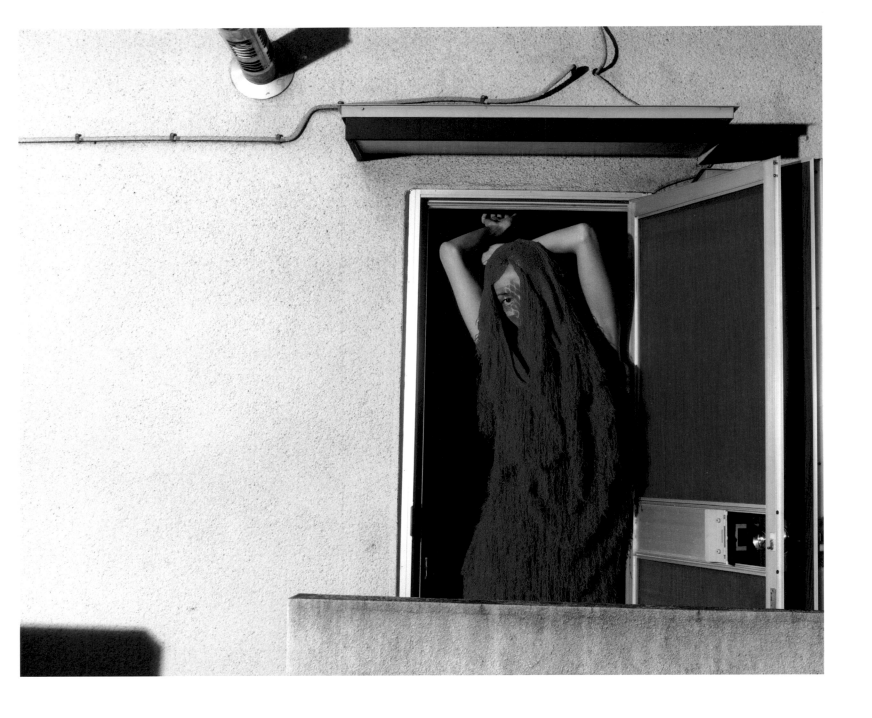

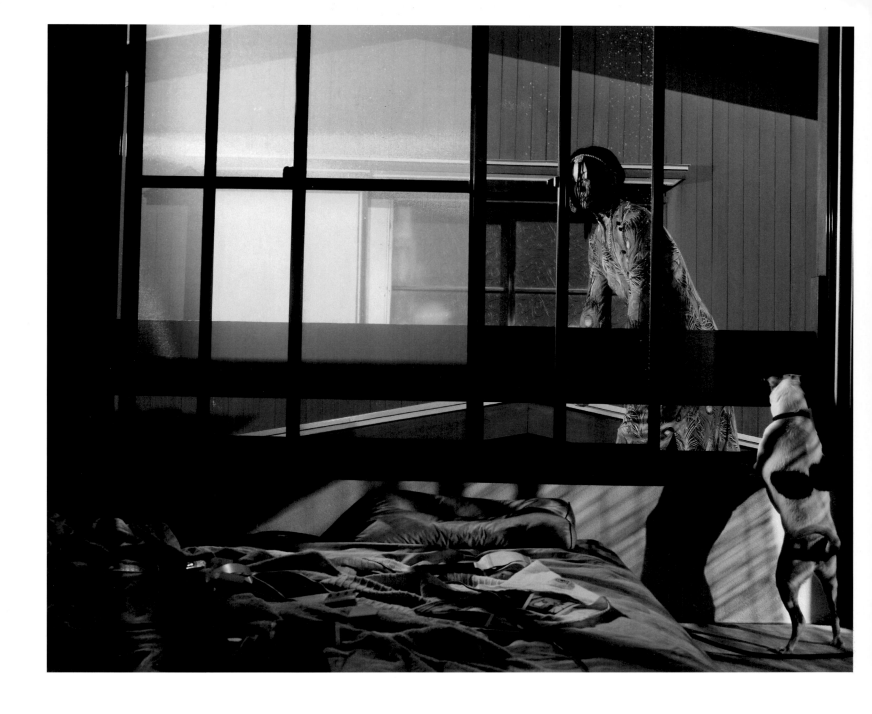

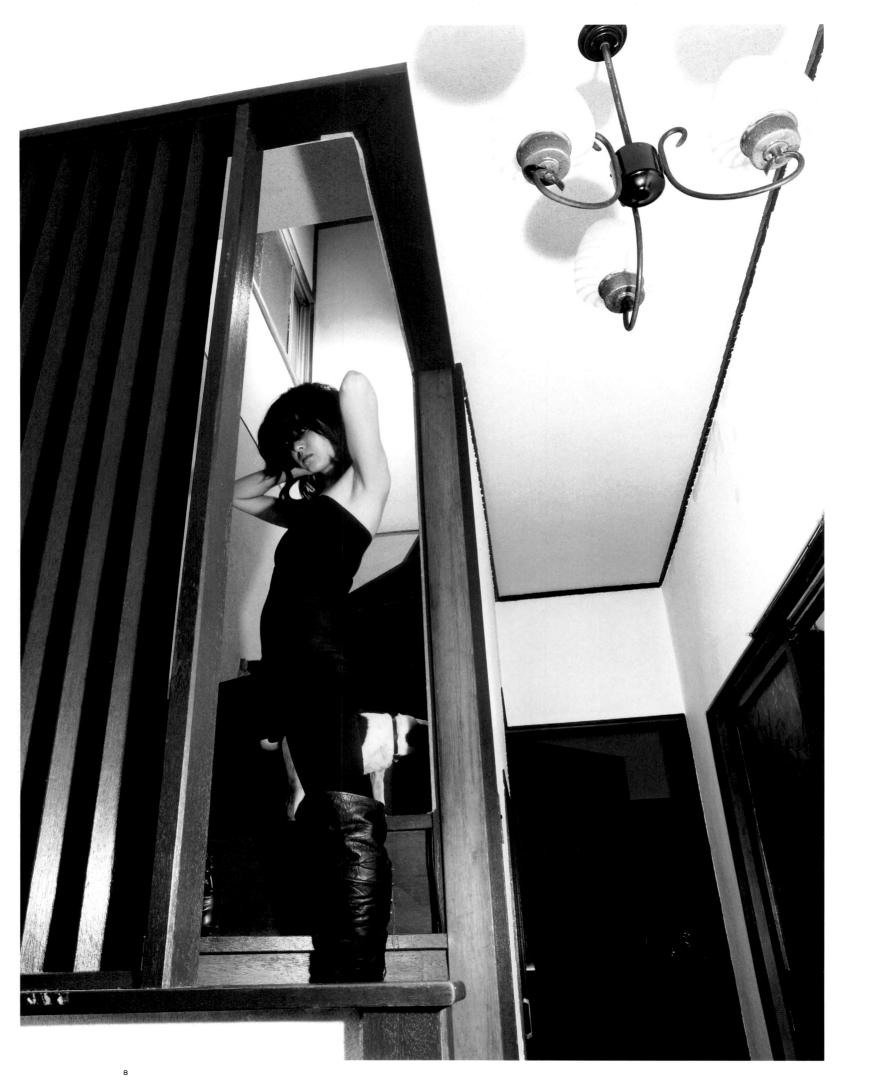

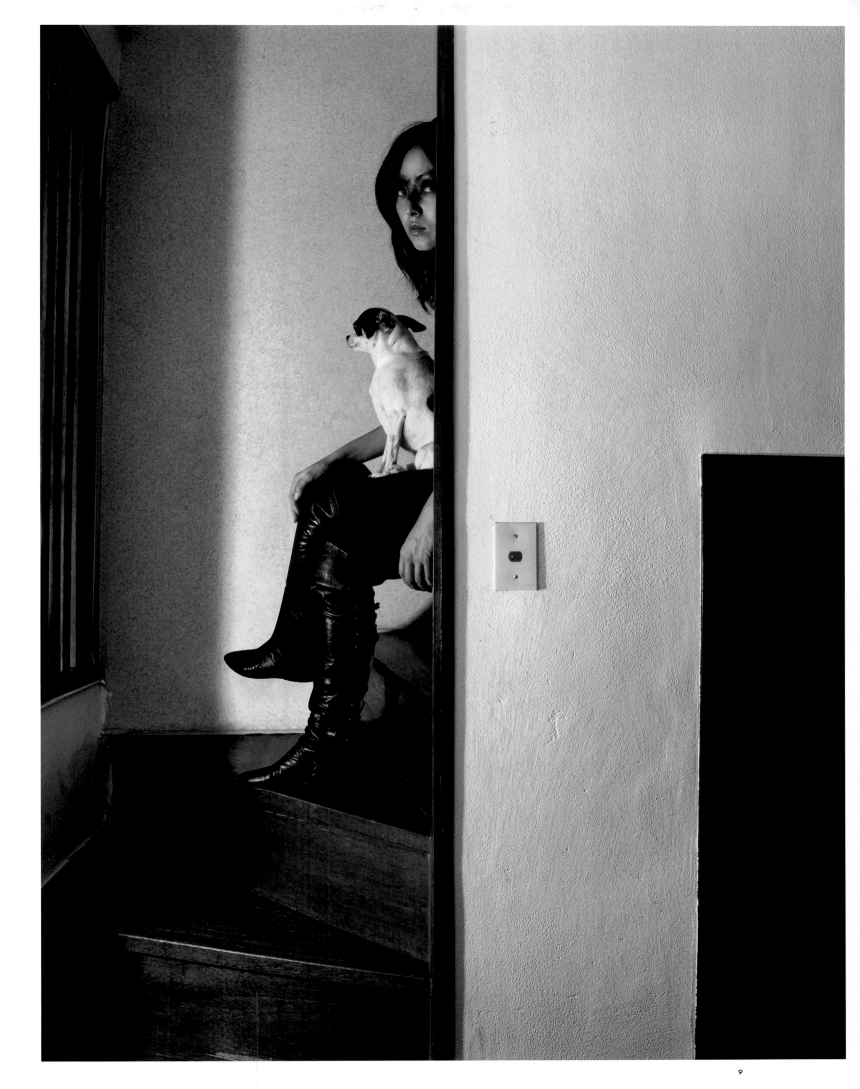

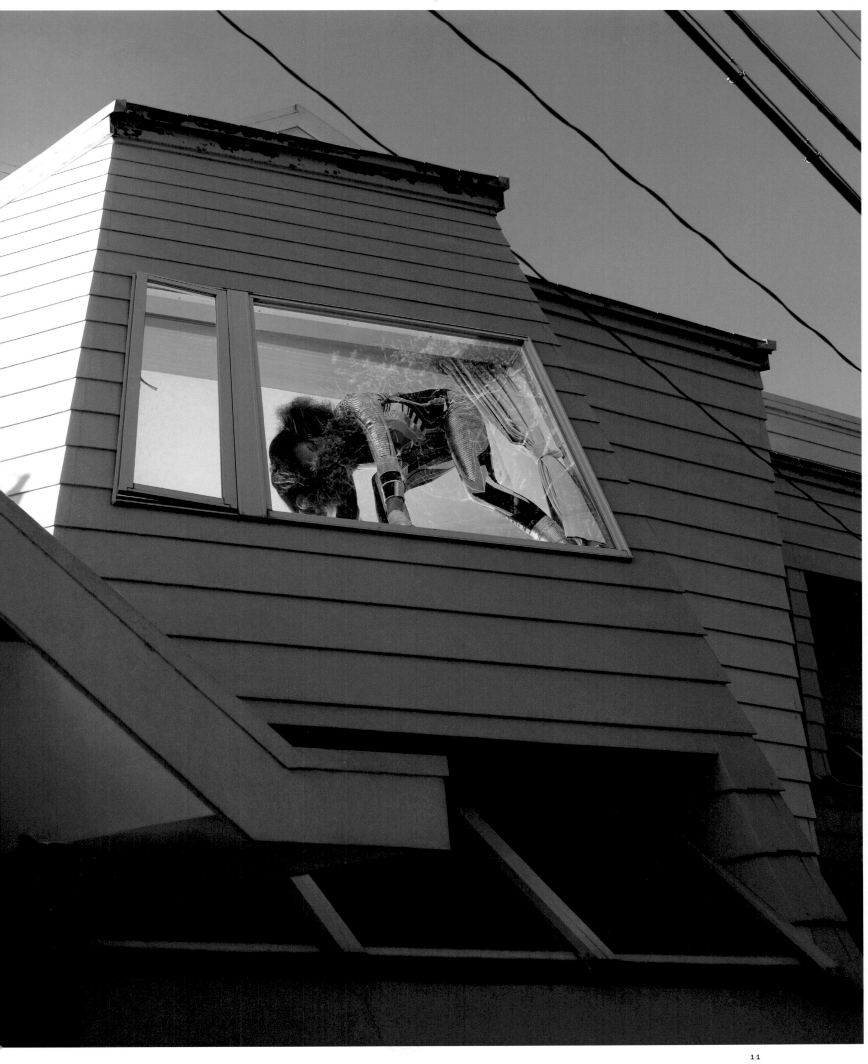

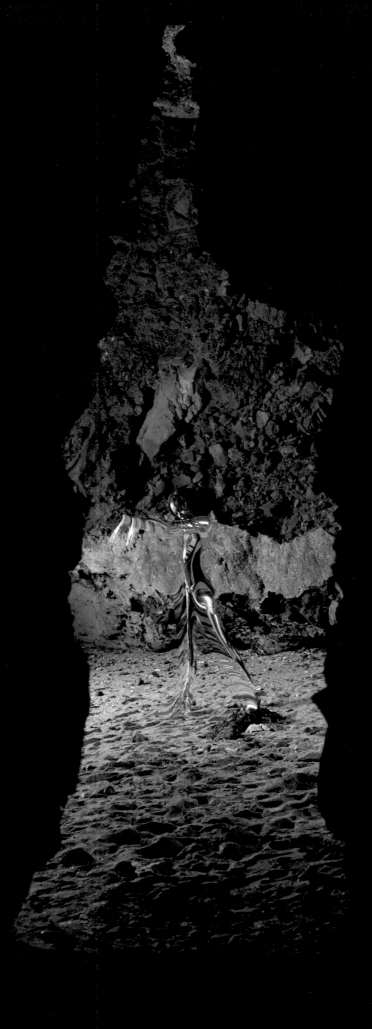

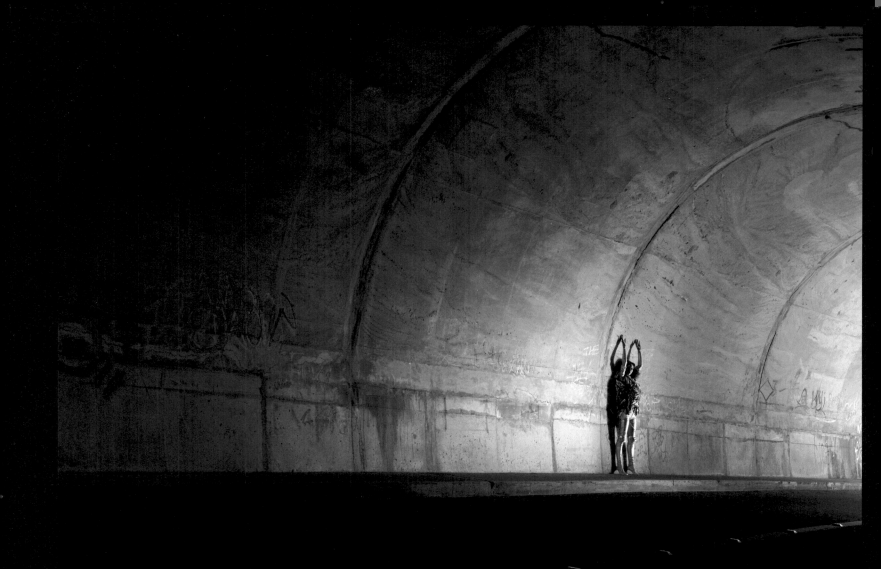

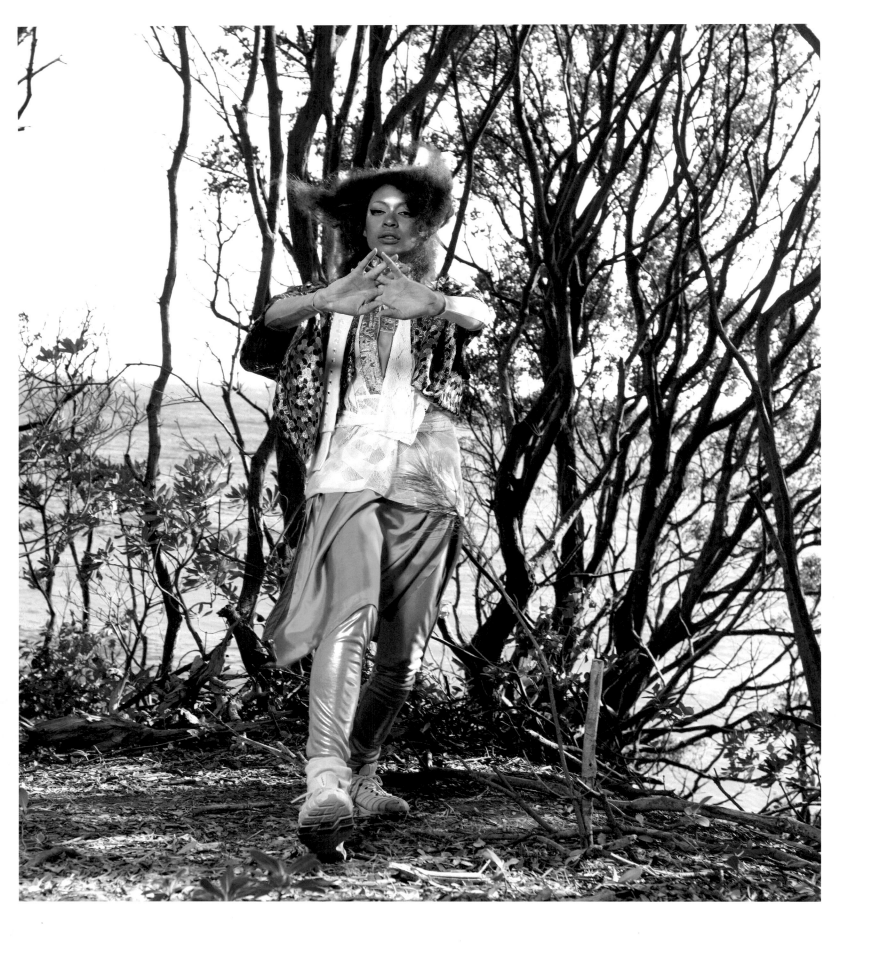

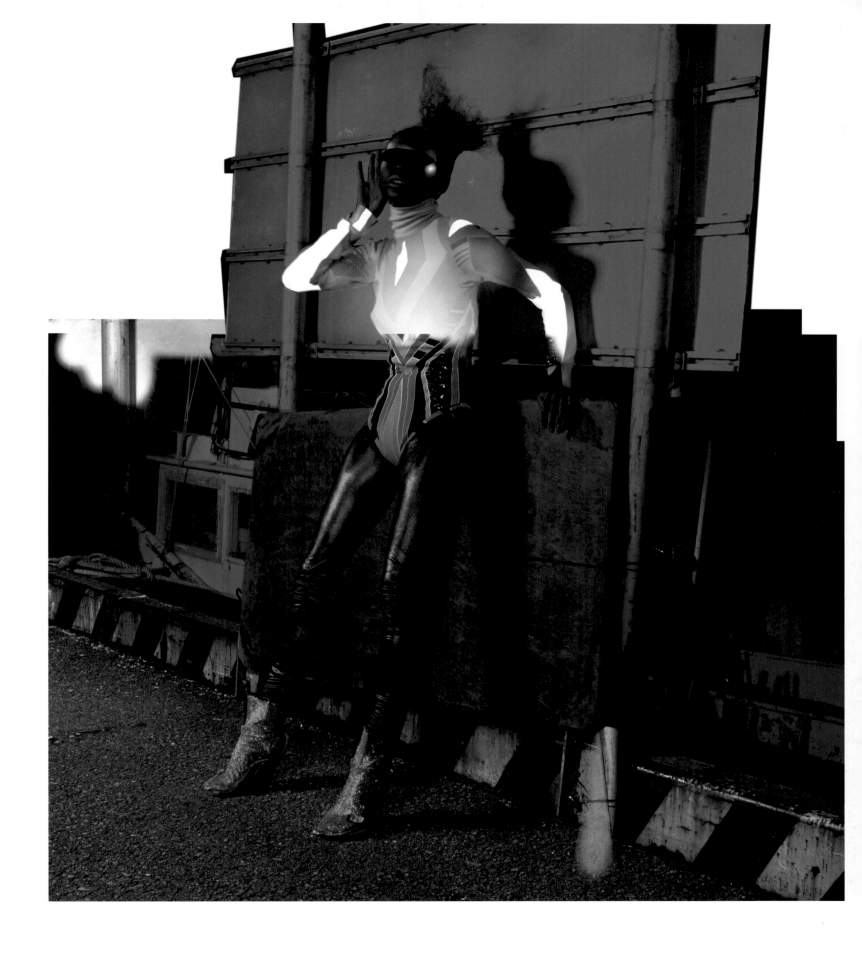

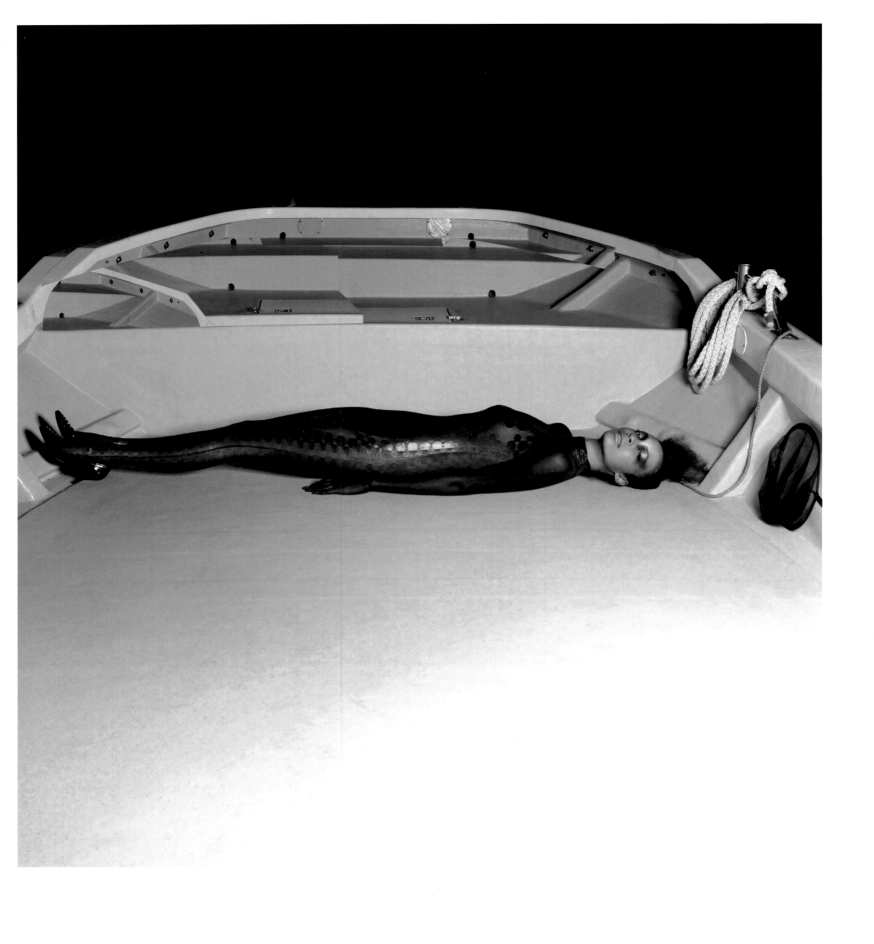

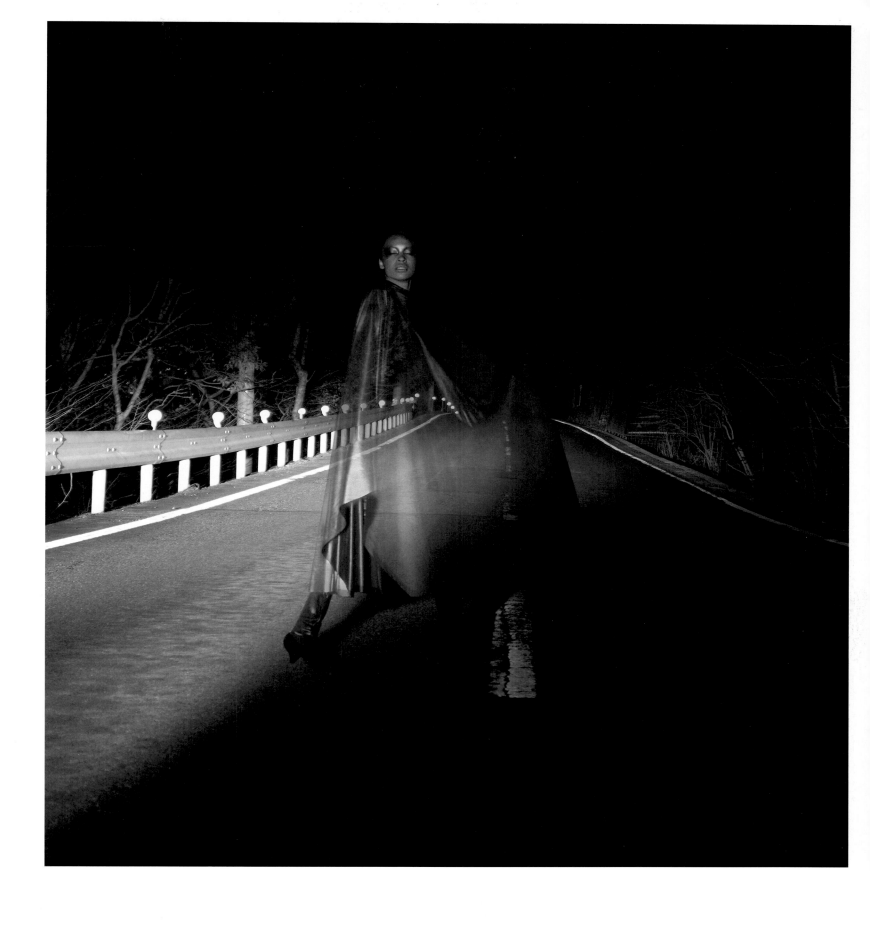

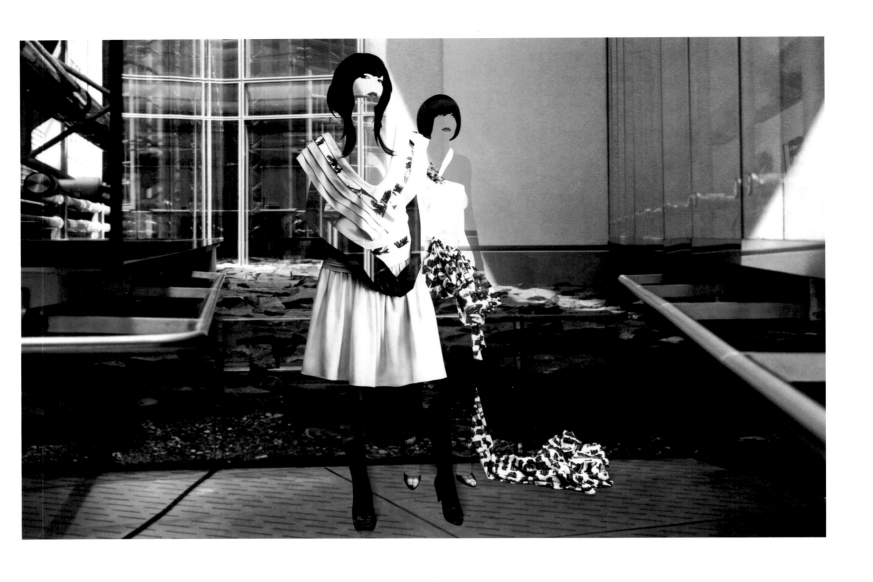

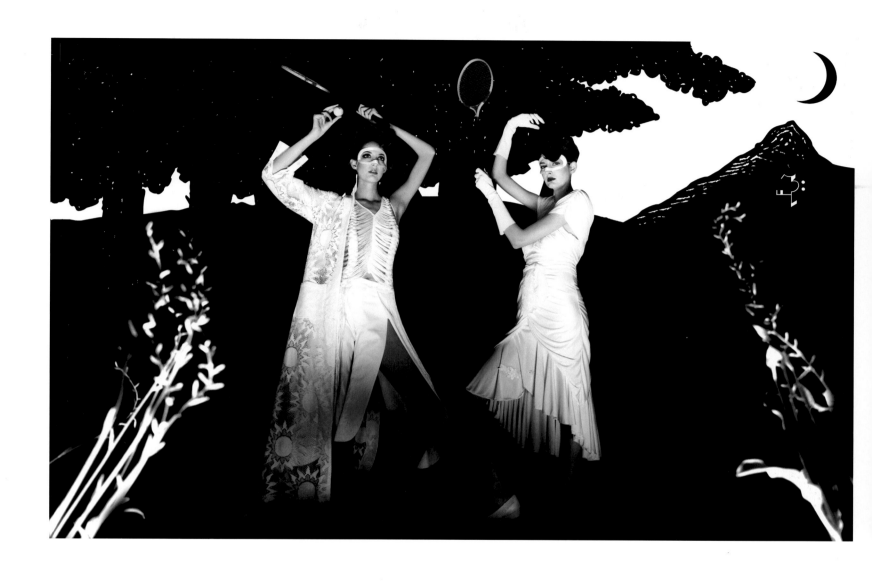

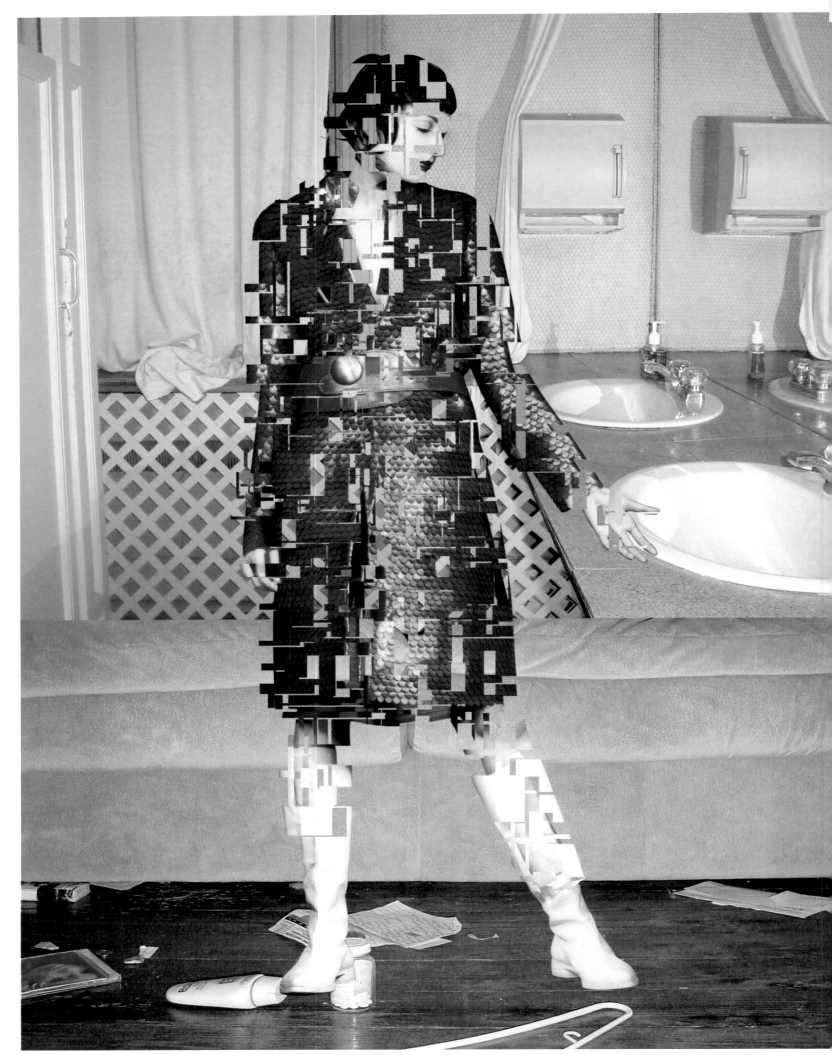

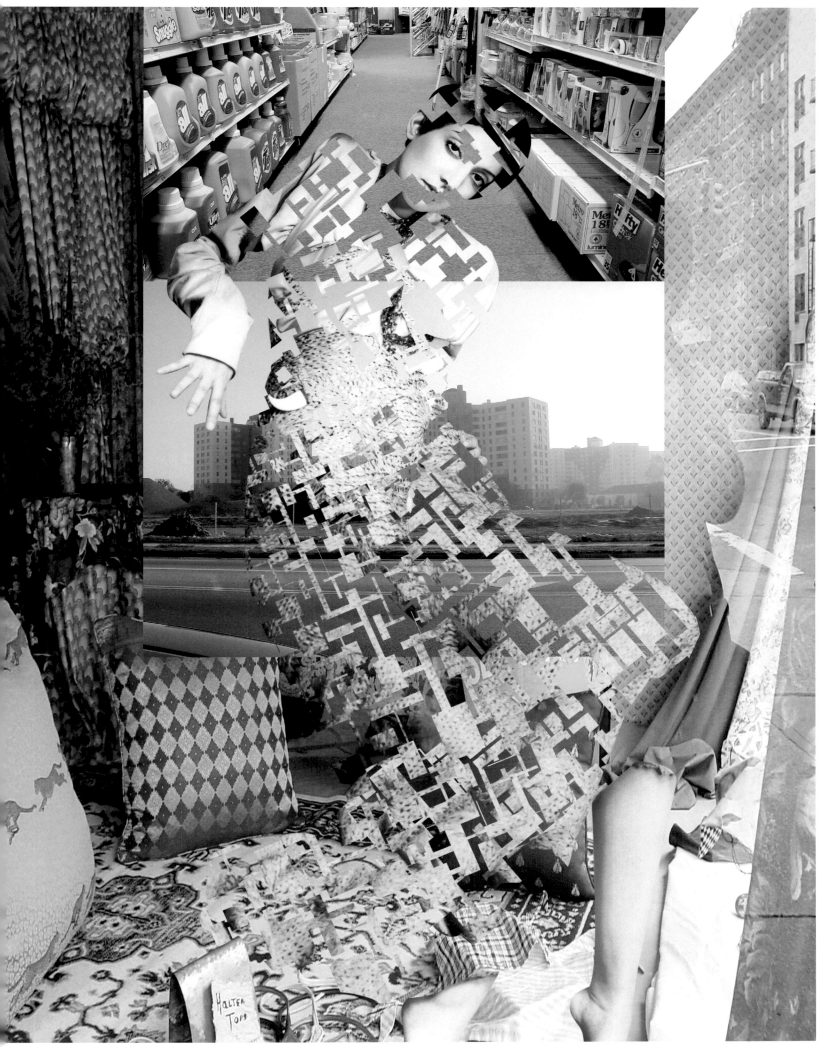

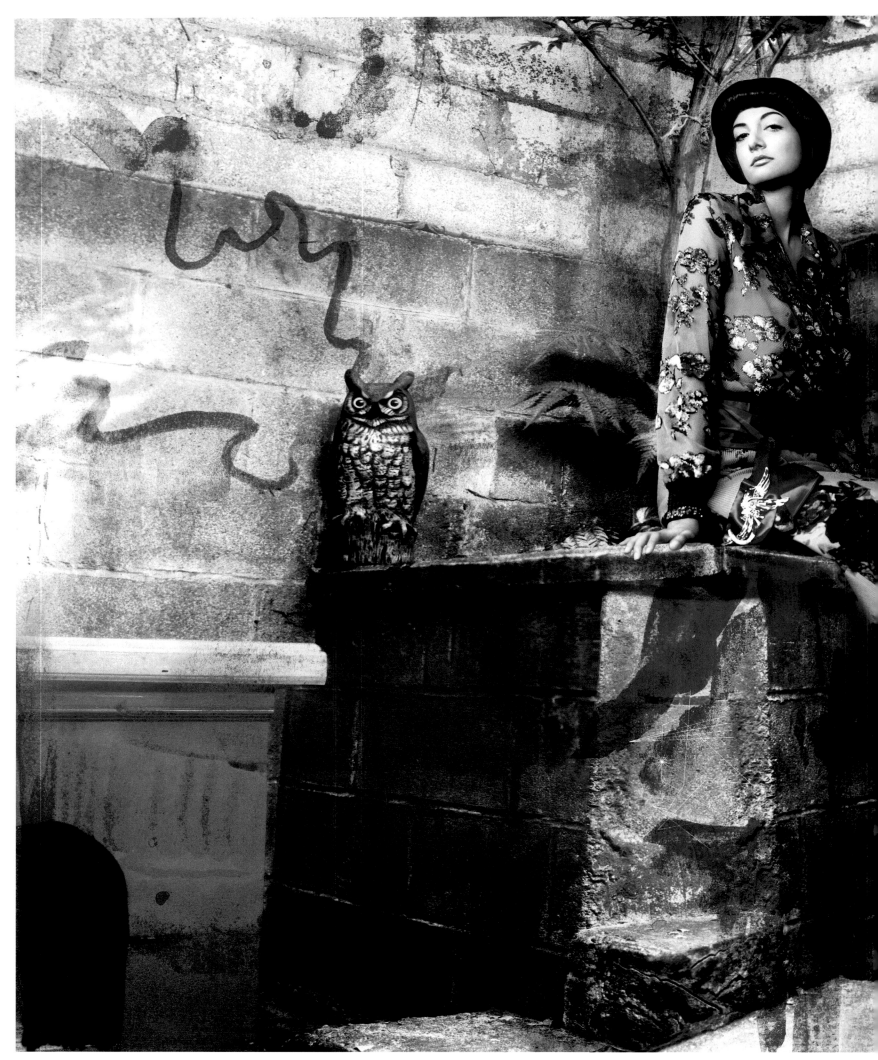

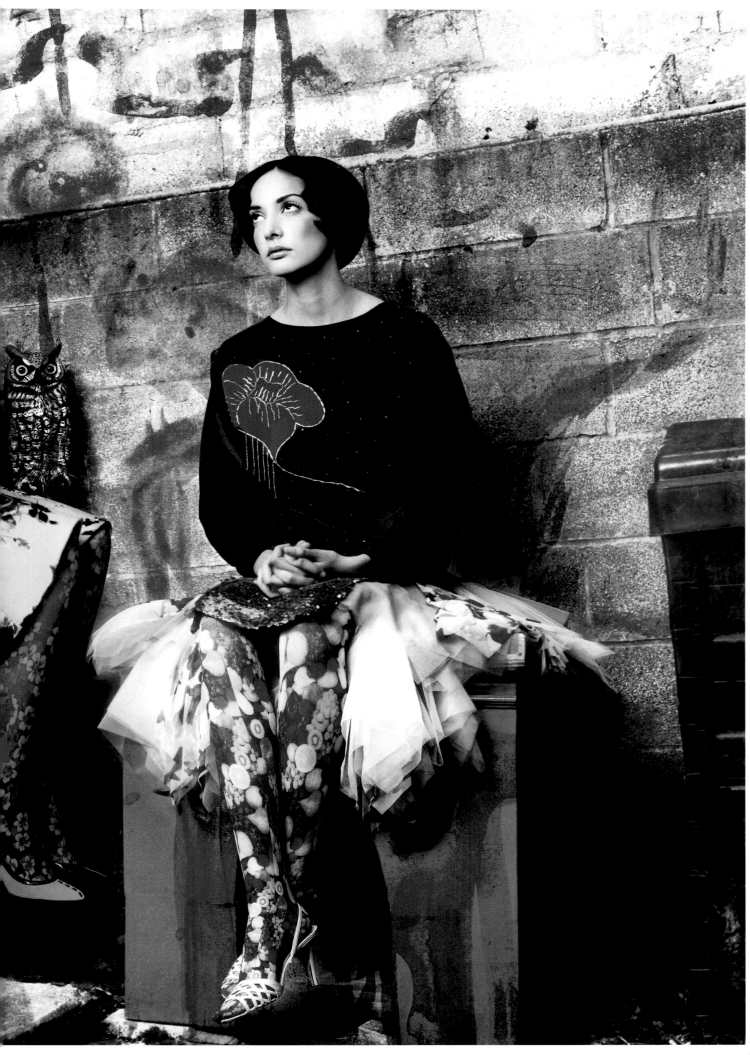

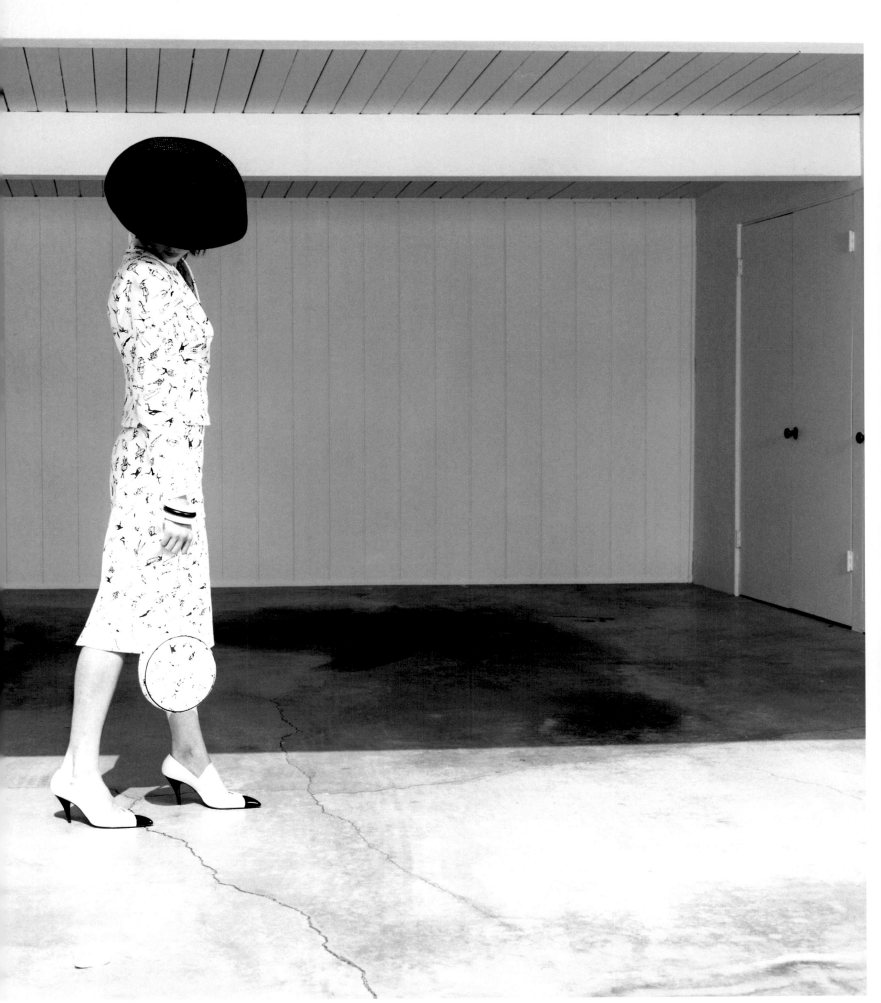

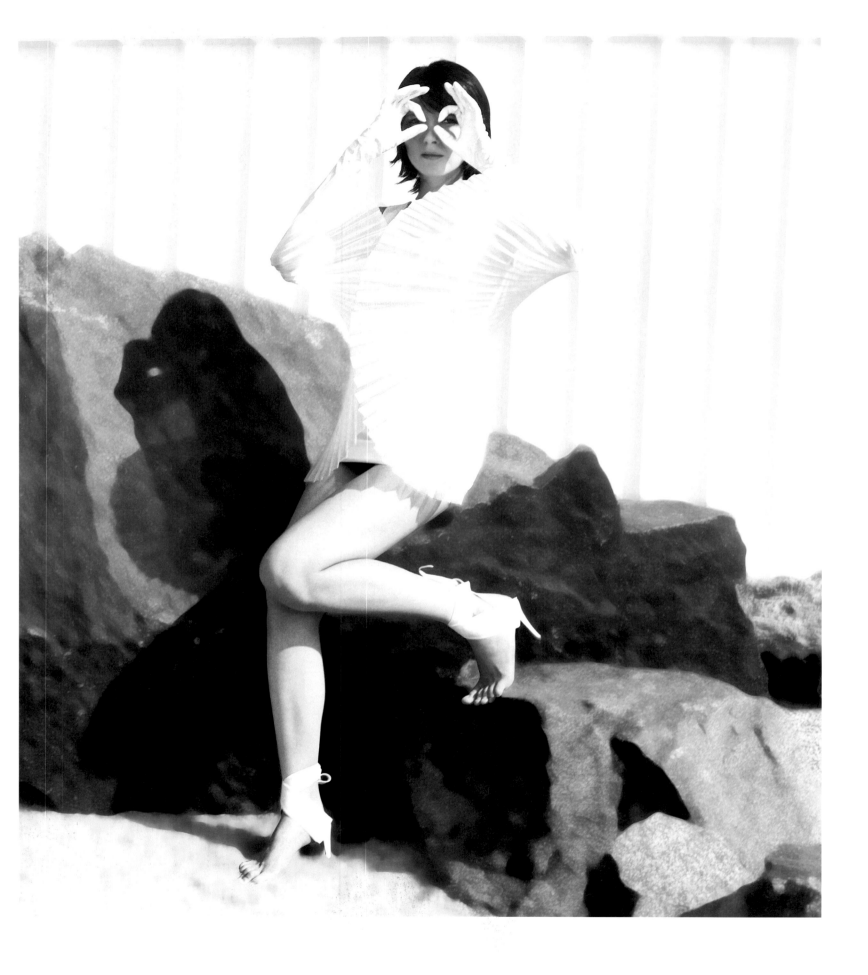

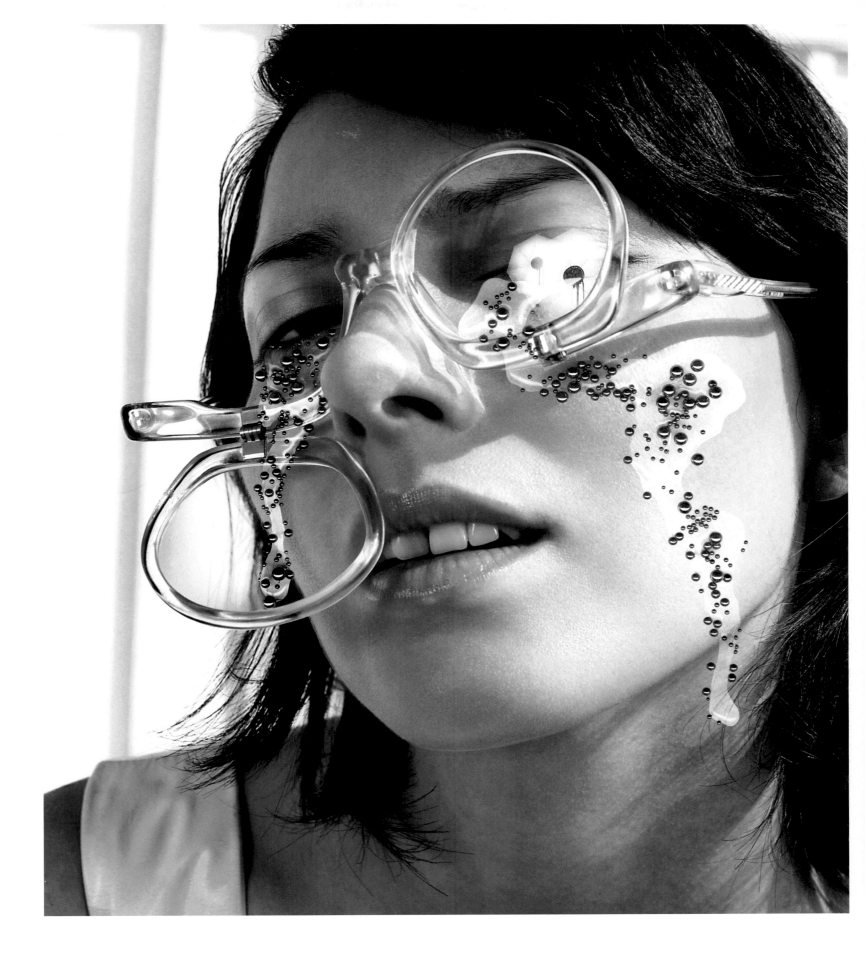

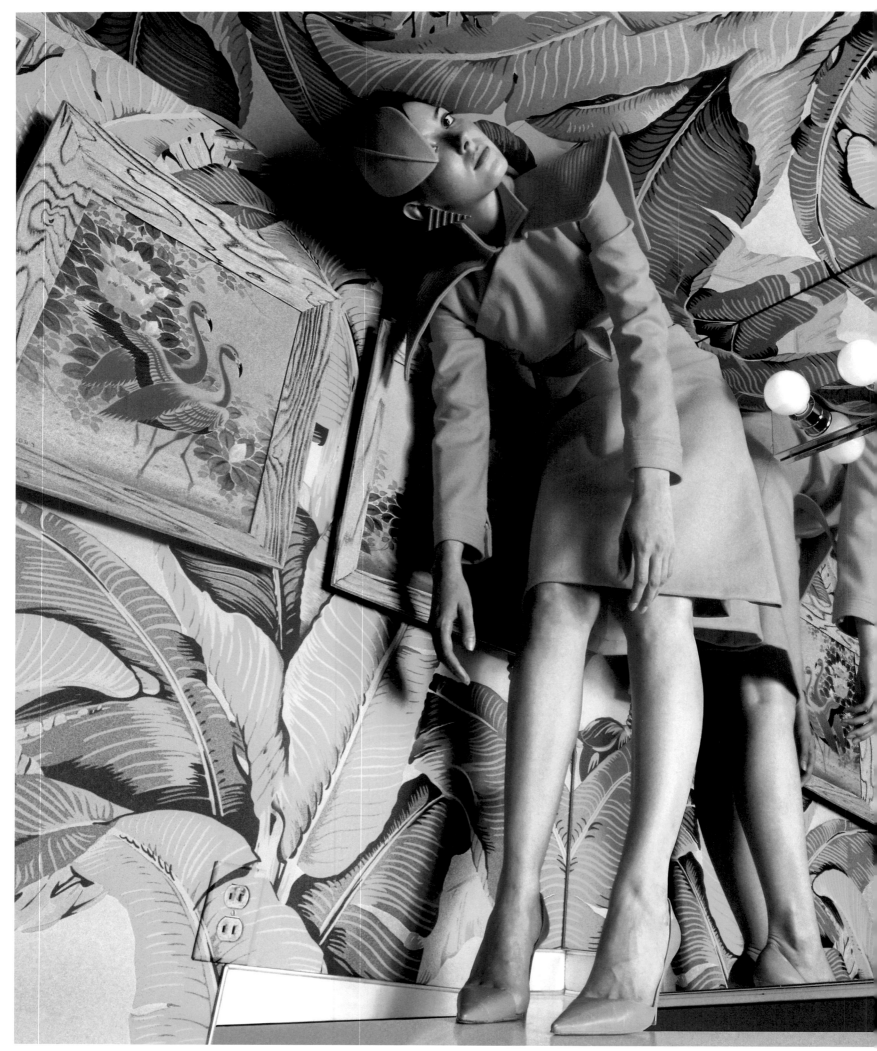

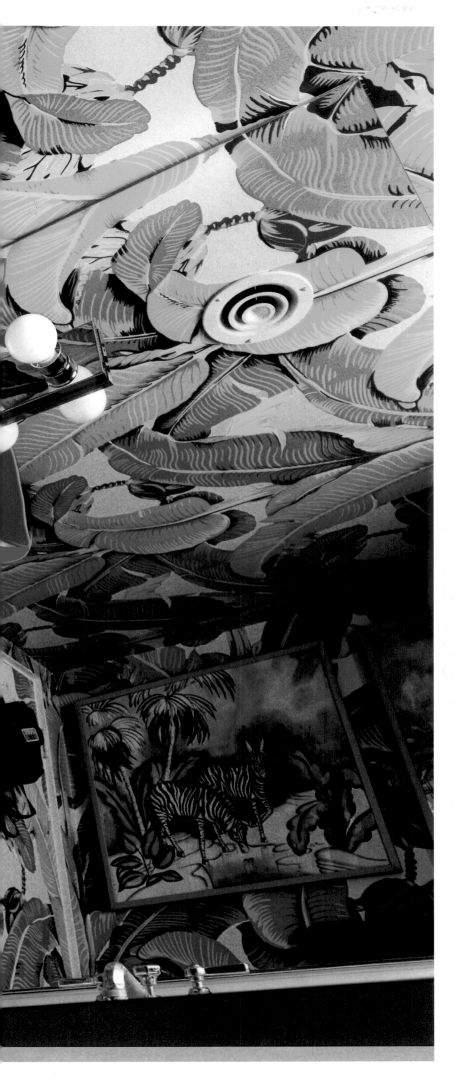

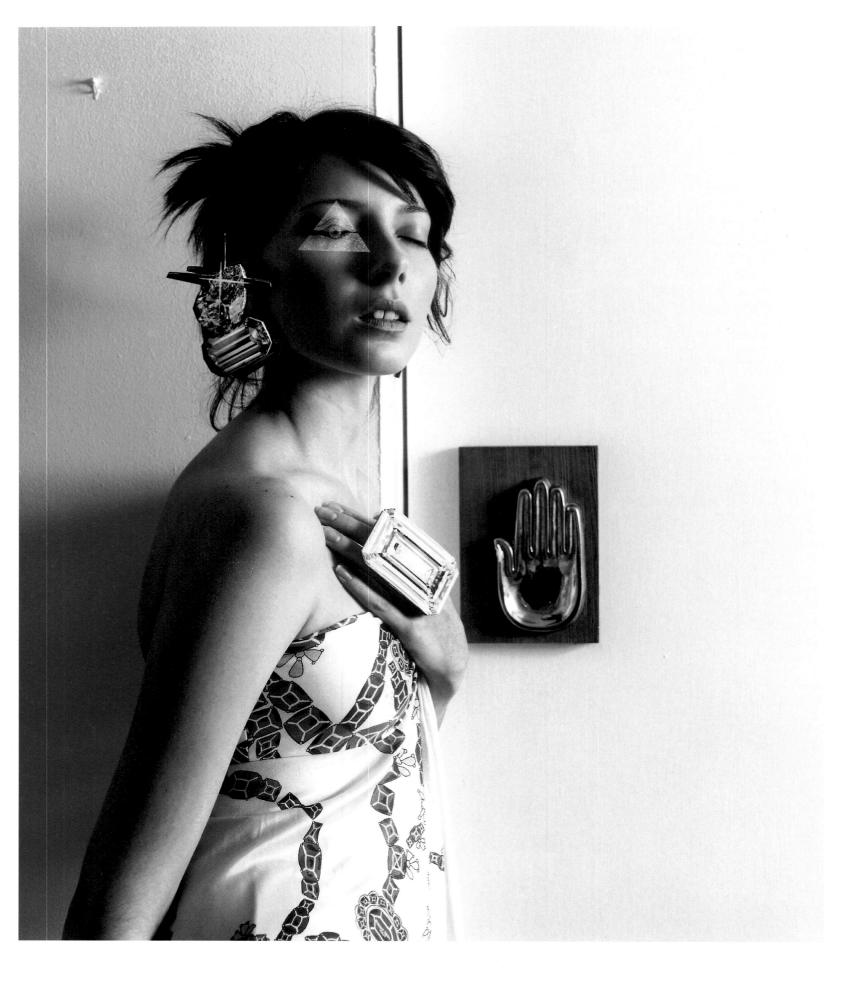

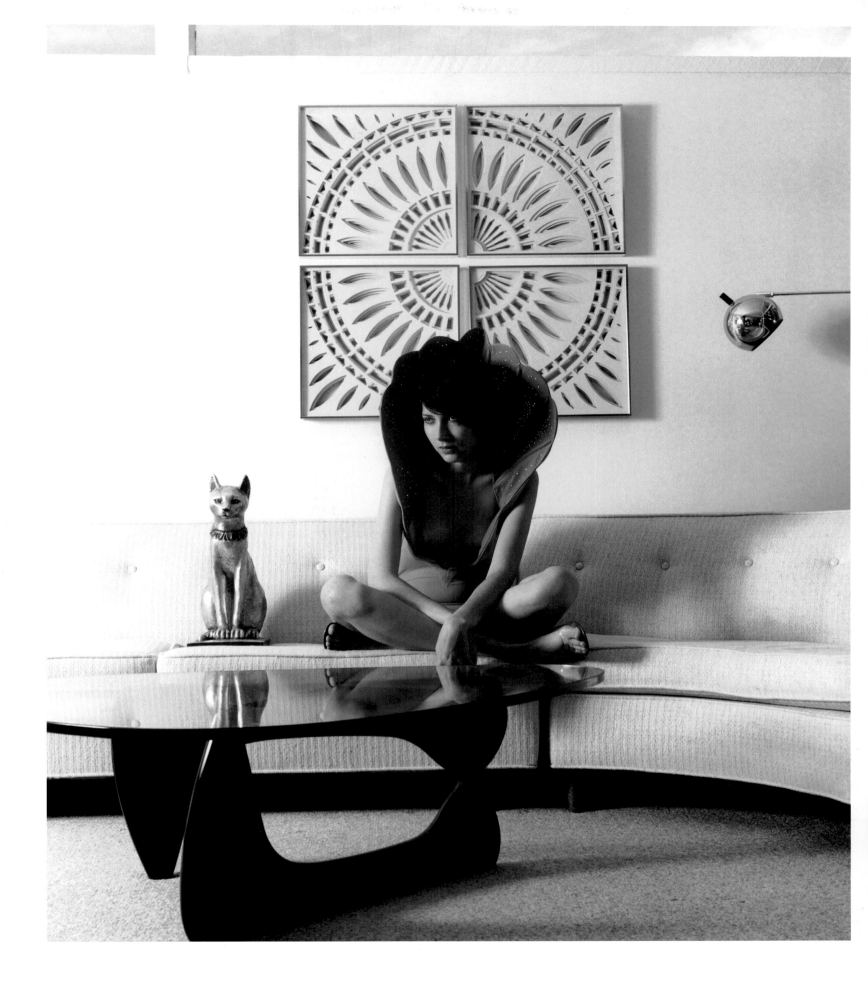

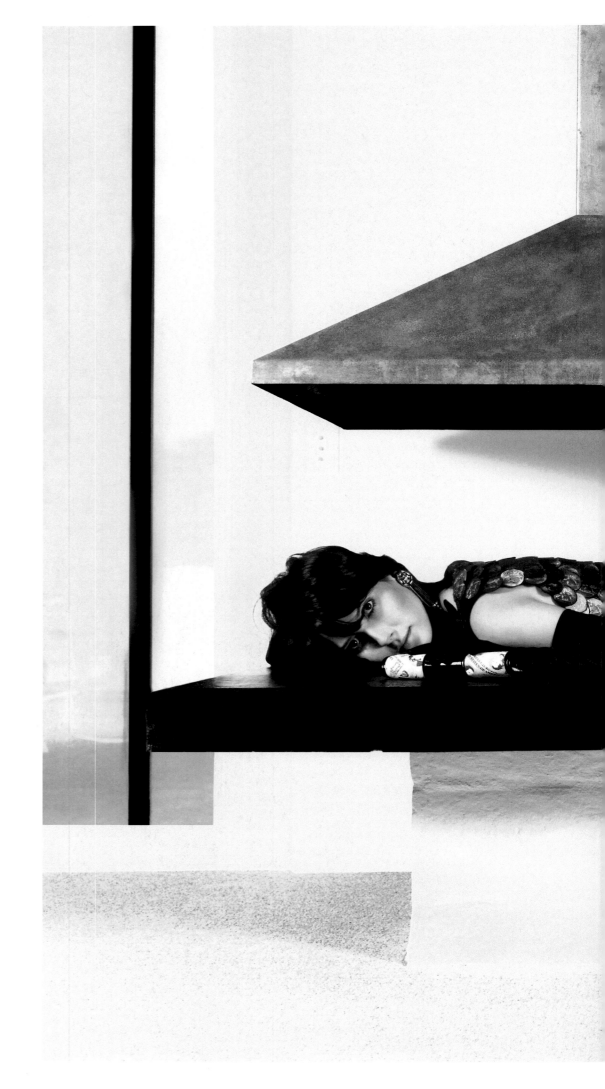

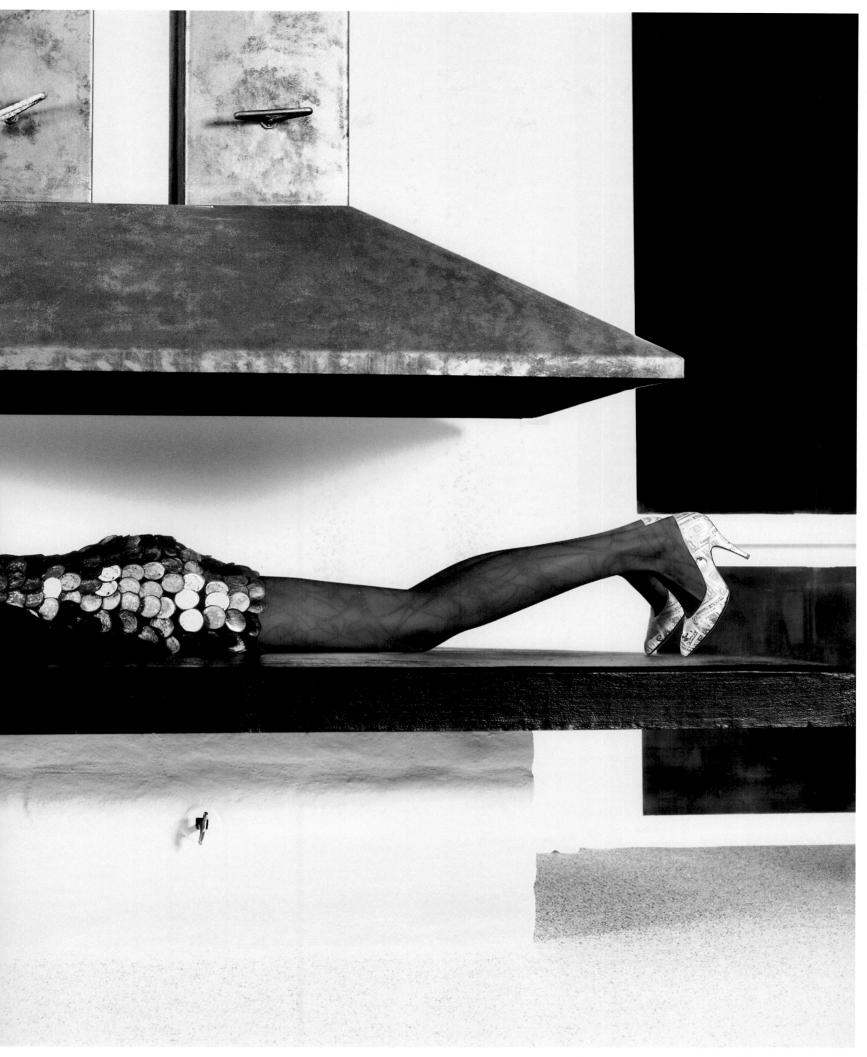

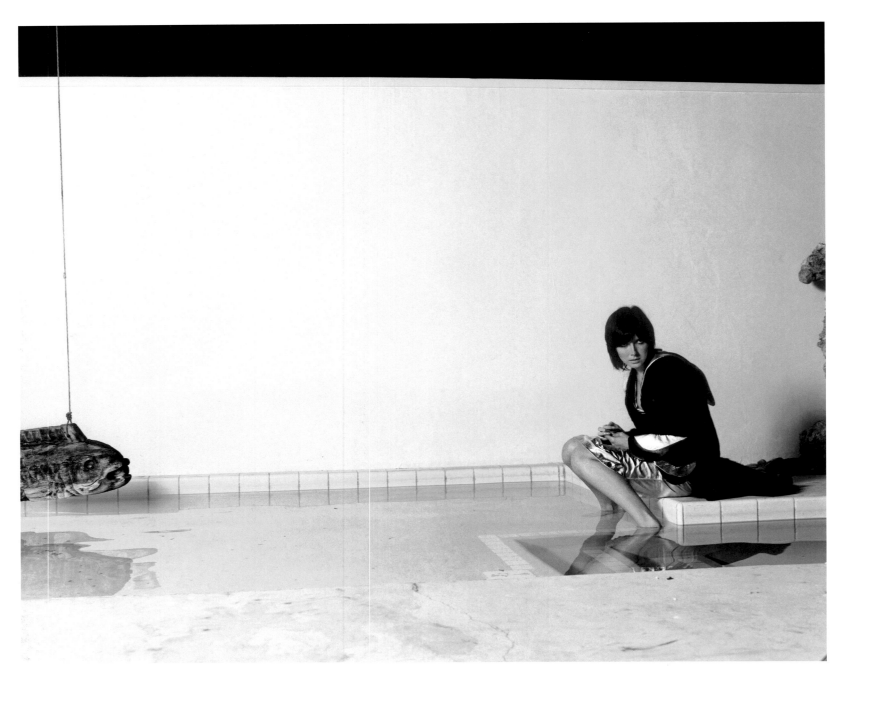

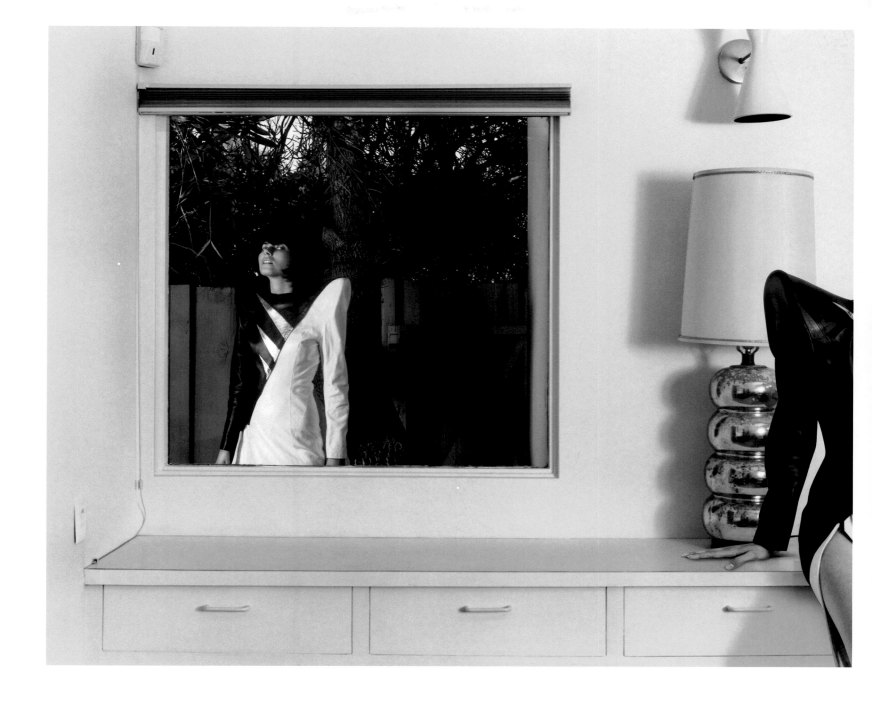

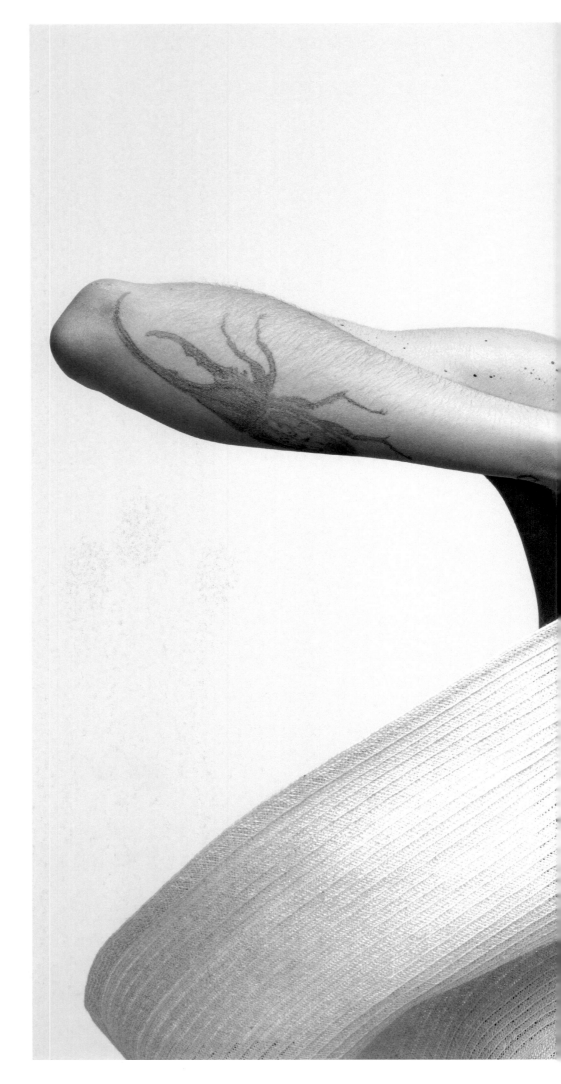

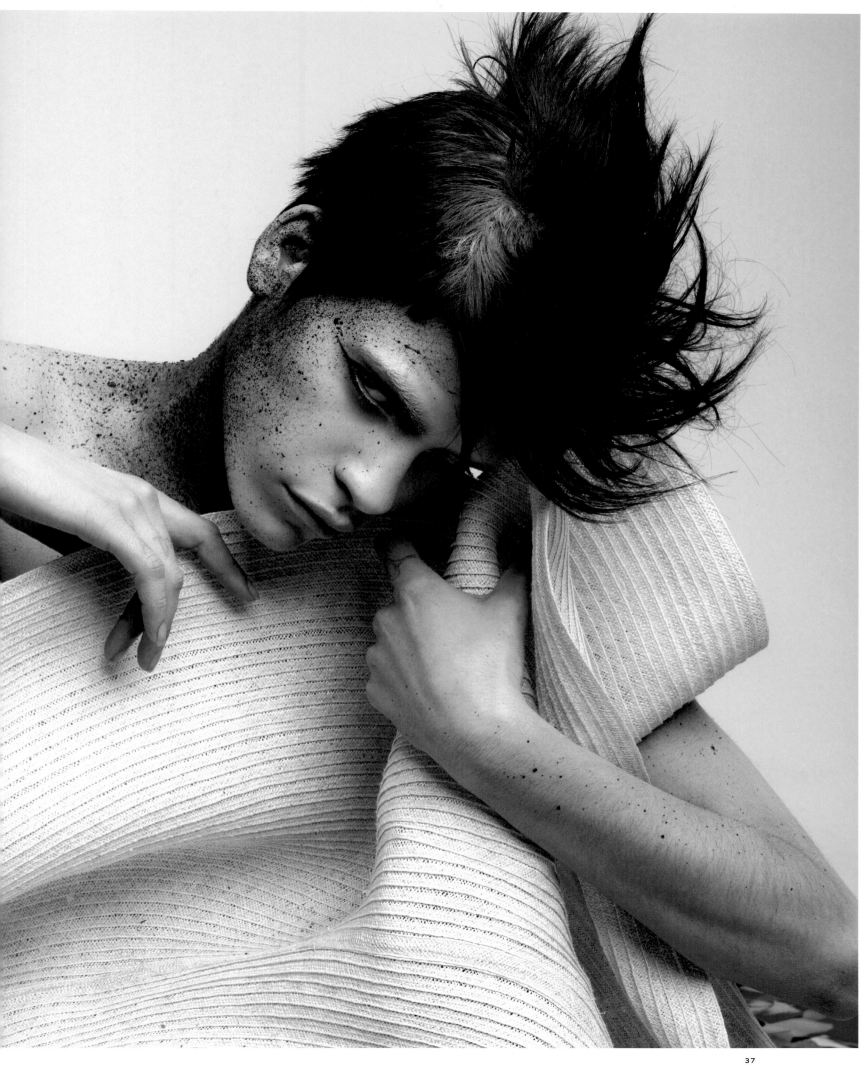

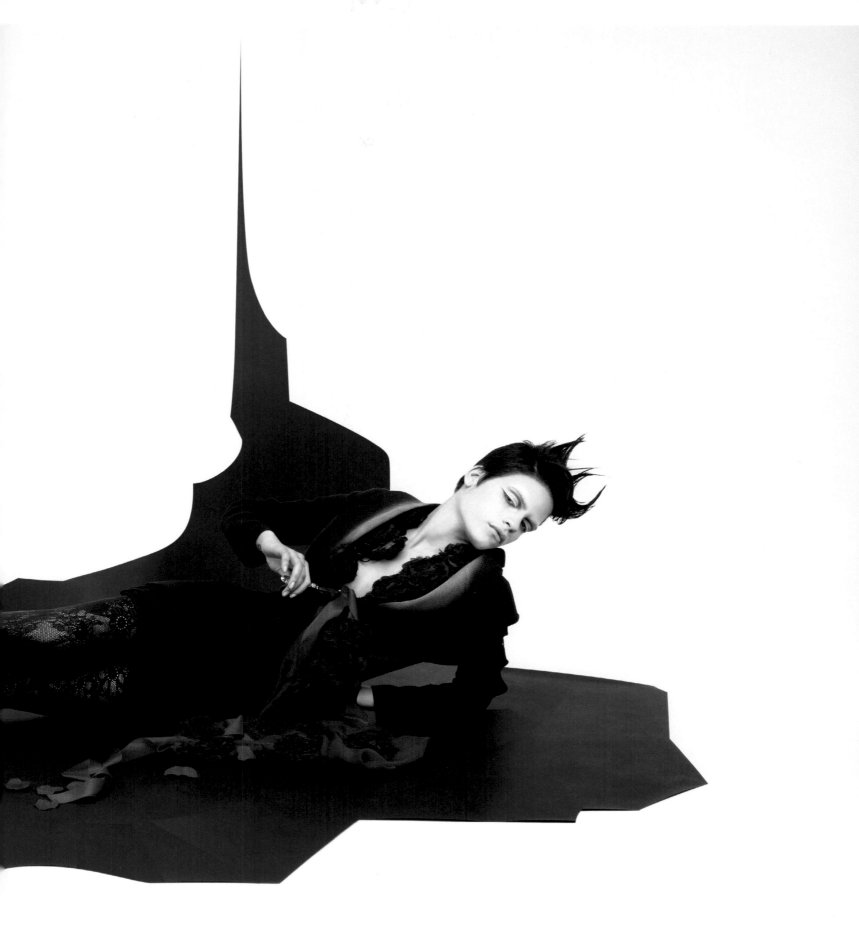

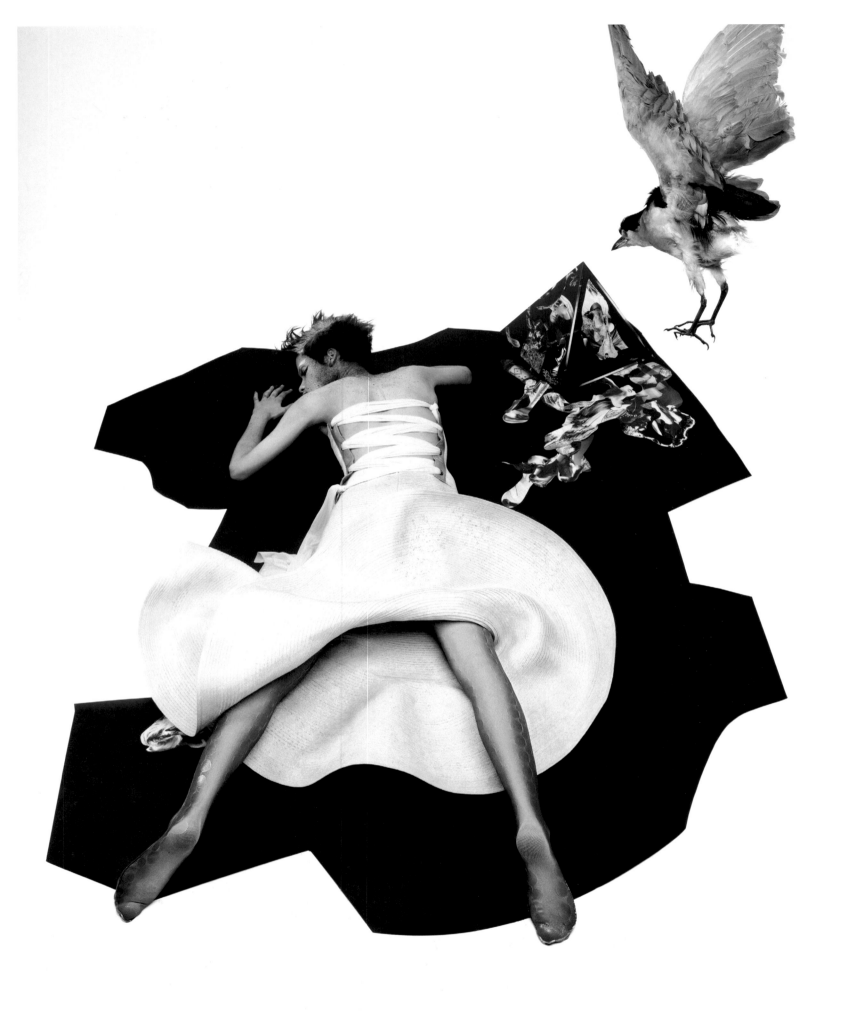

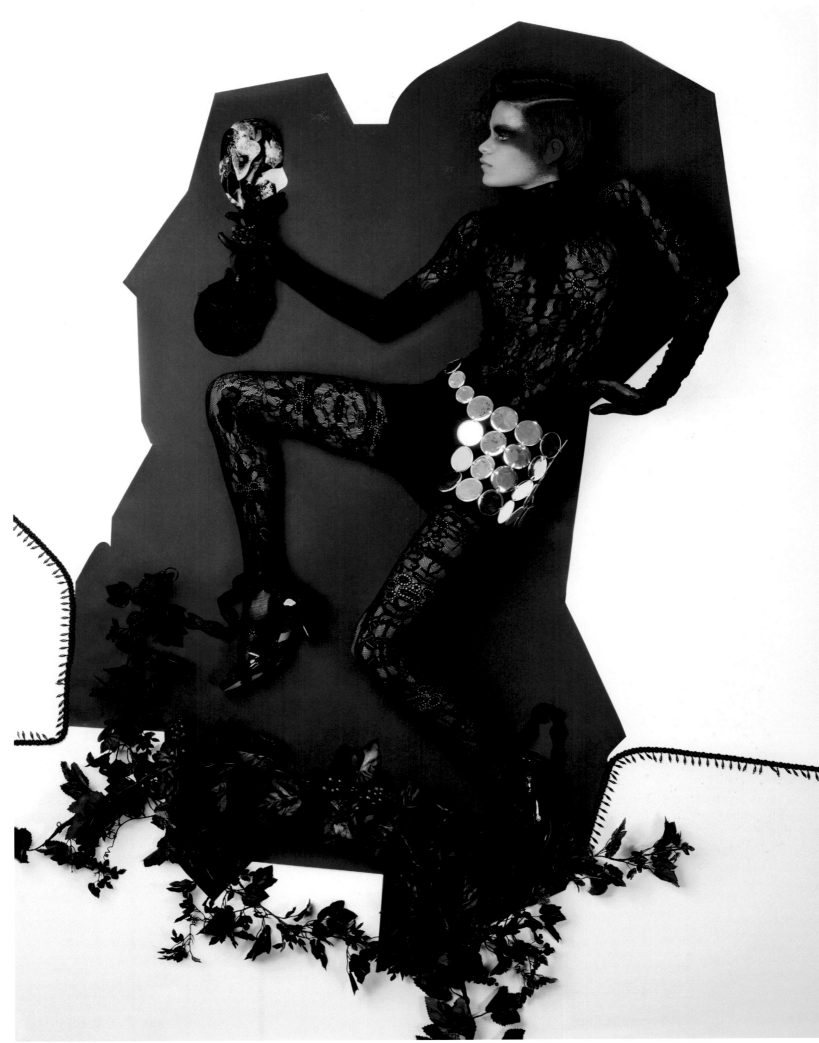

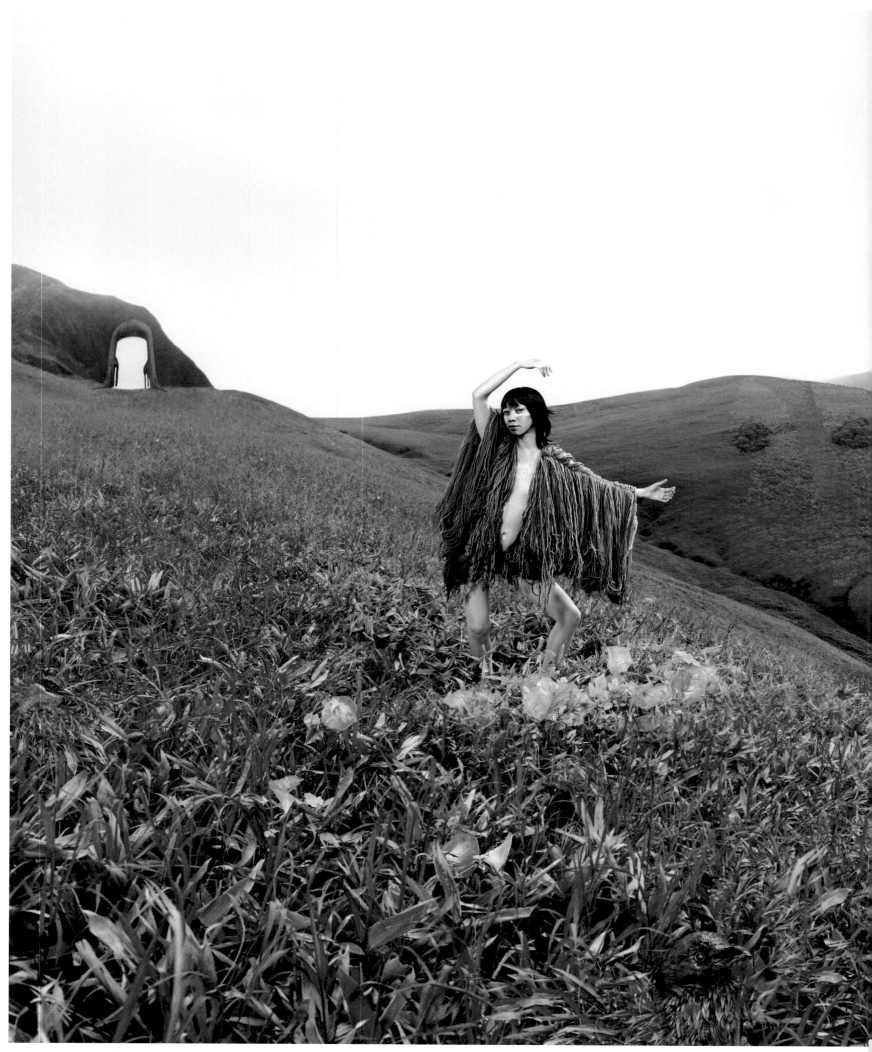

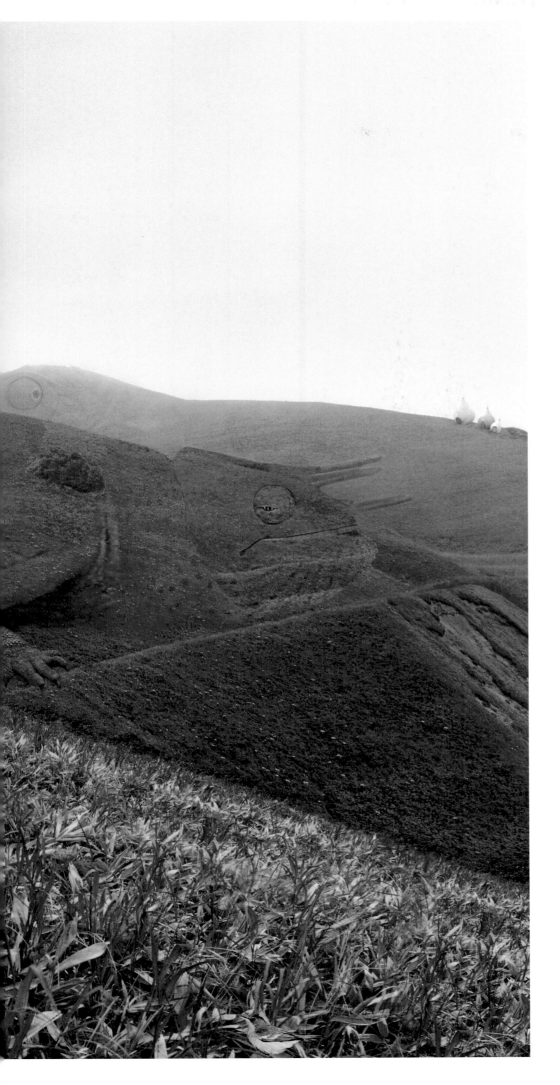

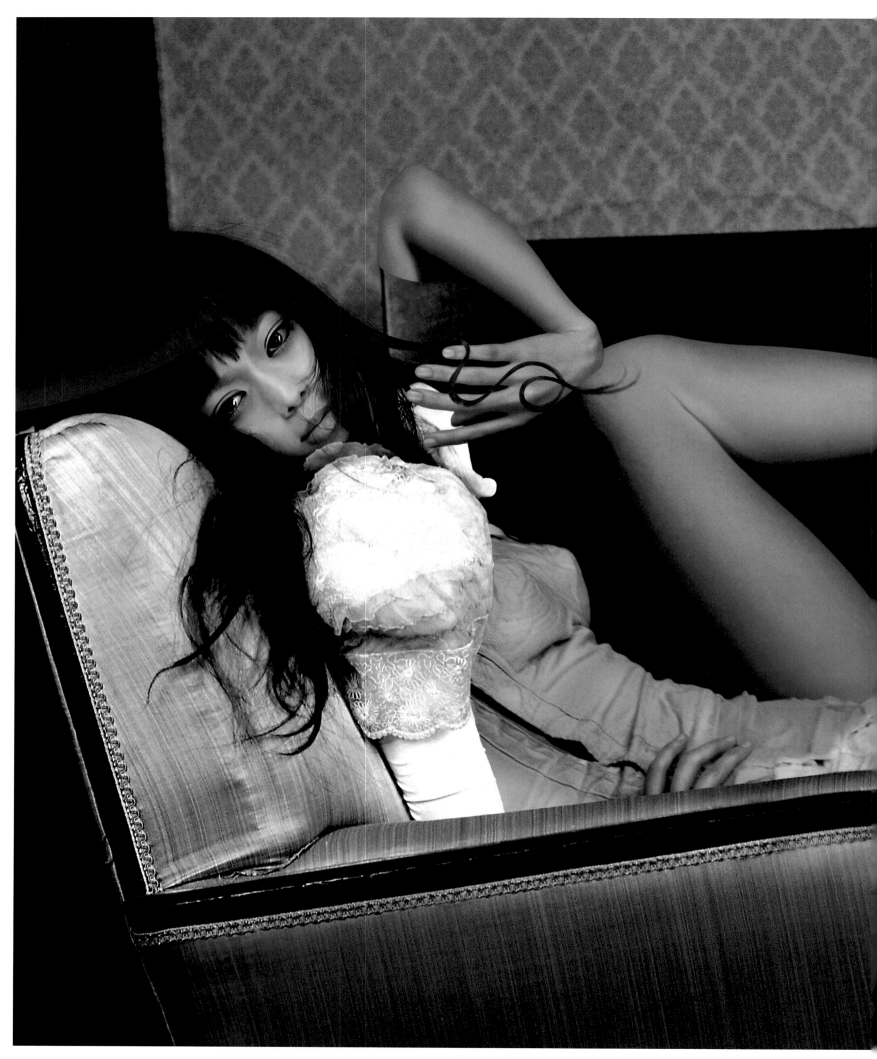

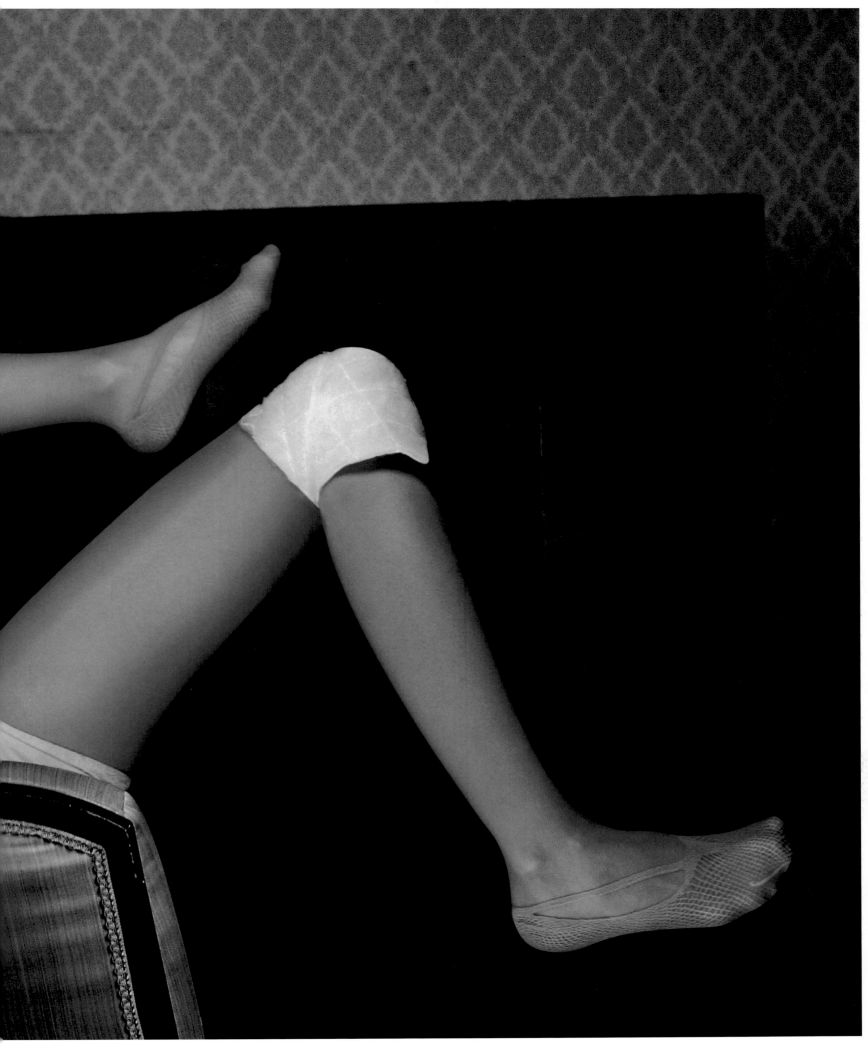

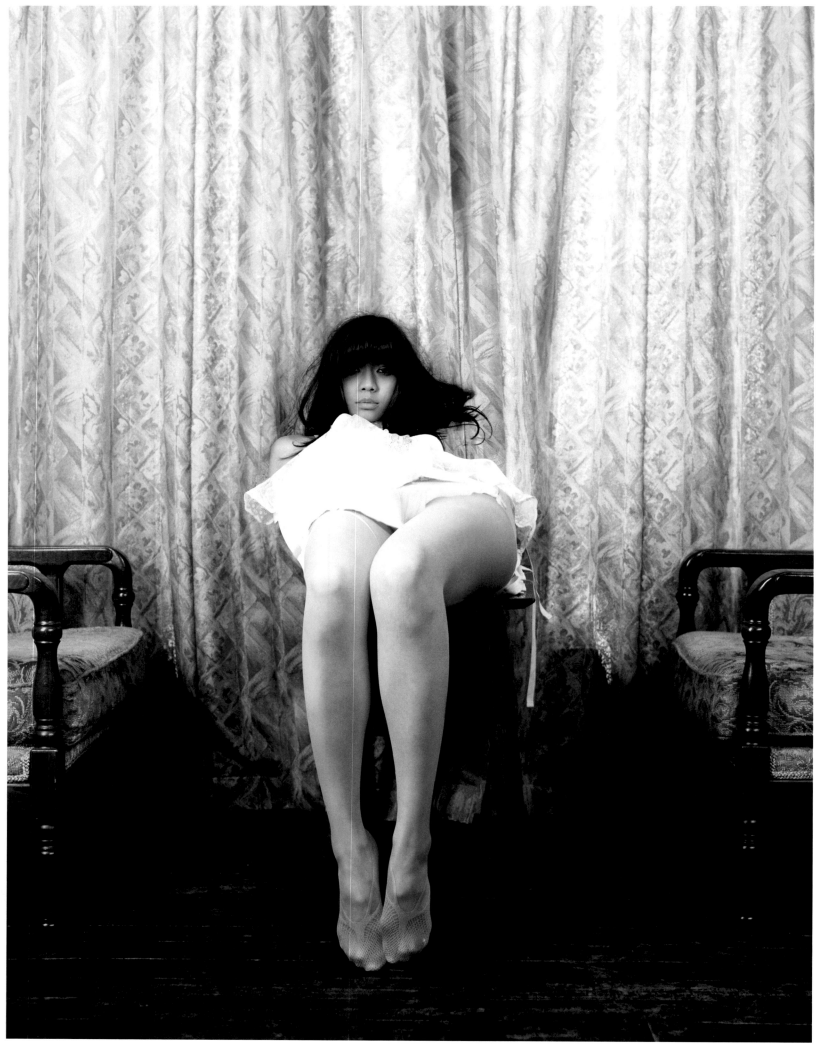

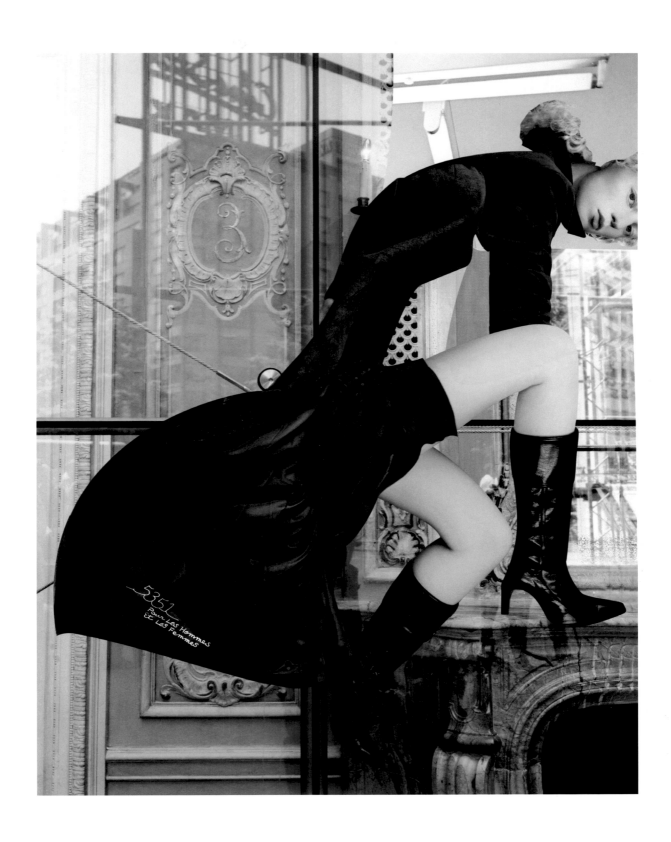

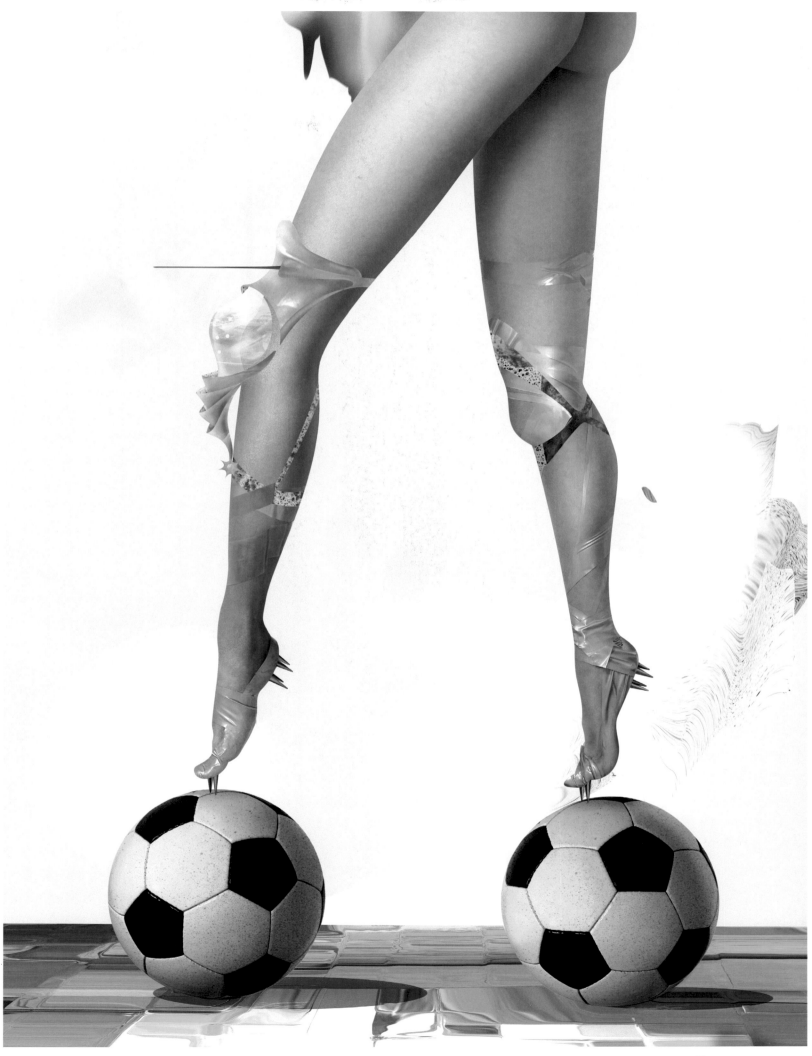

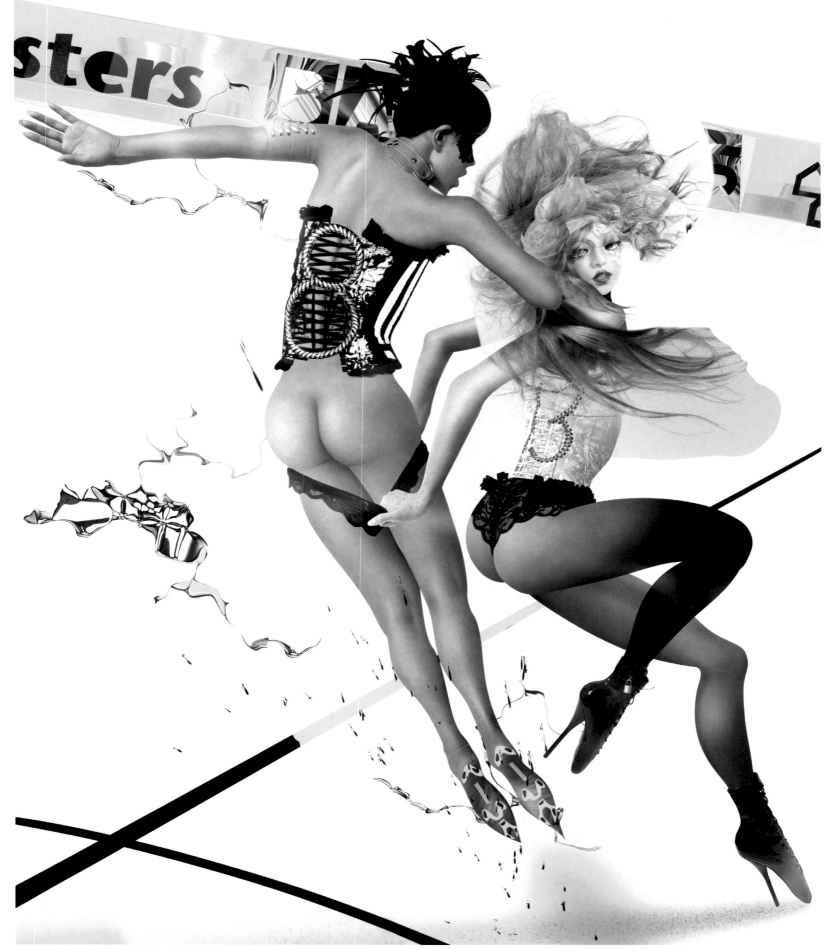

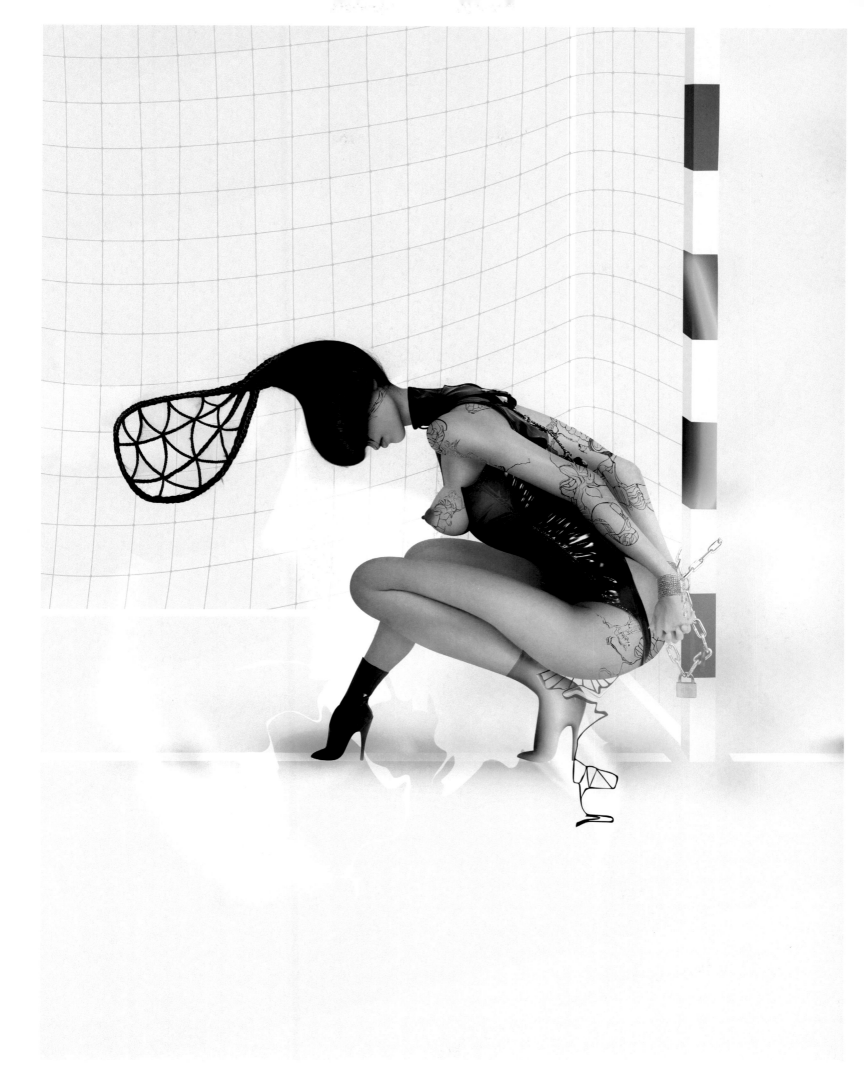

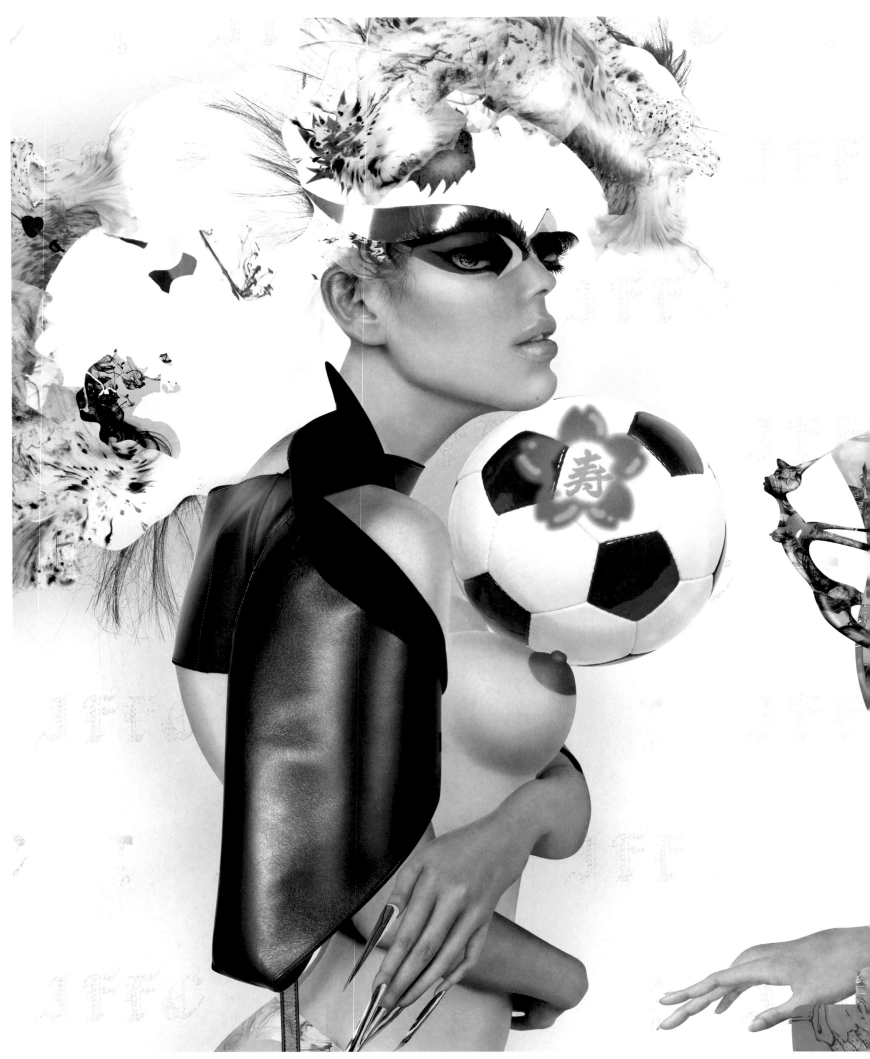

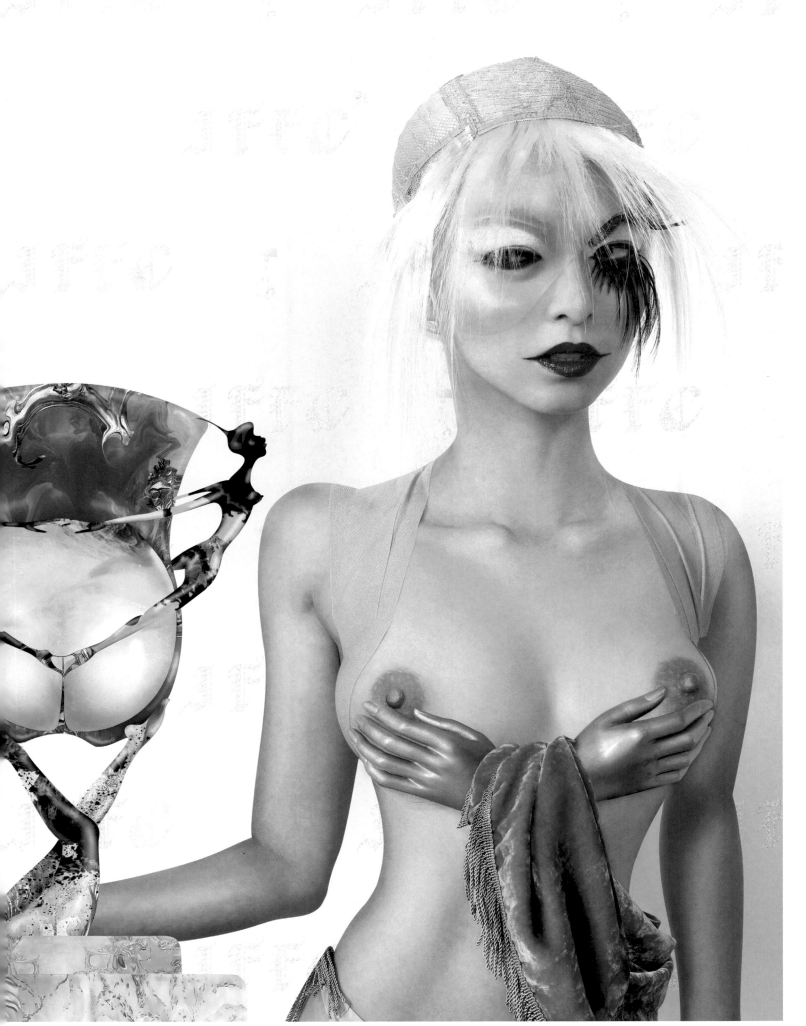

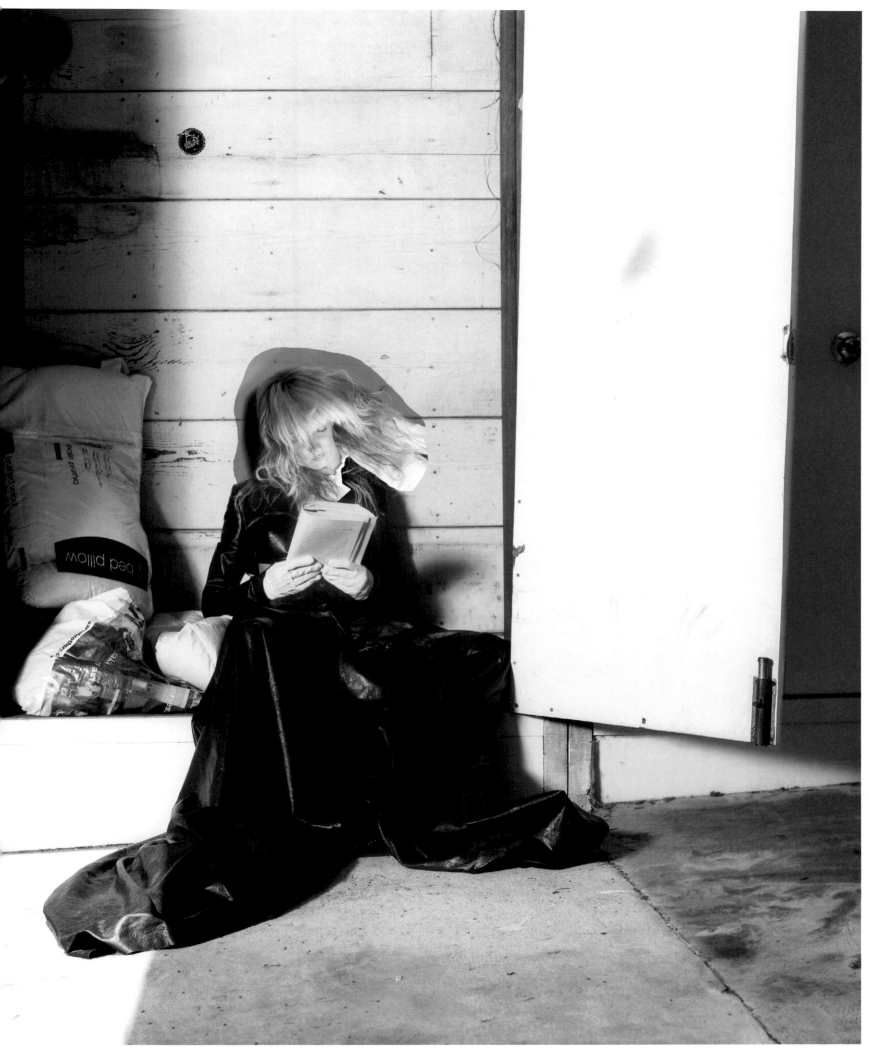

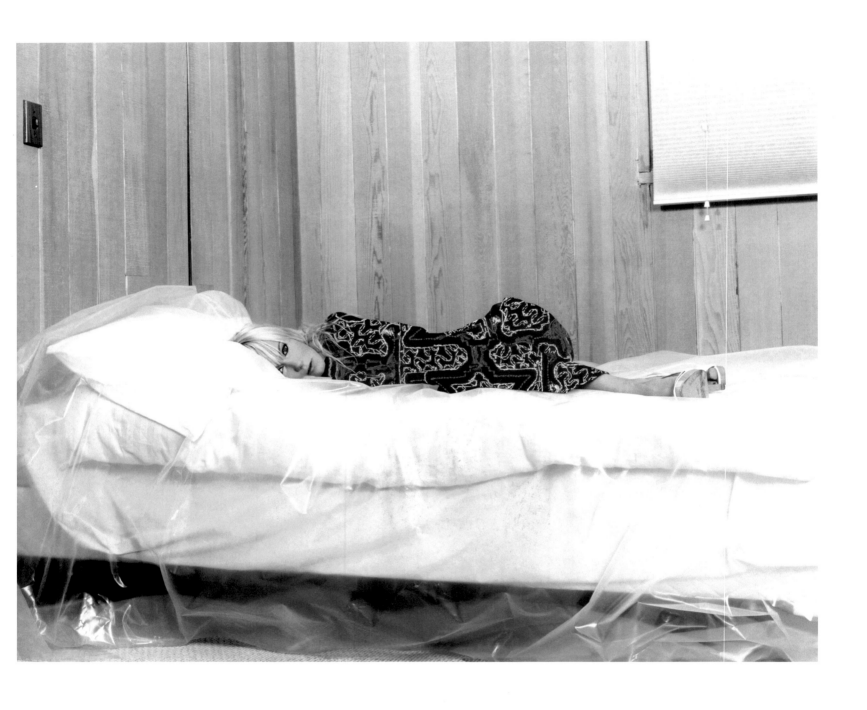

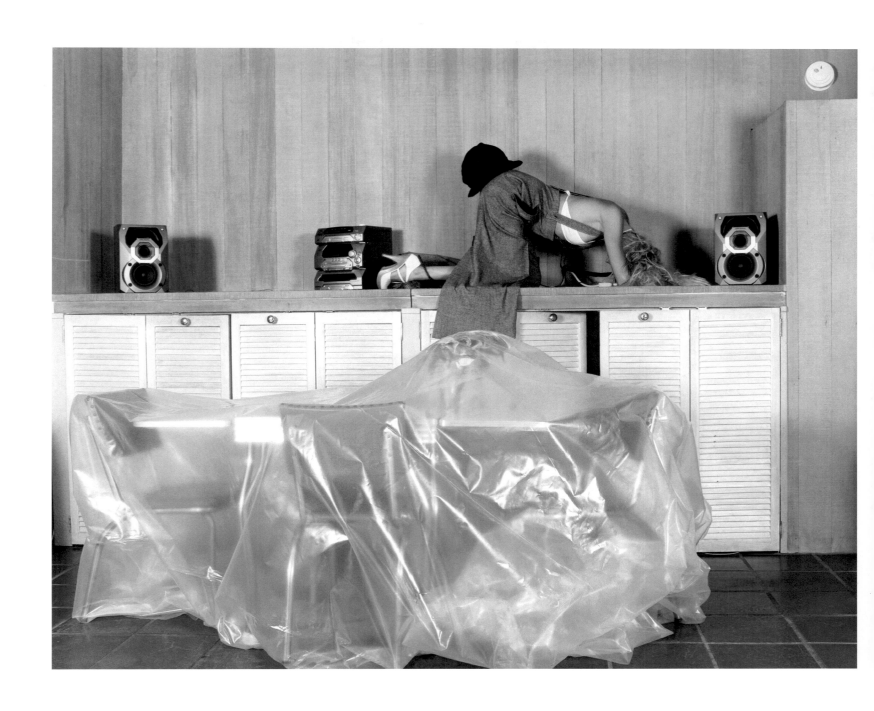

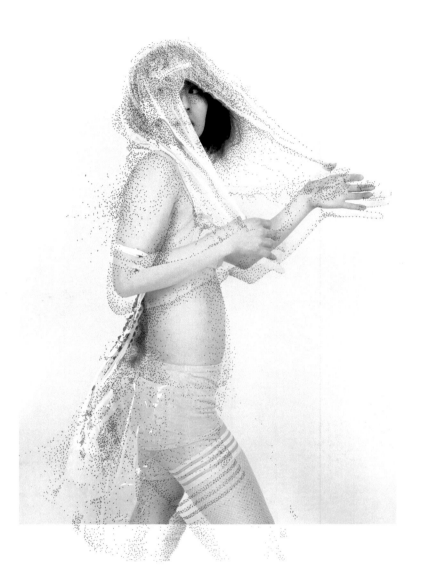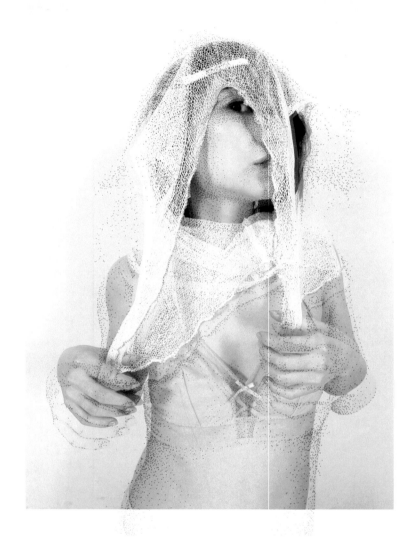

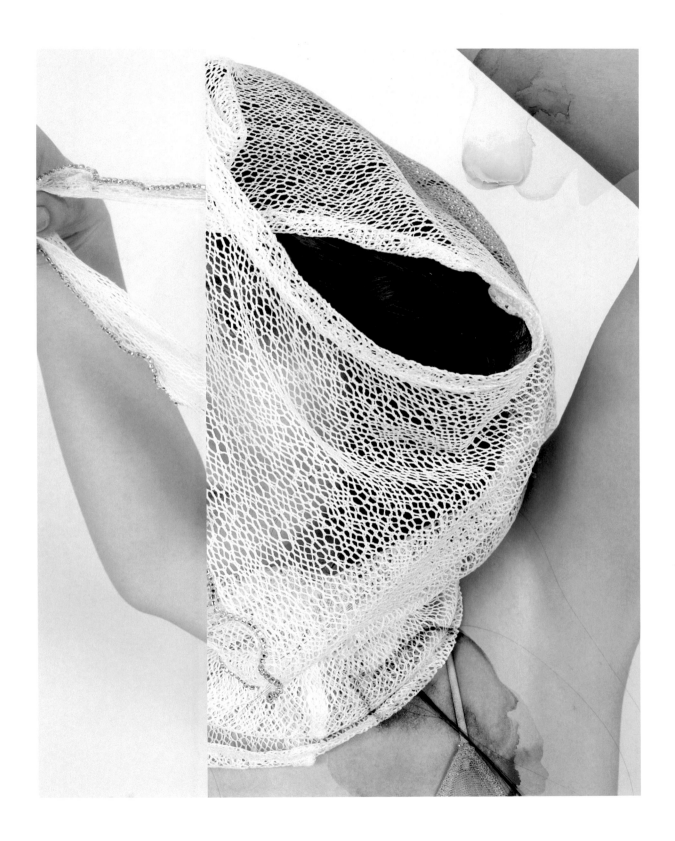

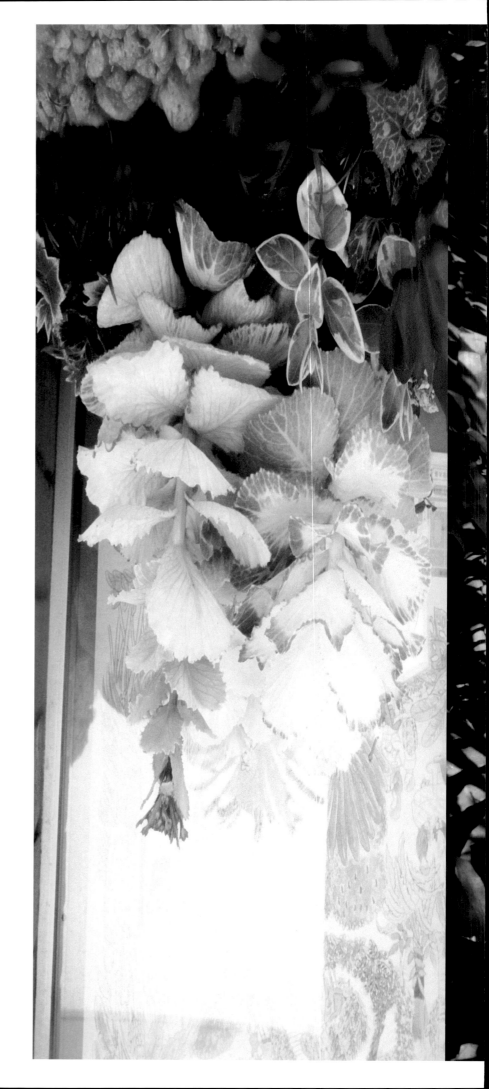

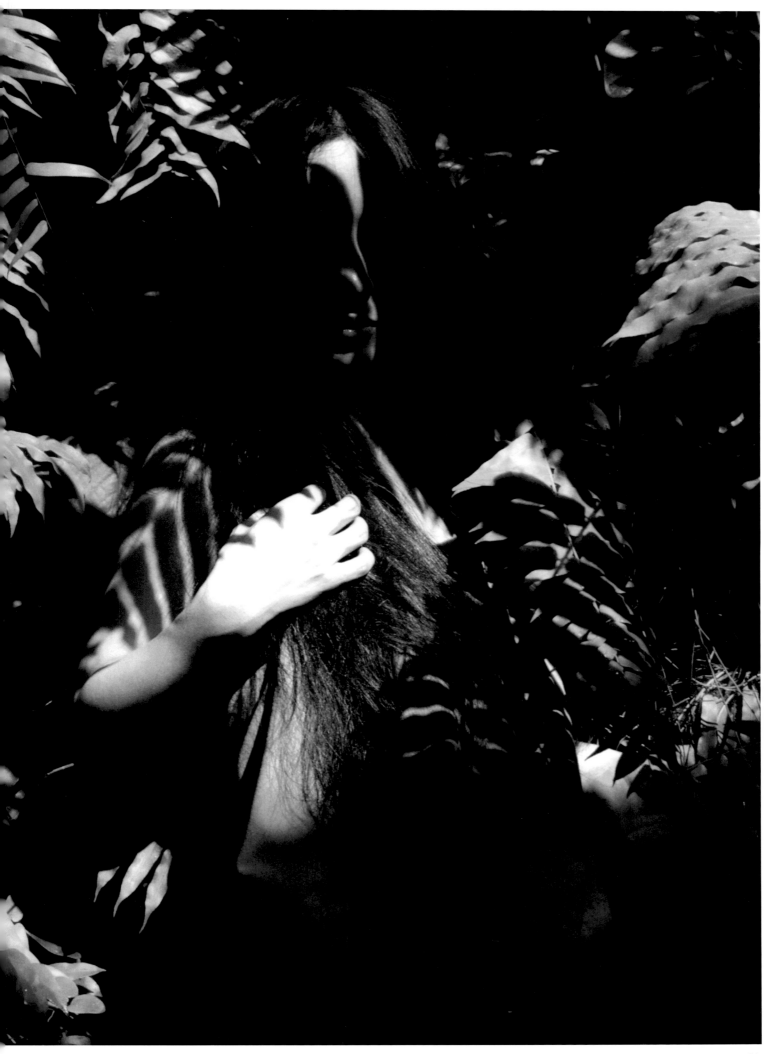

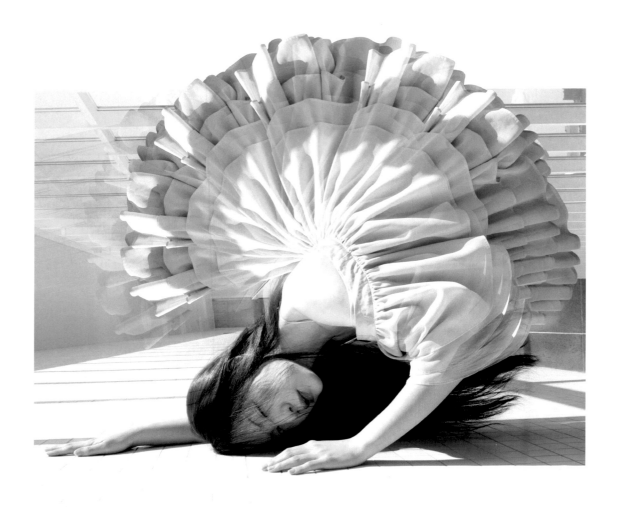

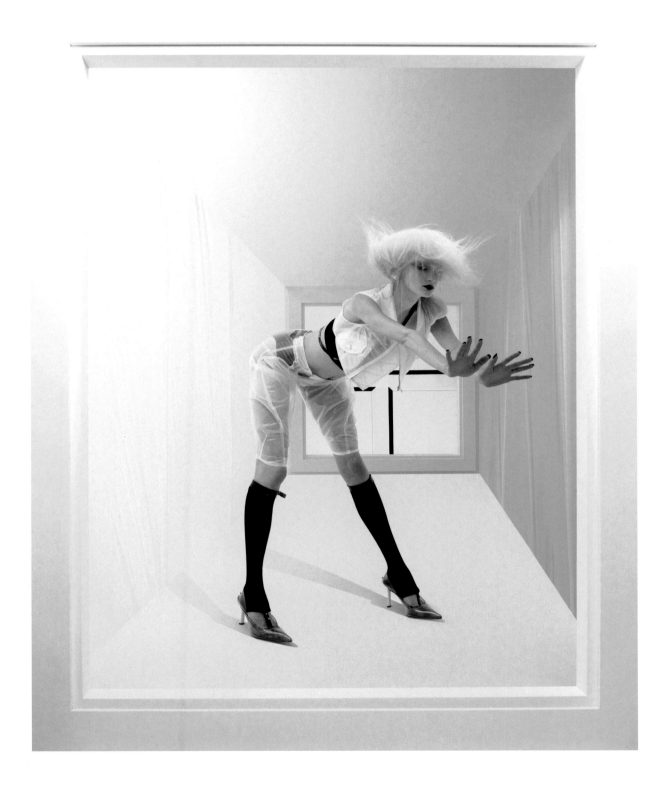

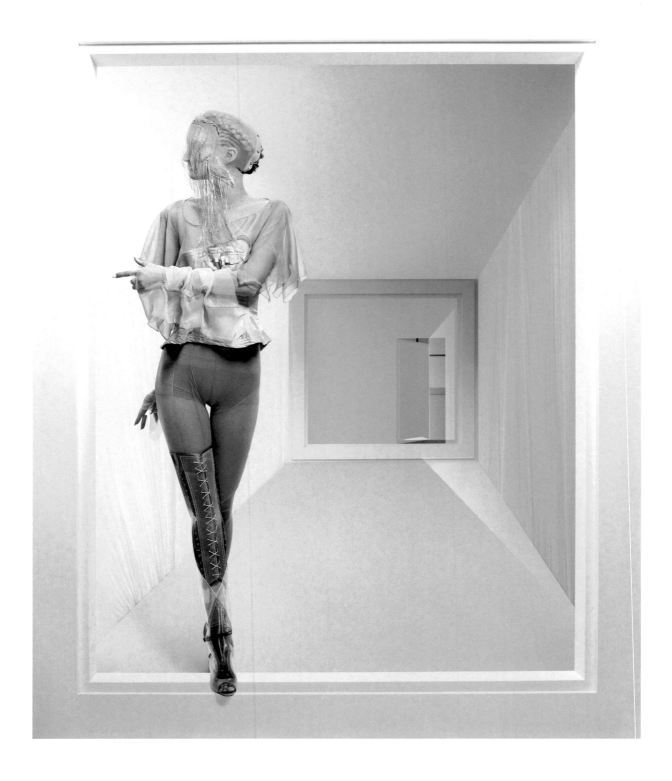

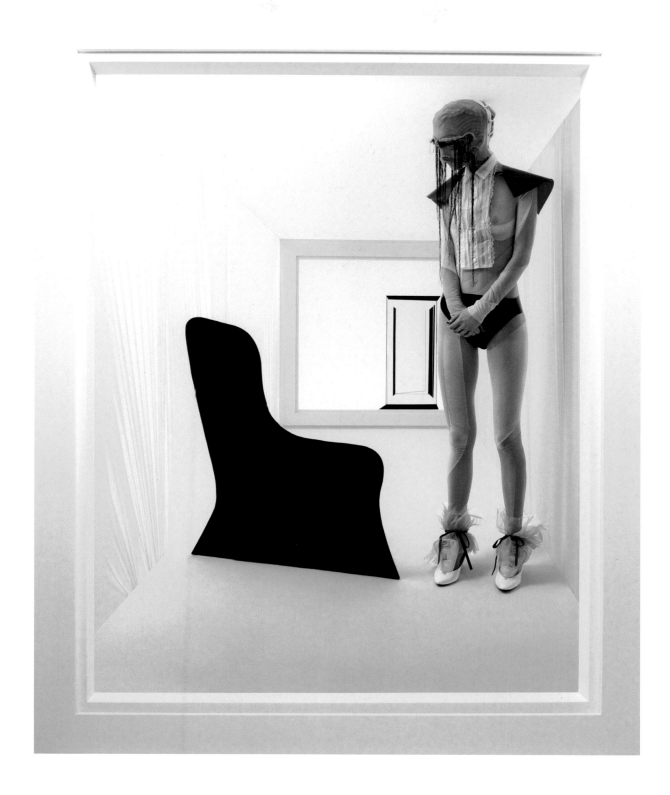

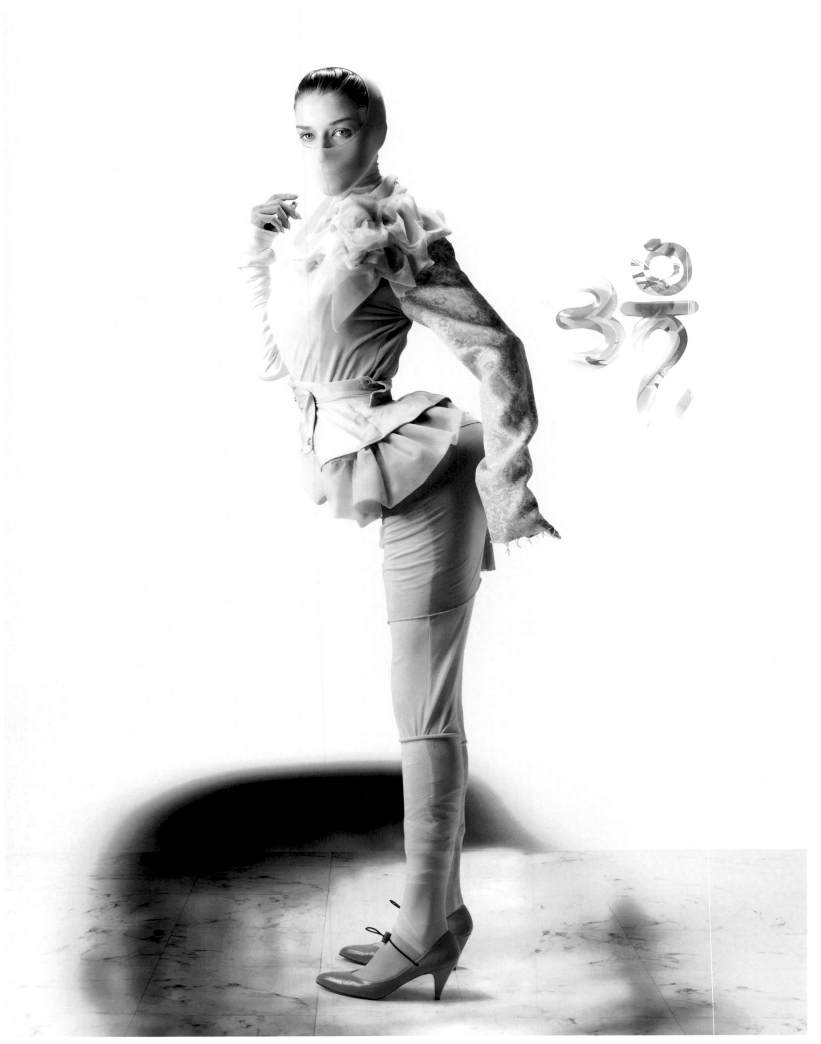

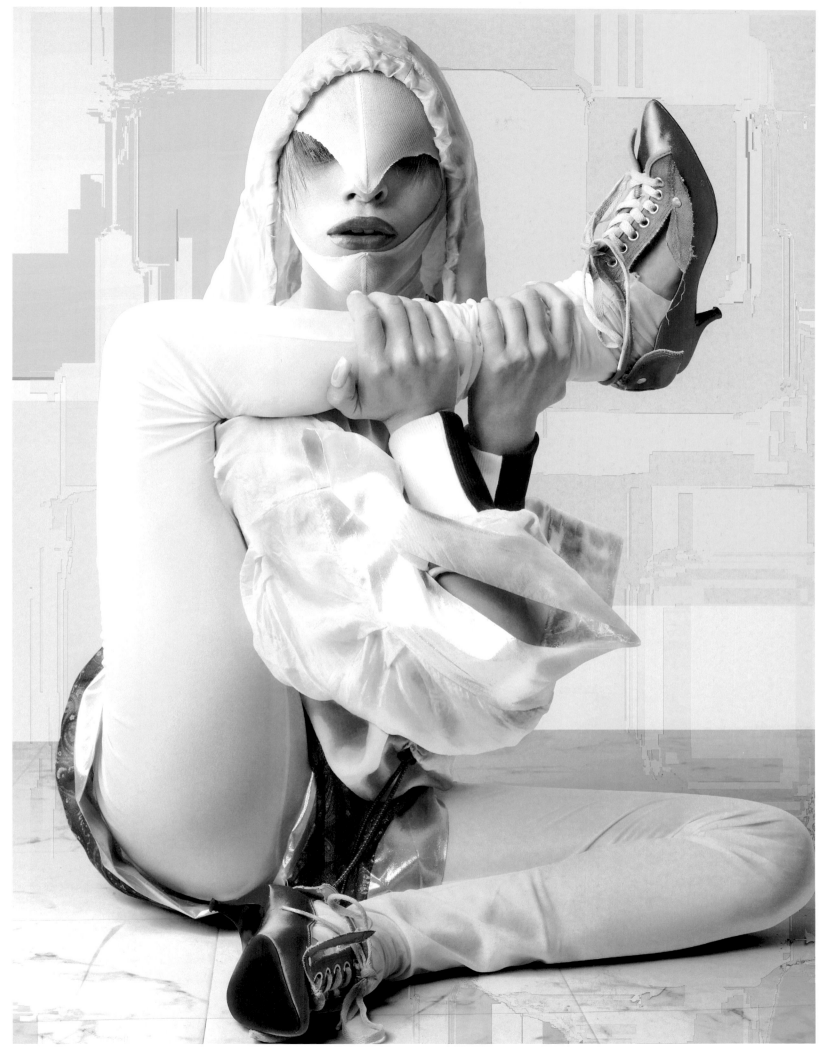

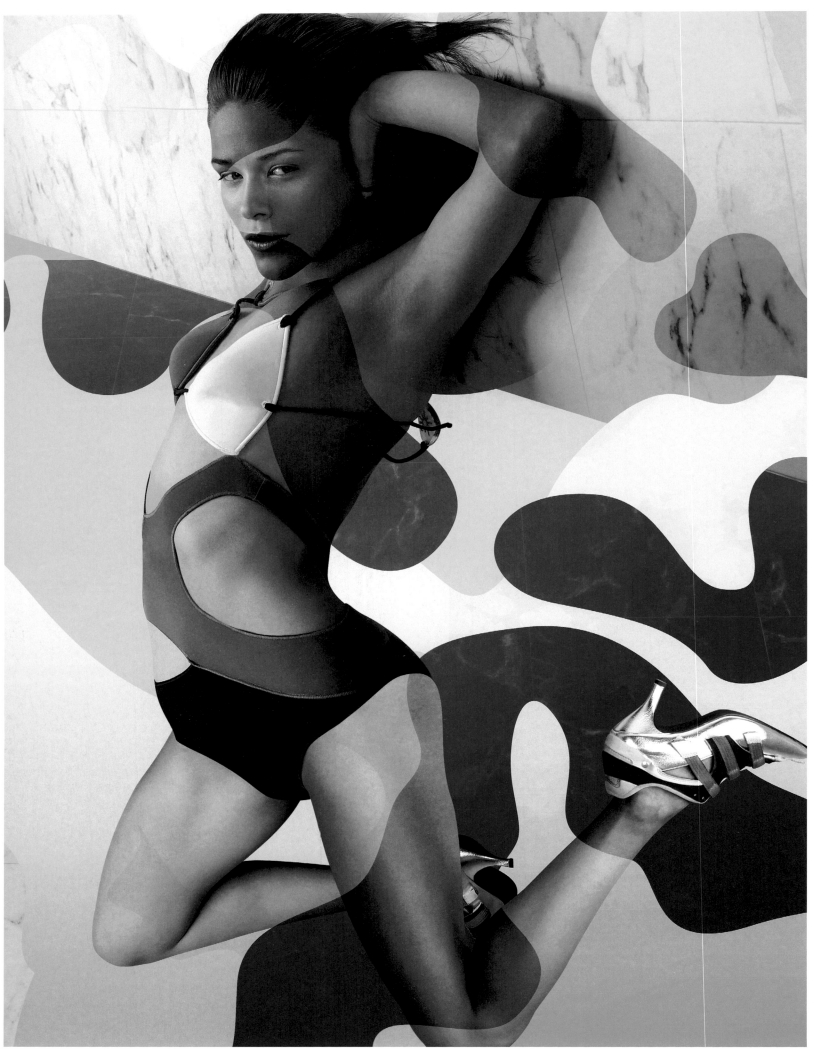

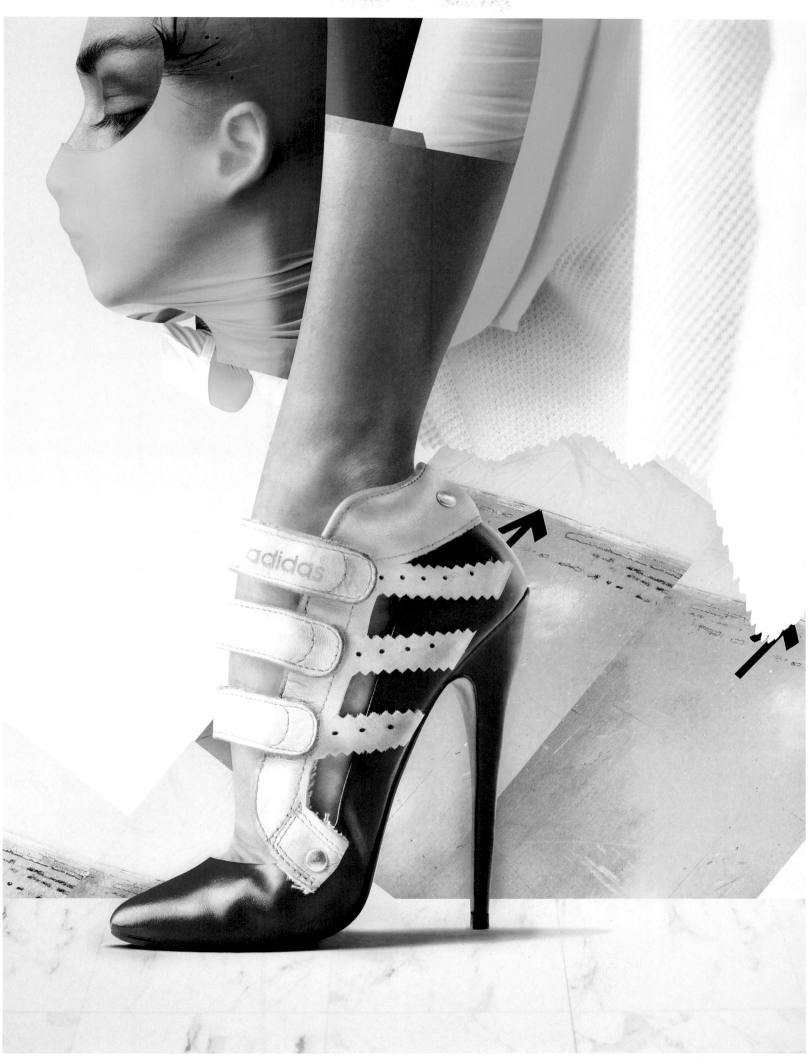

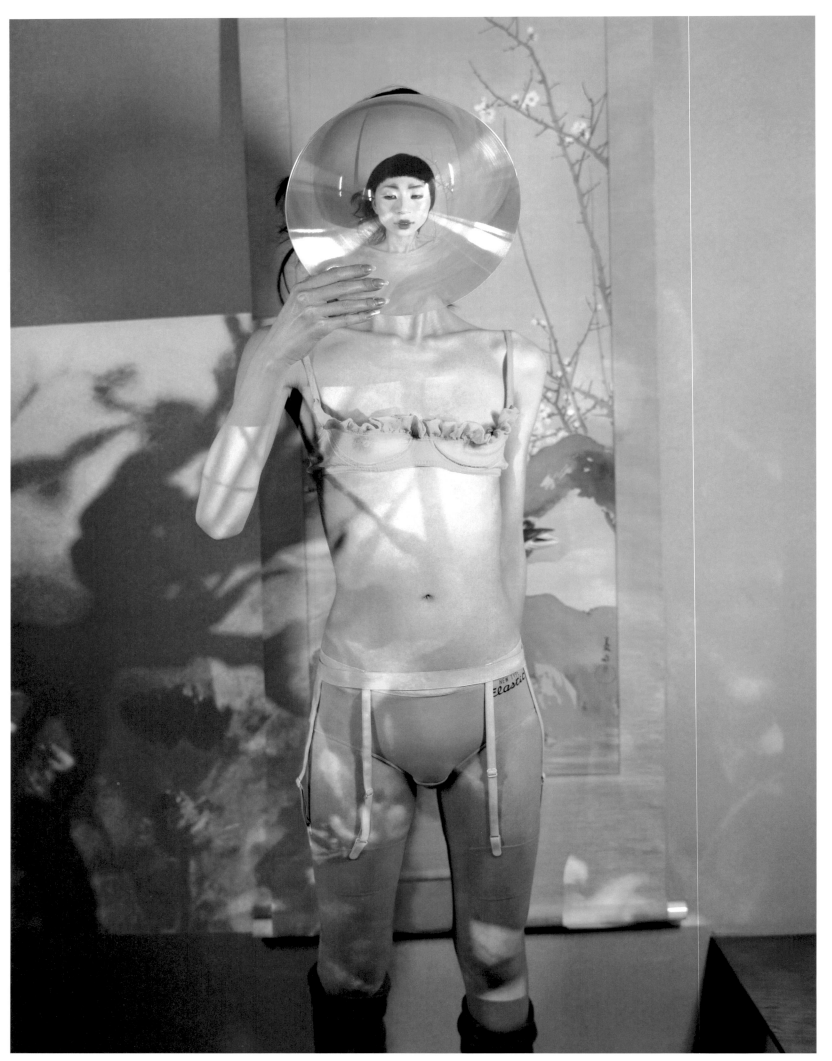

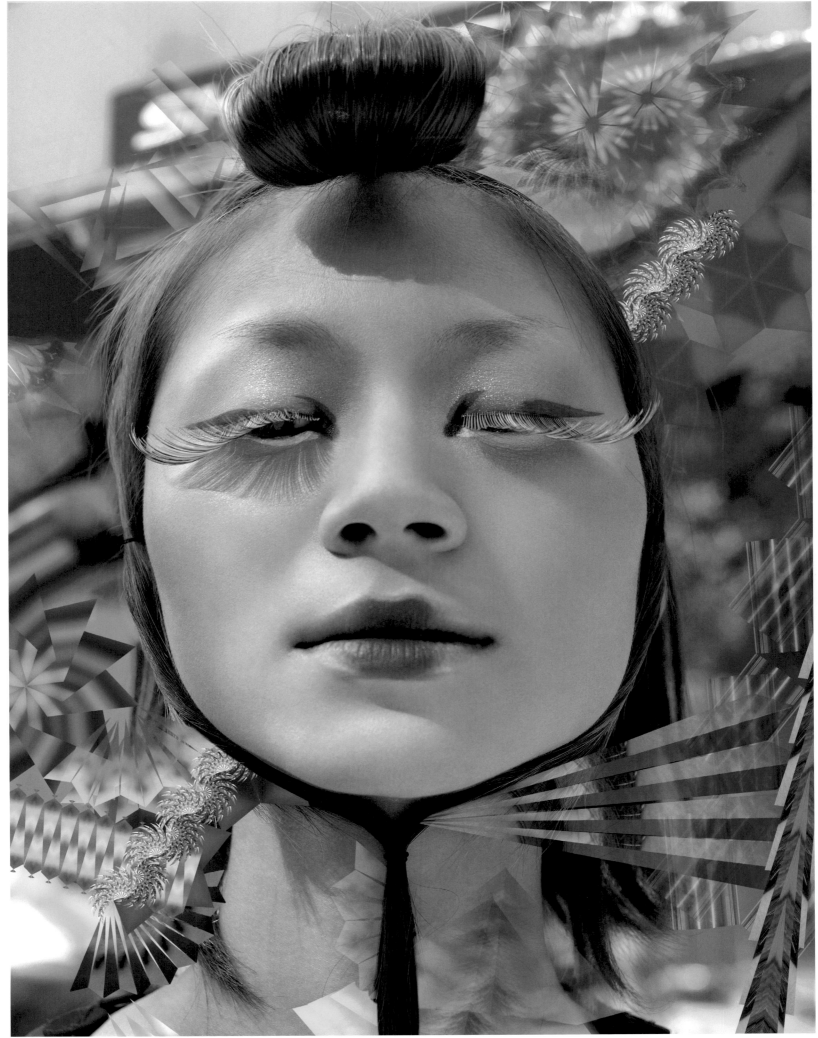

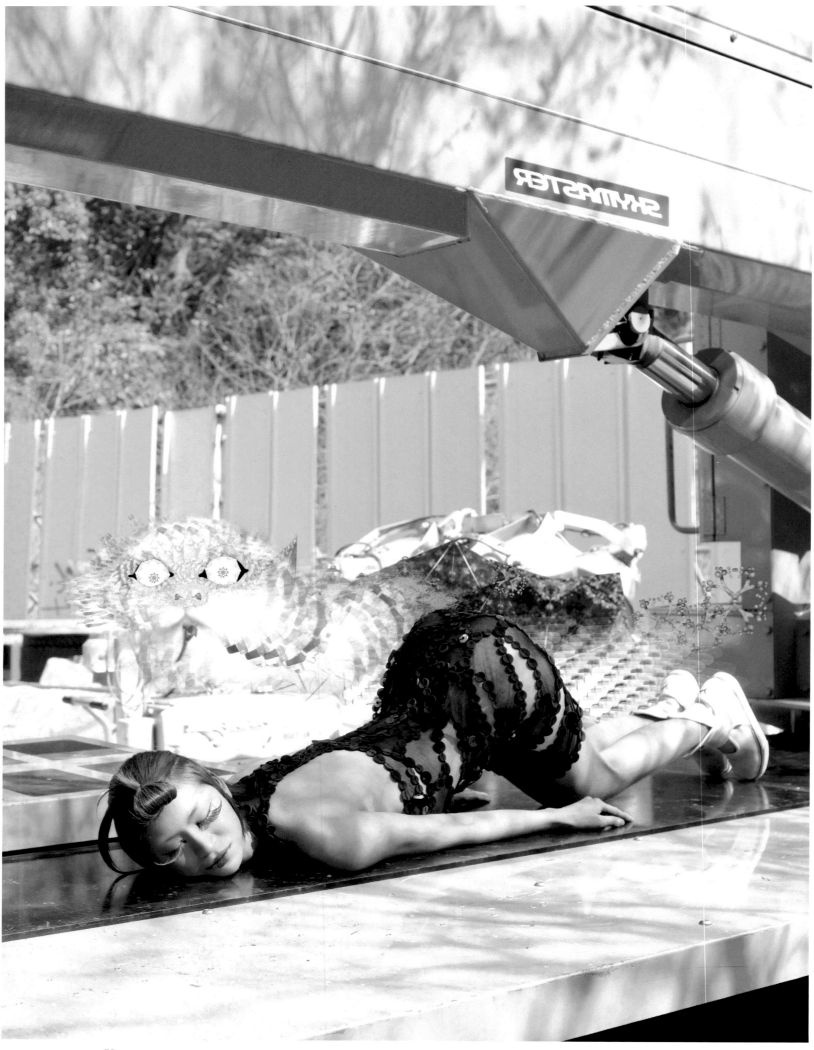

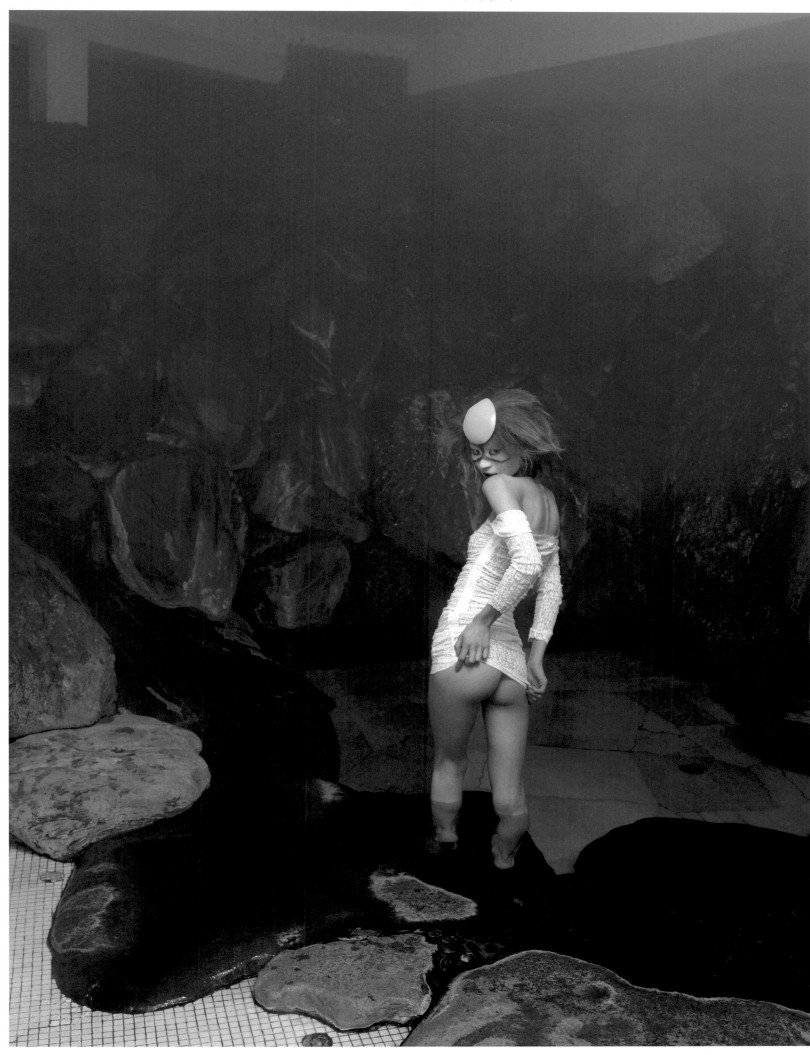

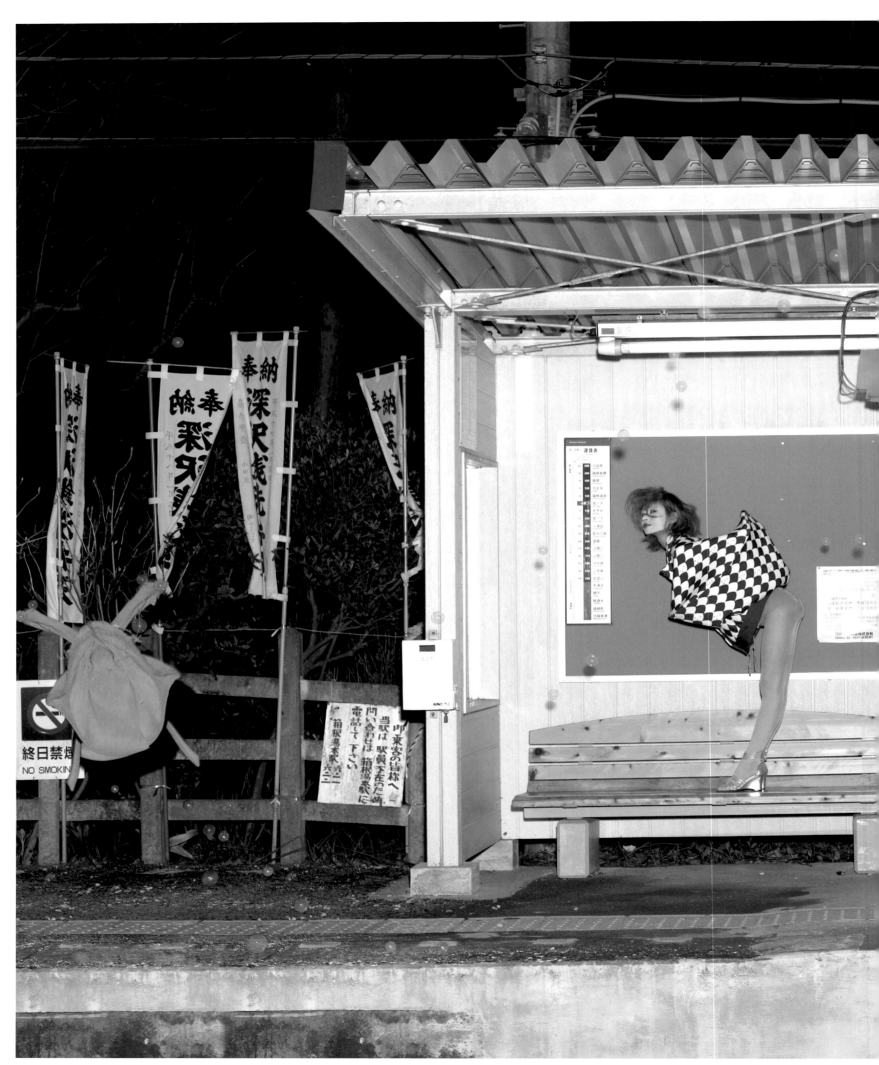

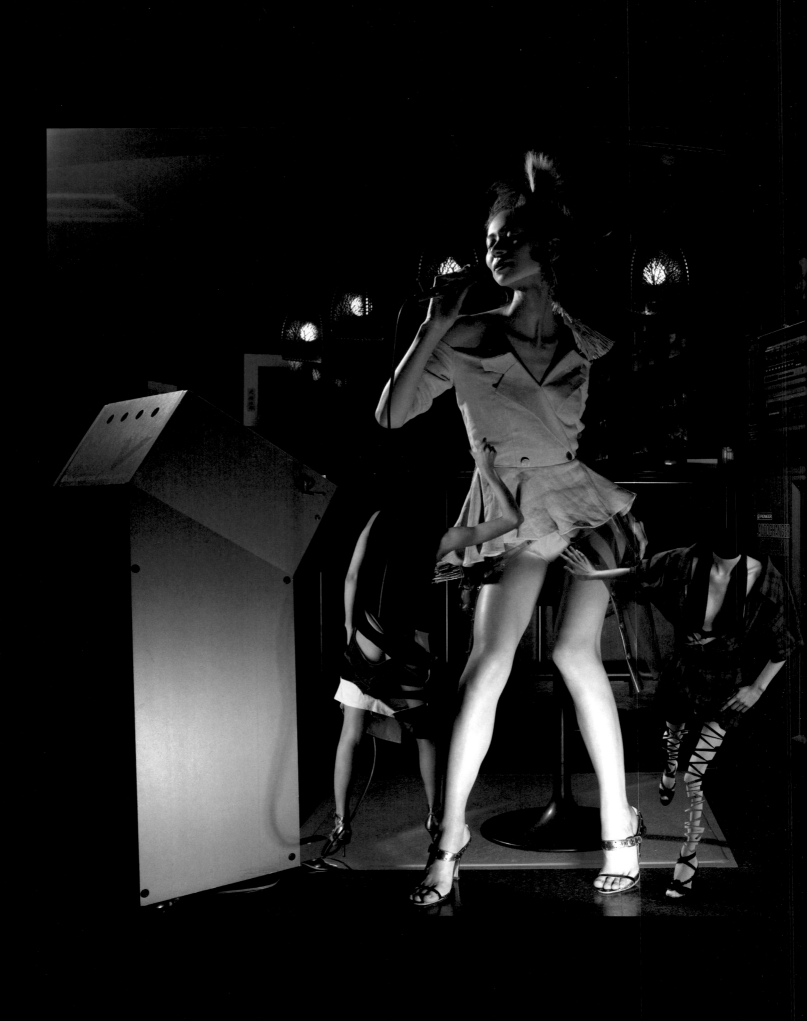

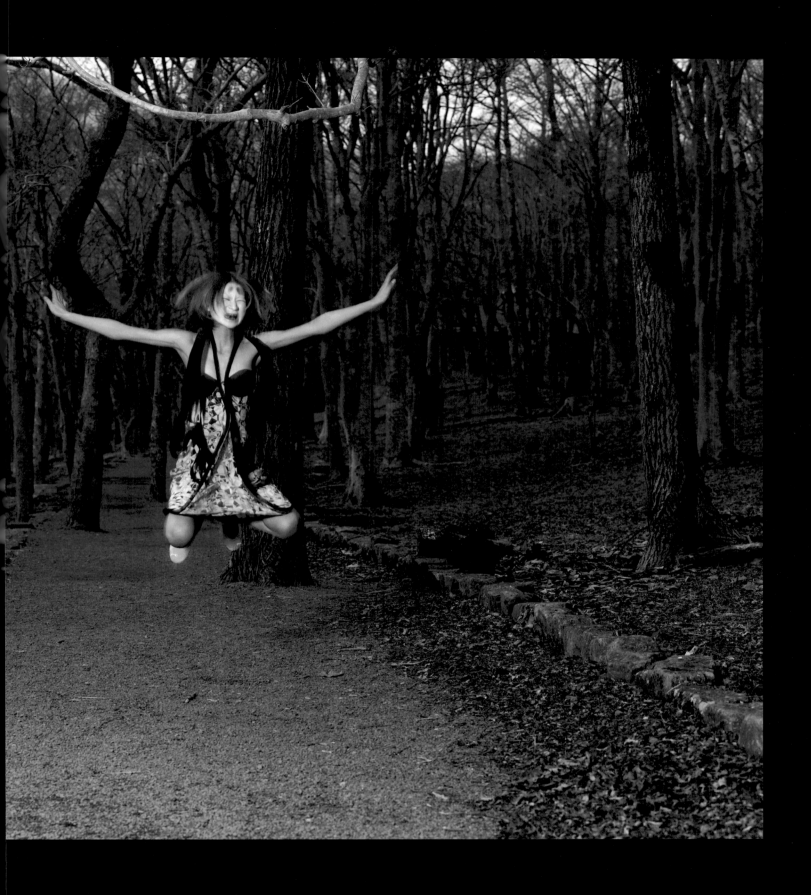

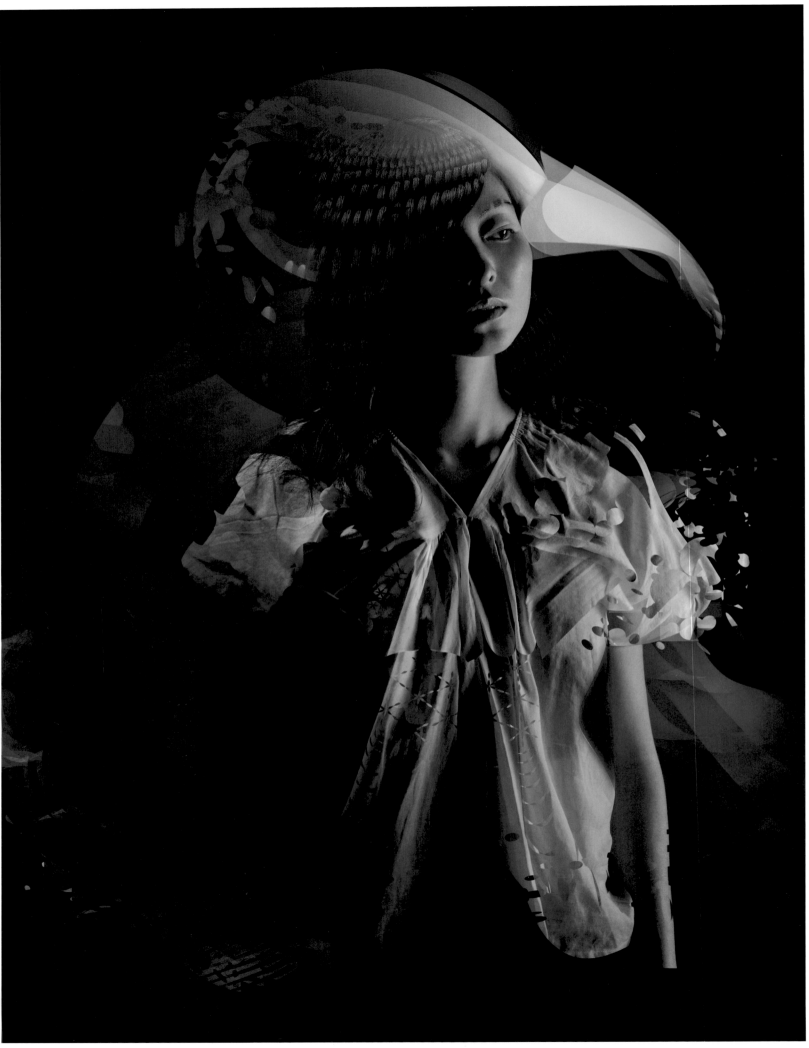

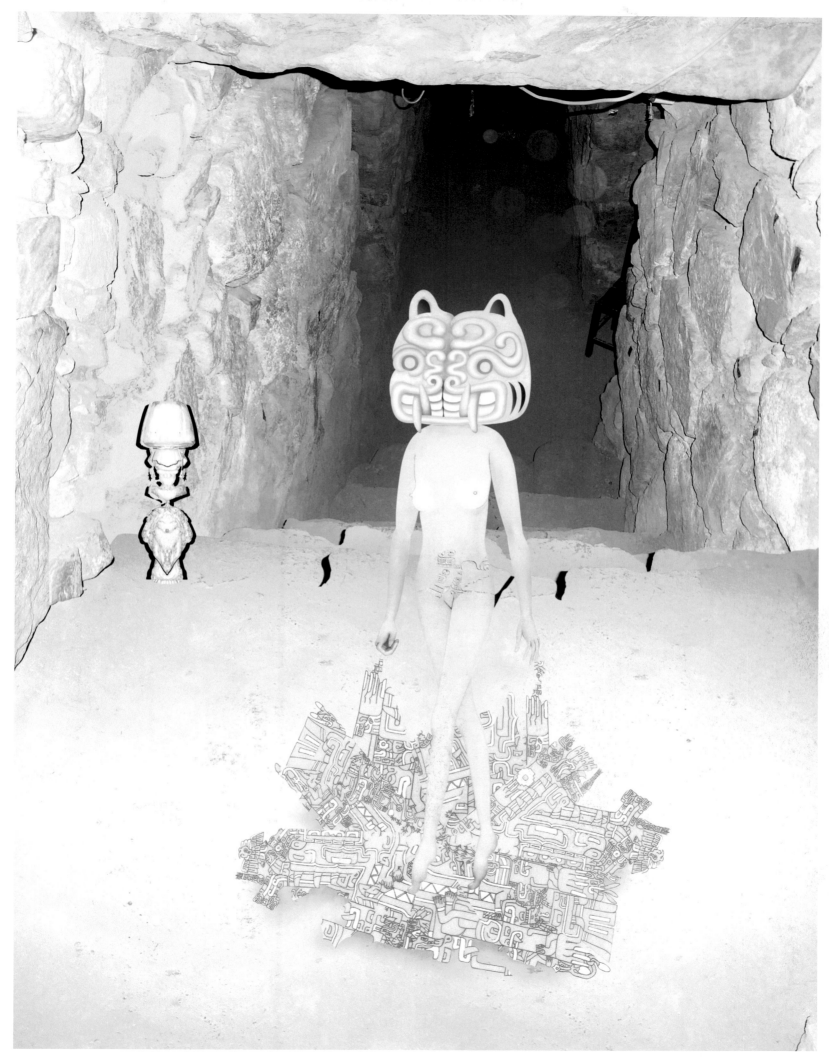

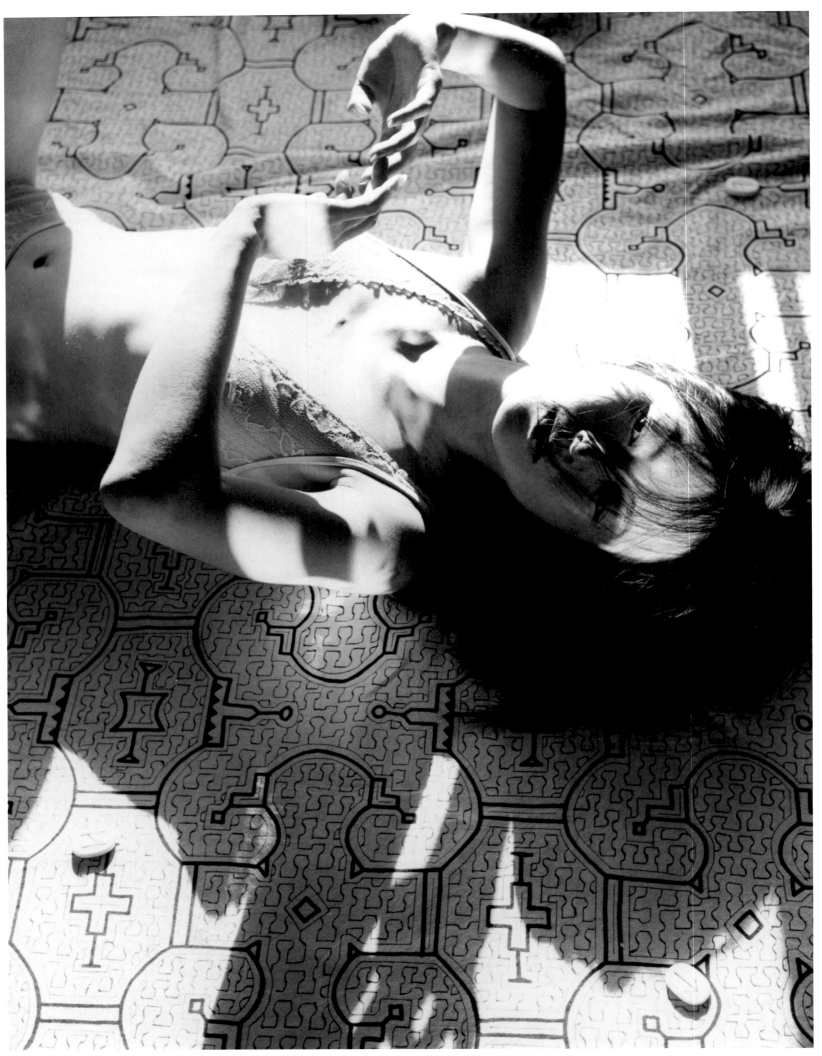

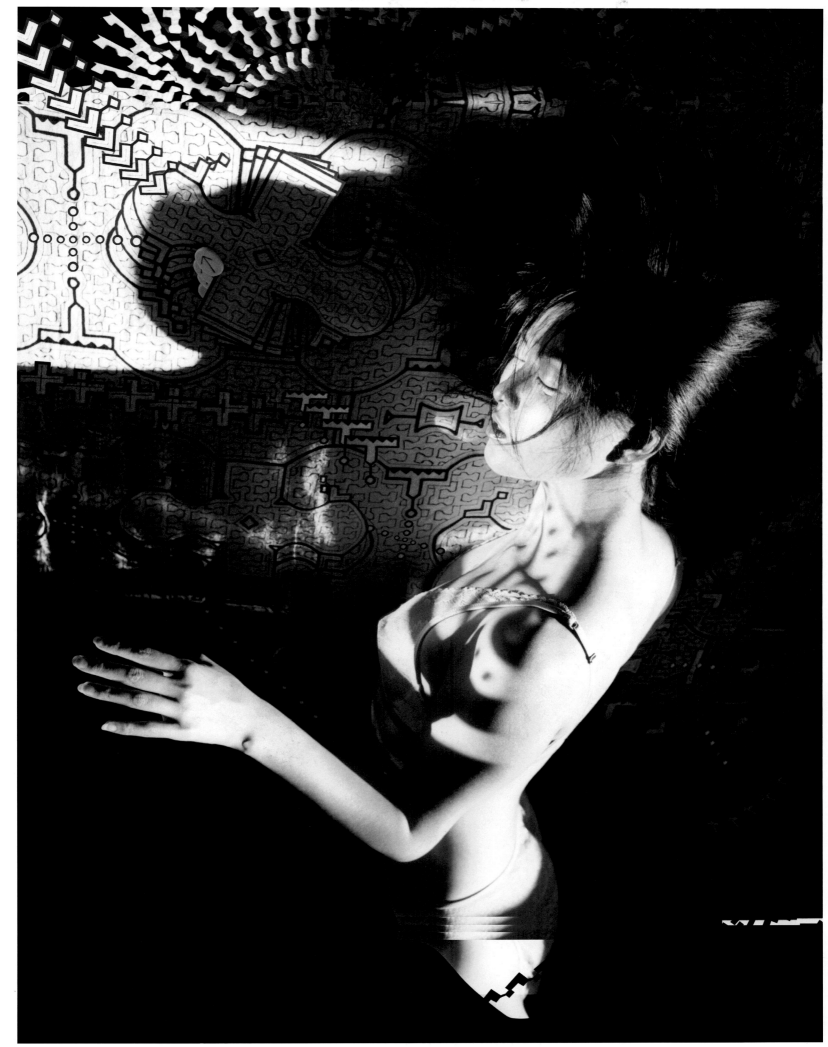

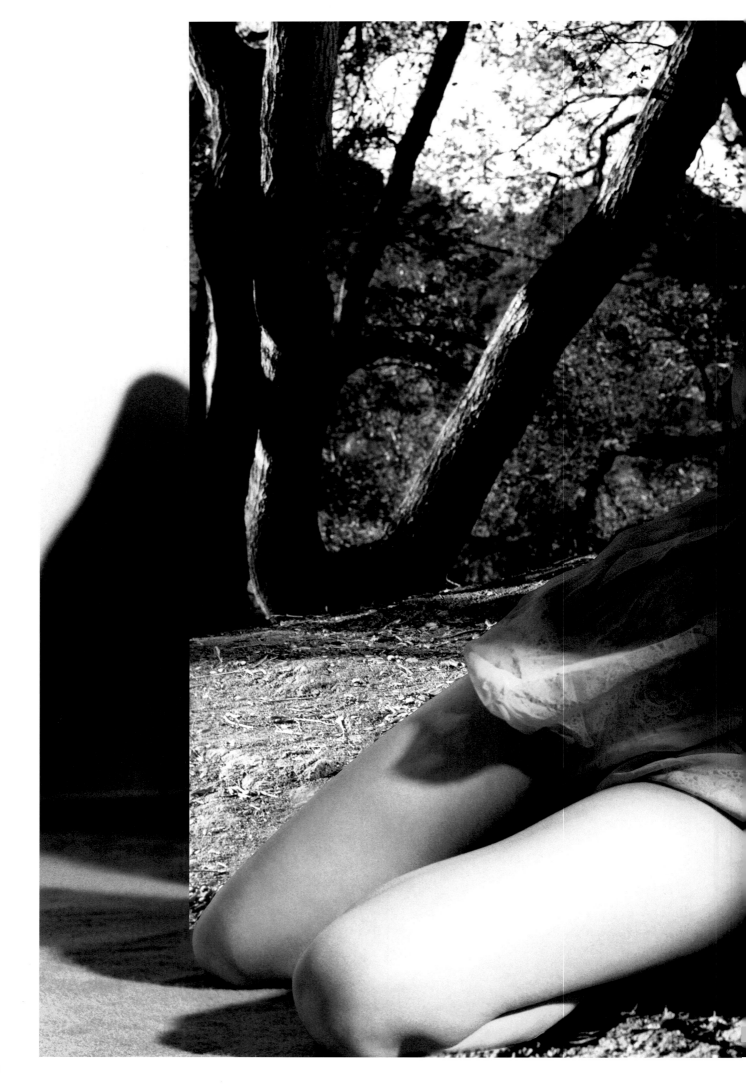

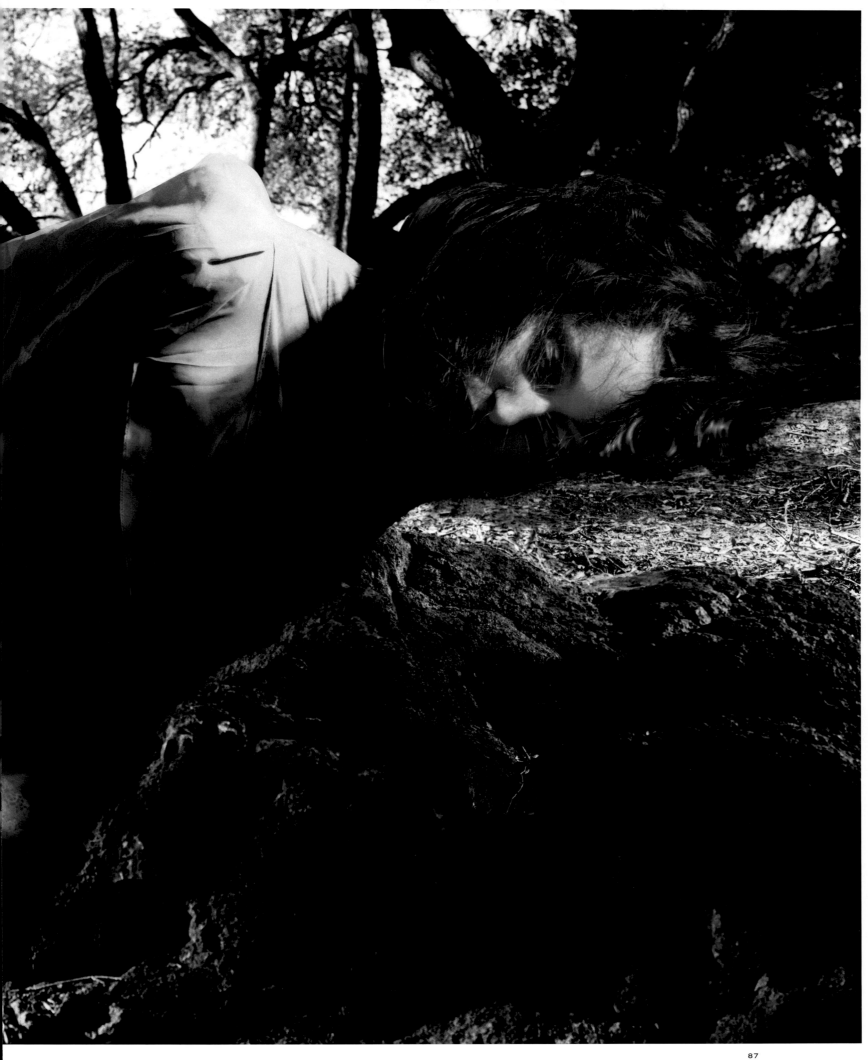

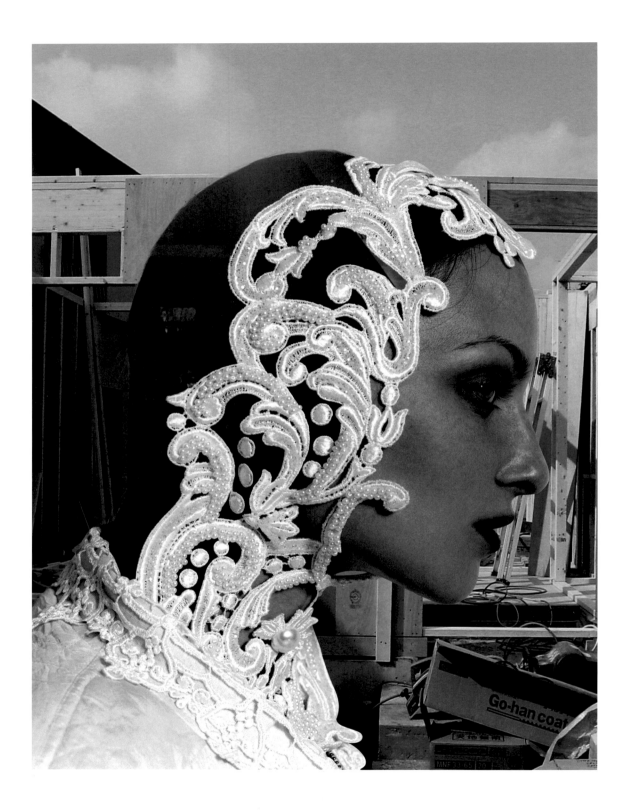

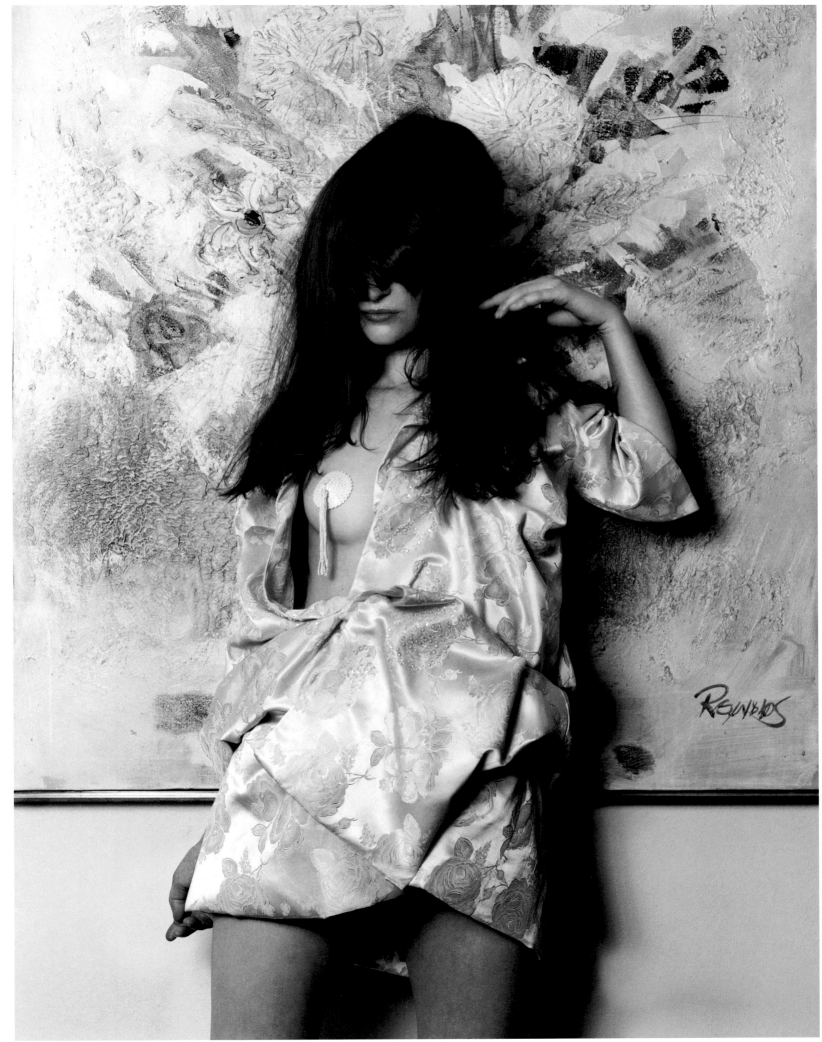

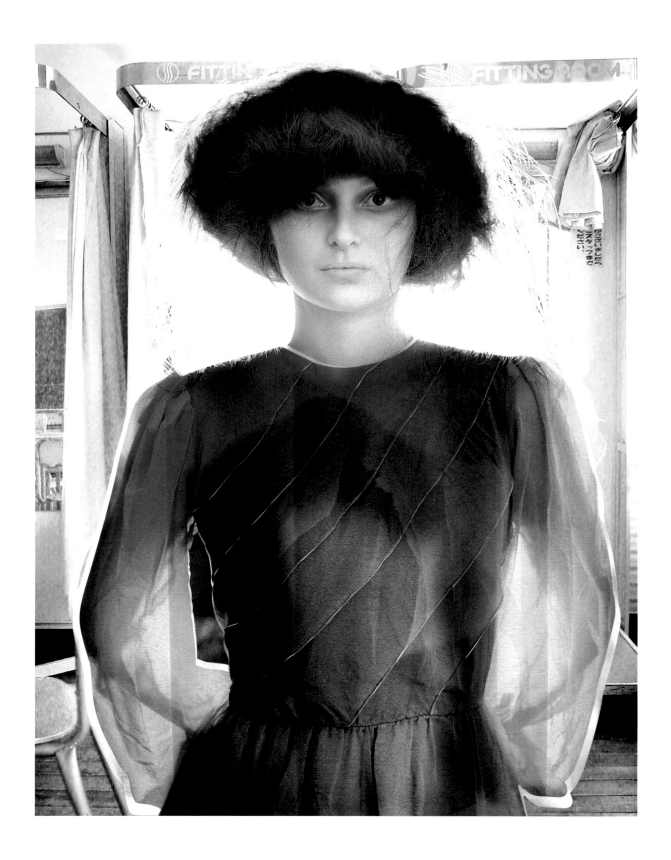

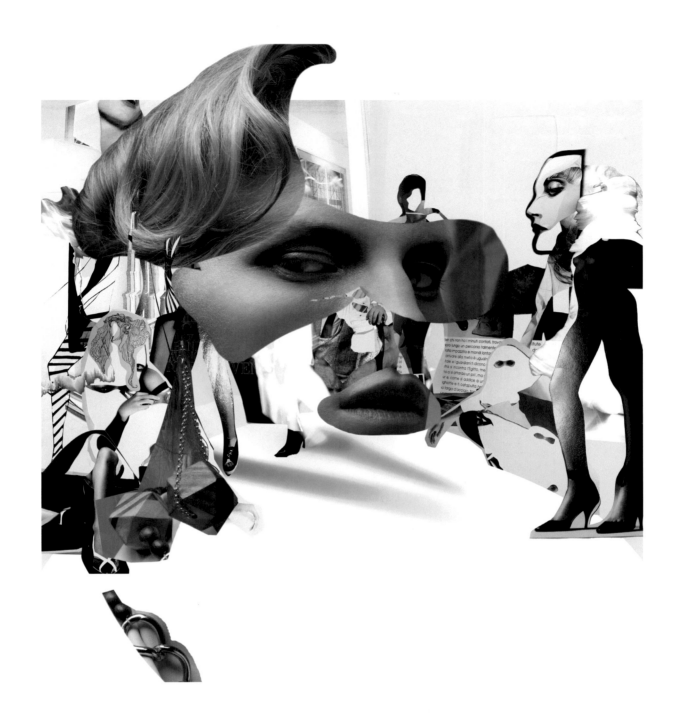

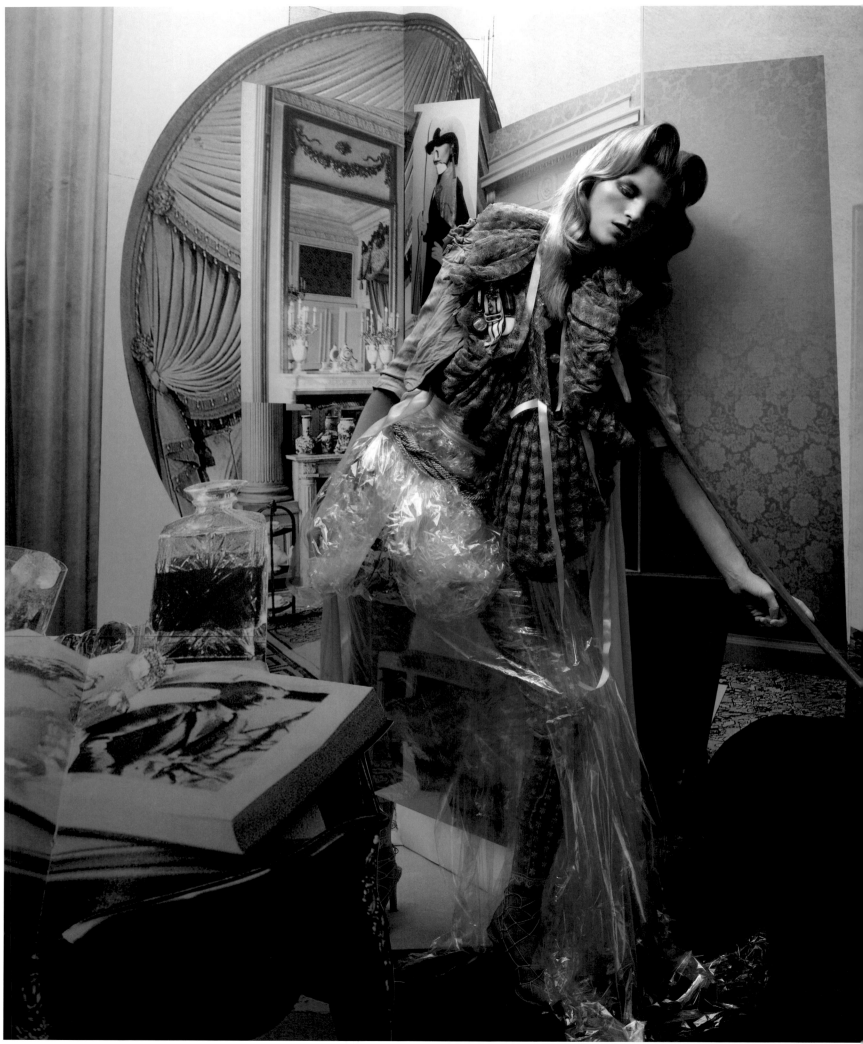

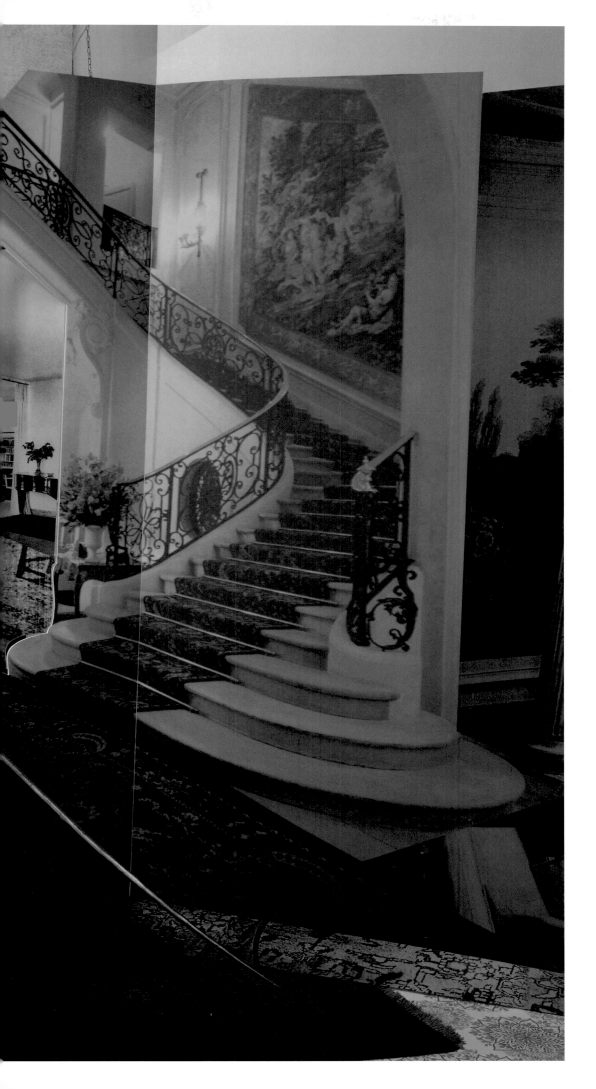

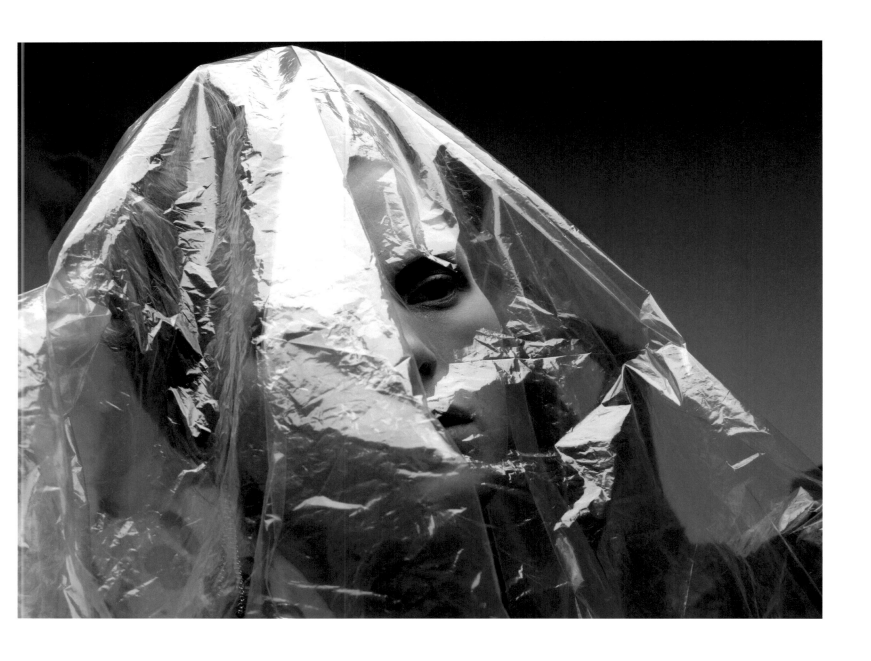

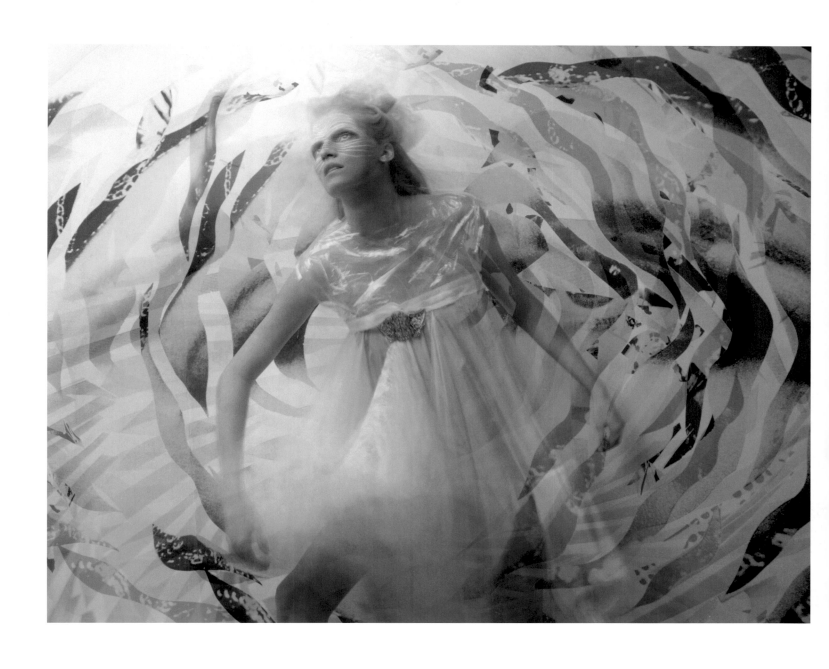

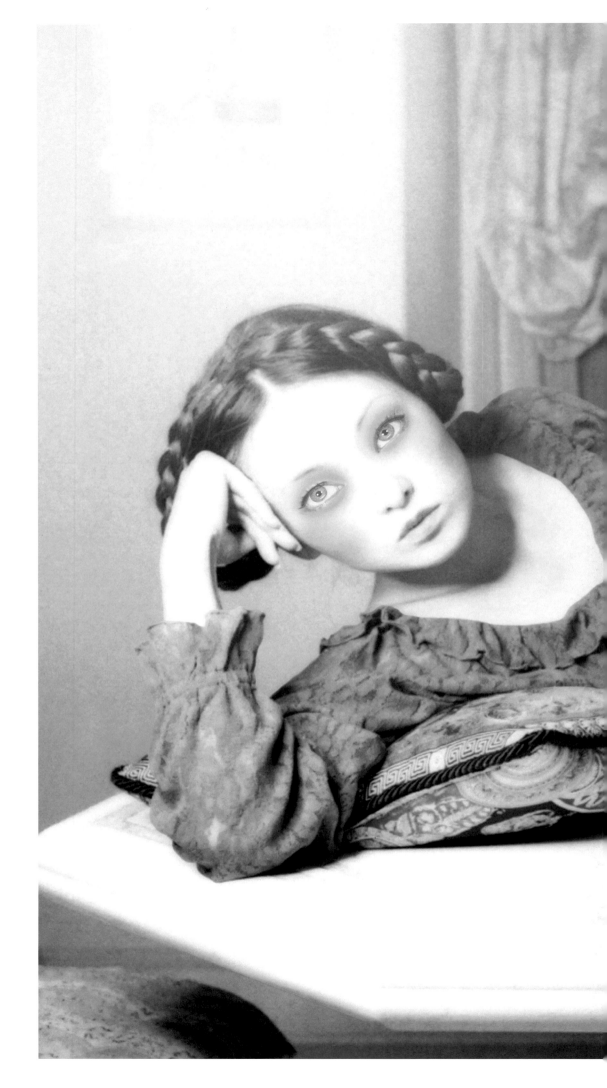

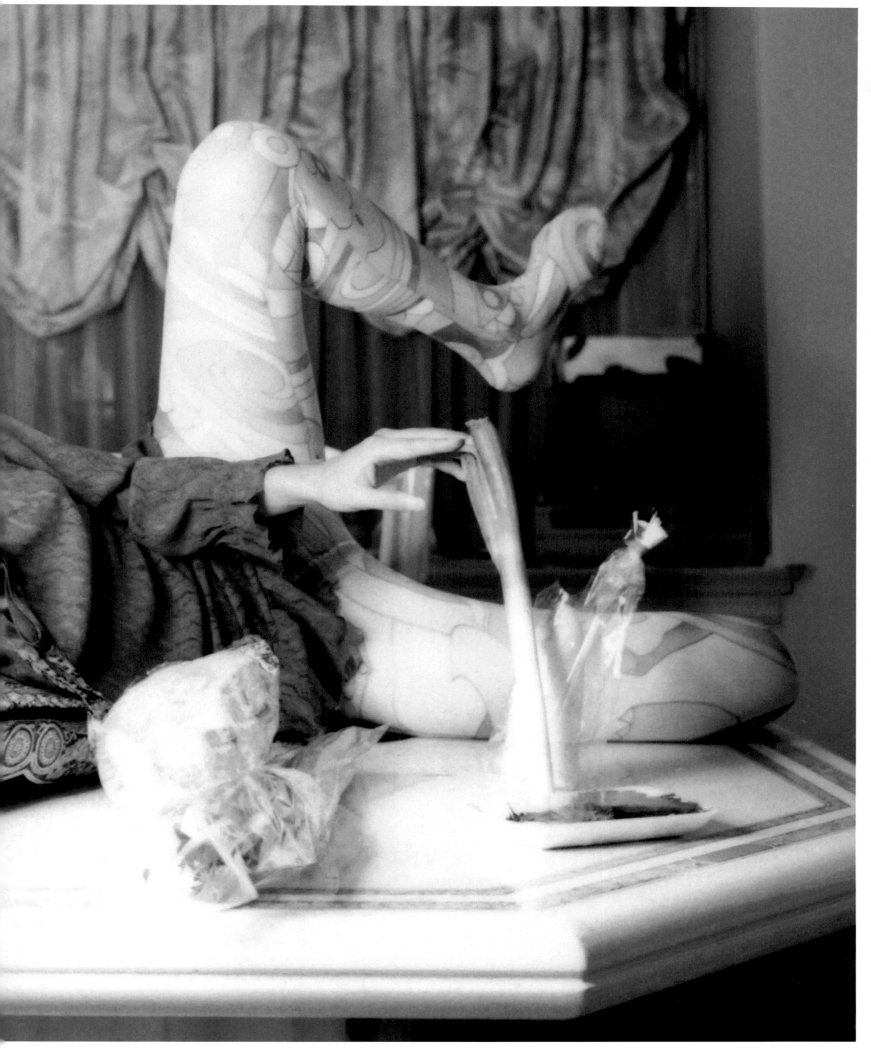

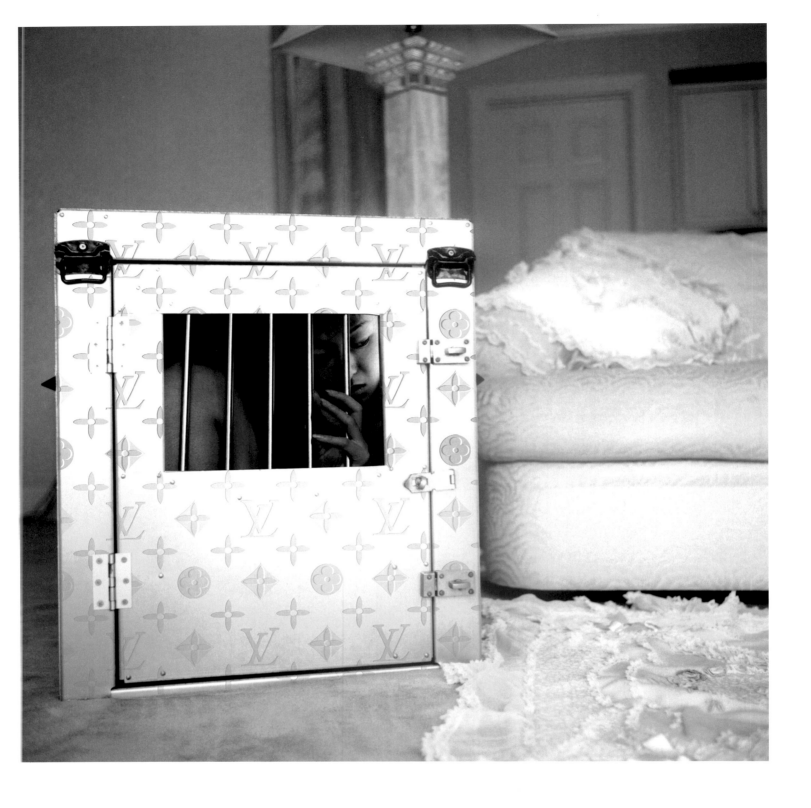

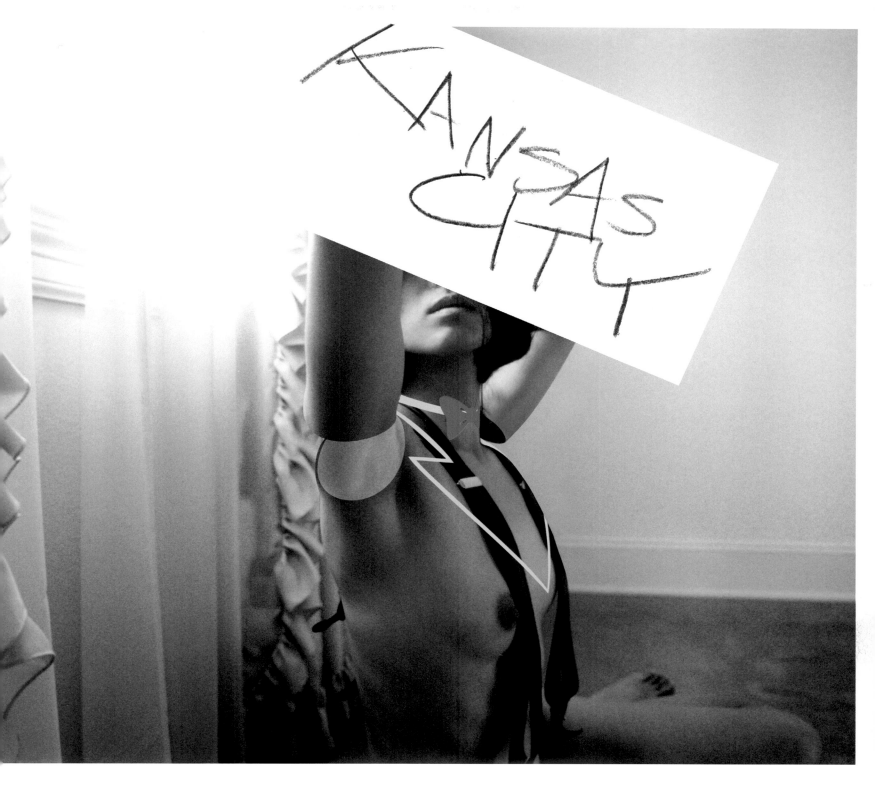

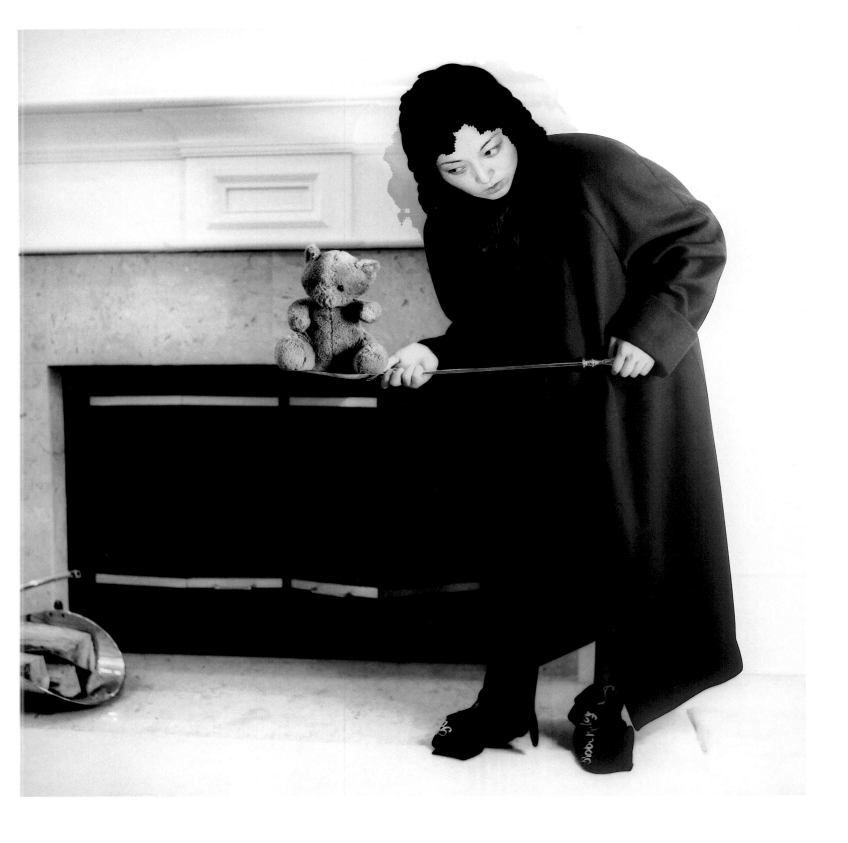

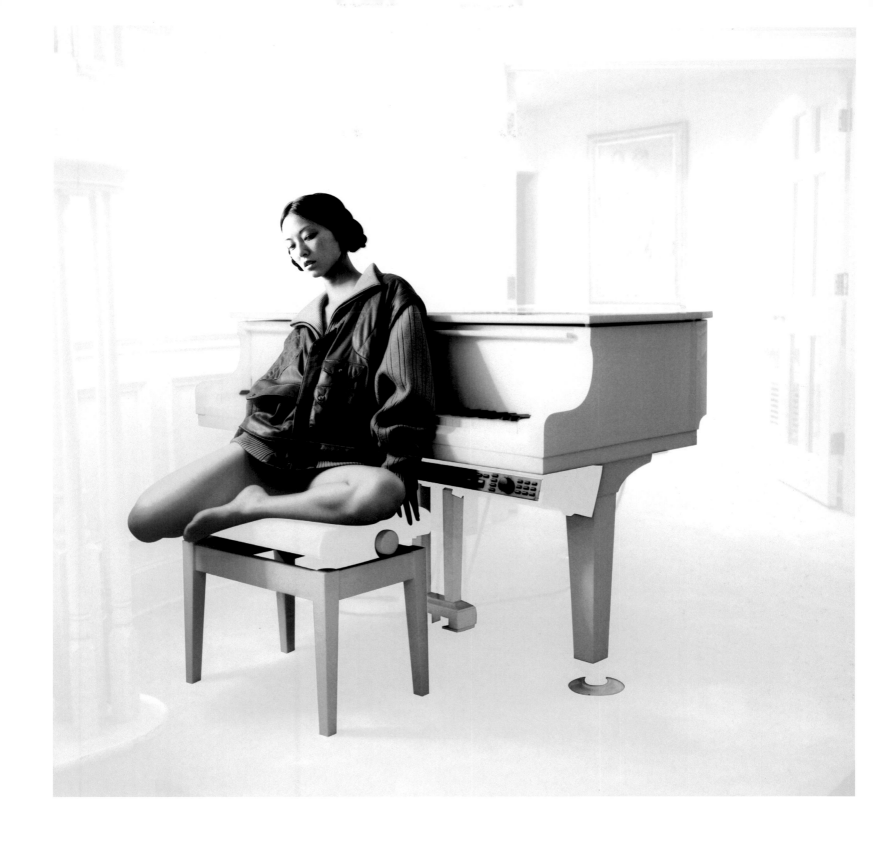

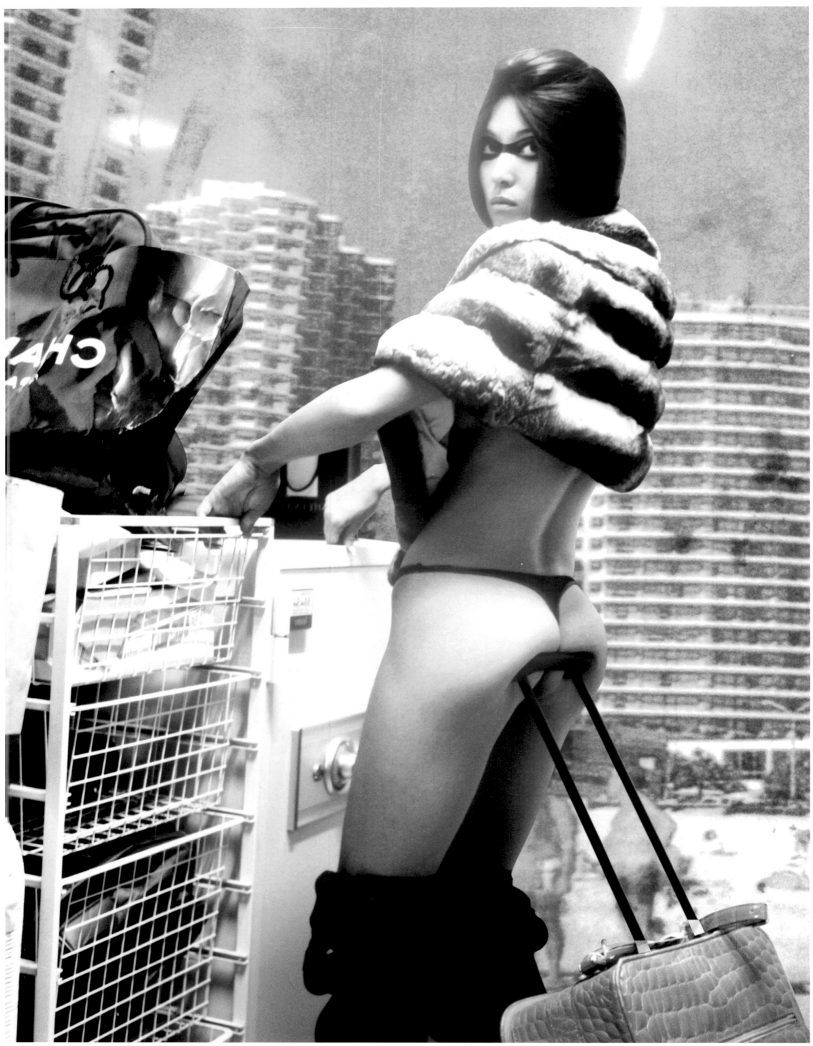

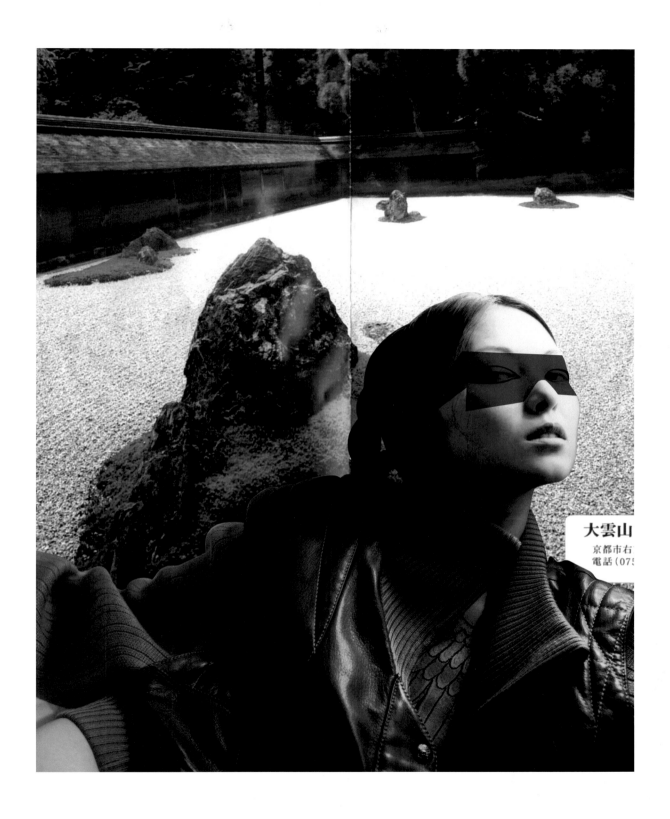

大雲山
京都市右
電話（07

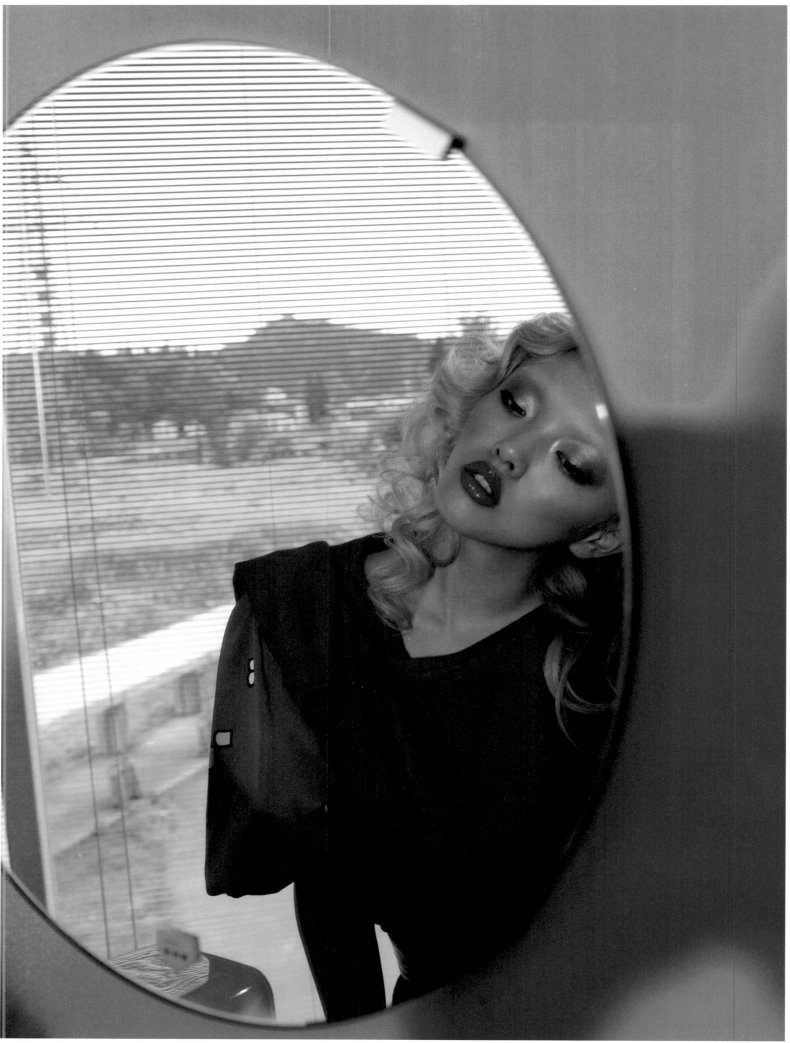

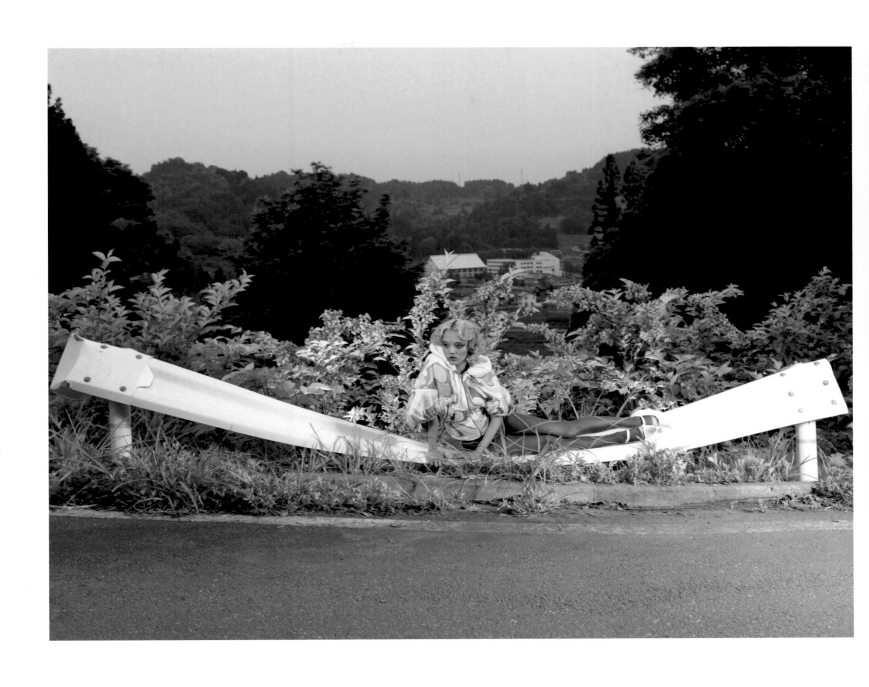

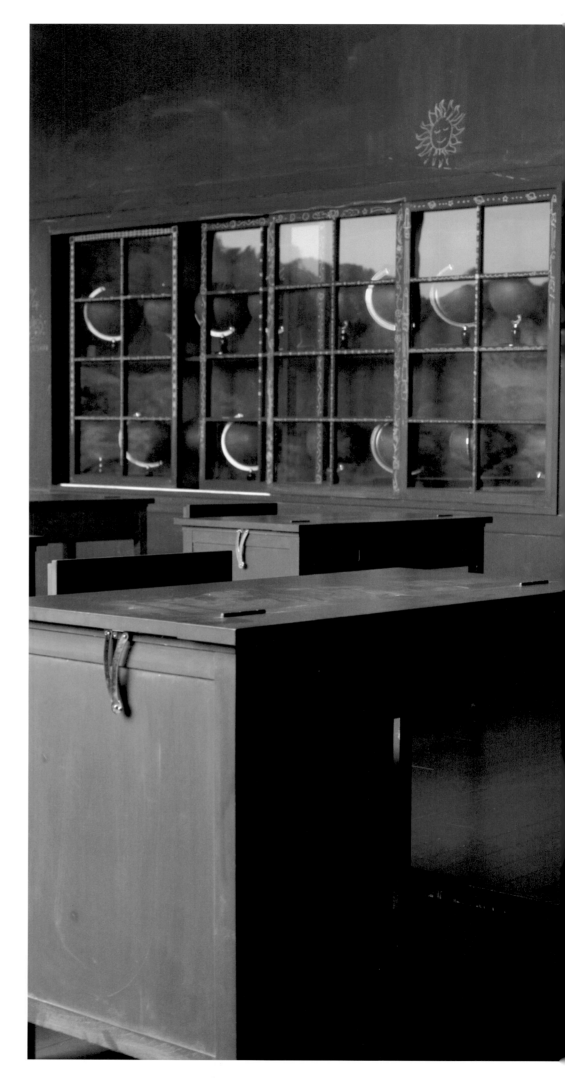

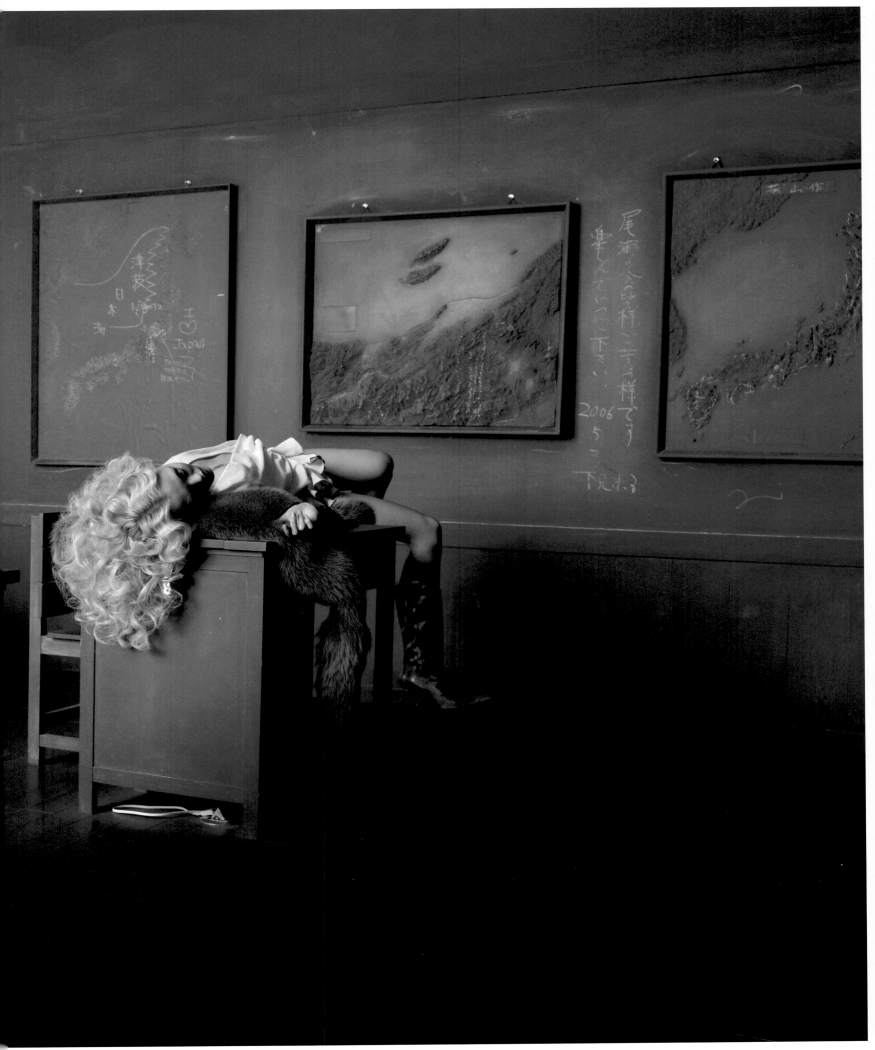

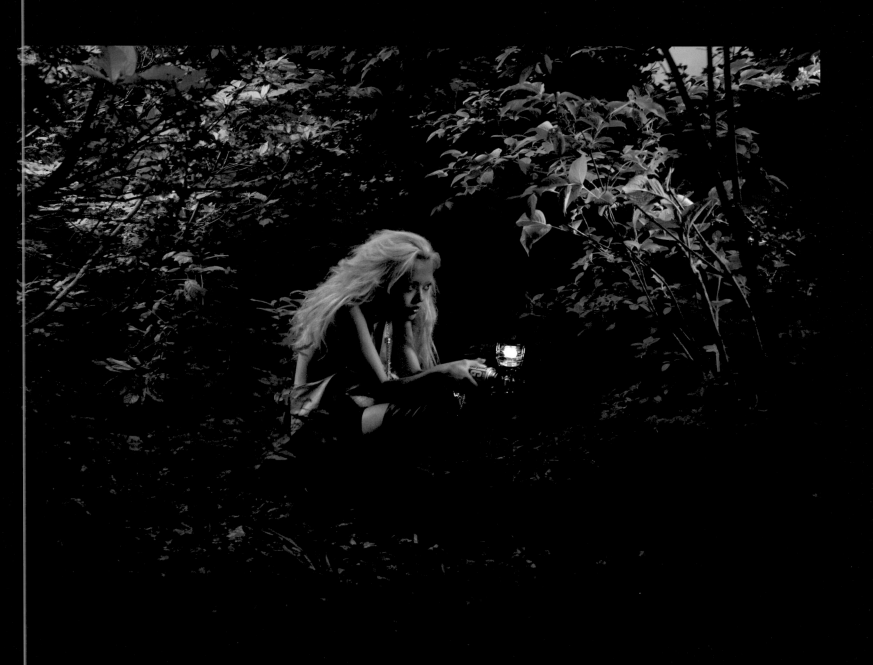

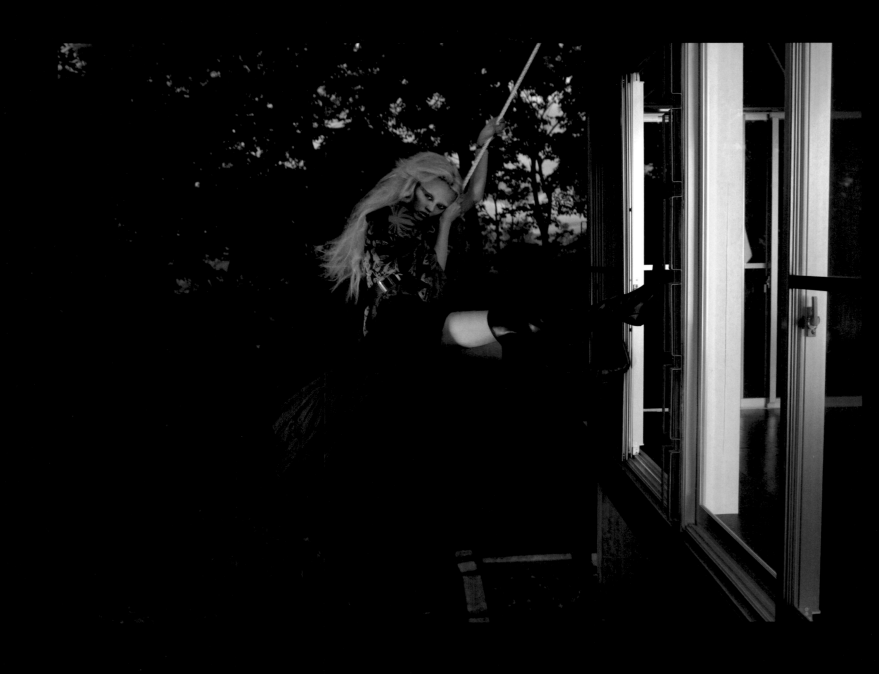

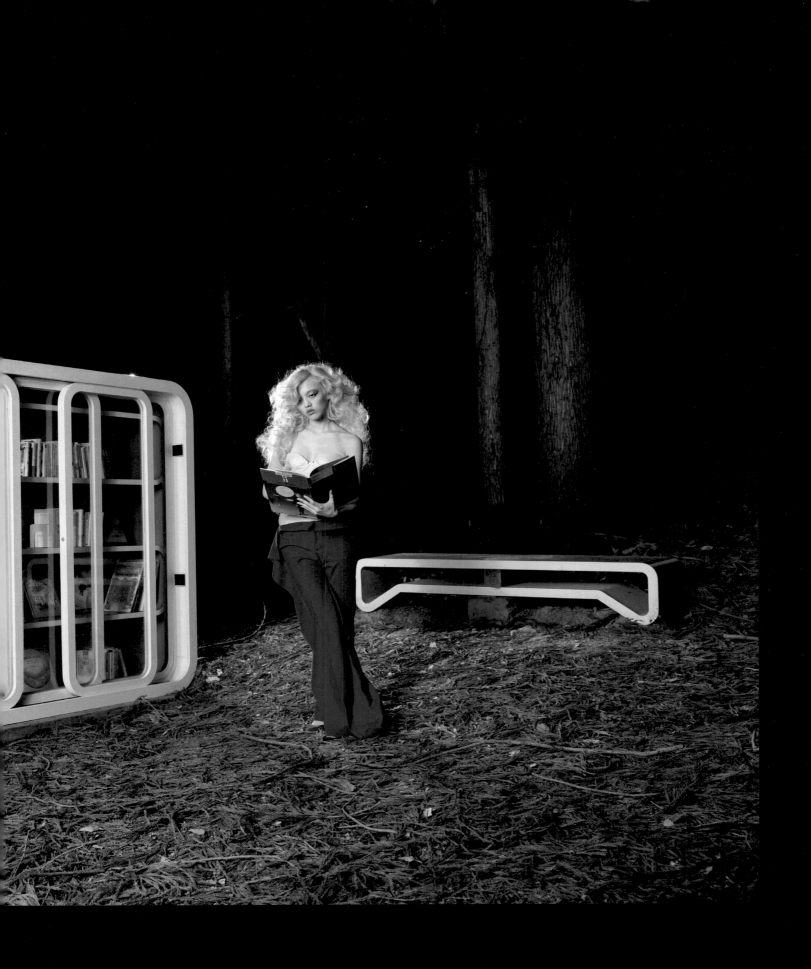

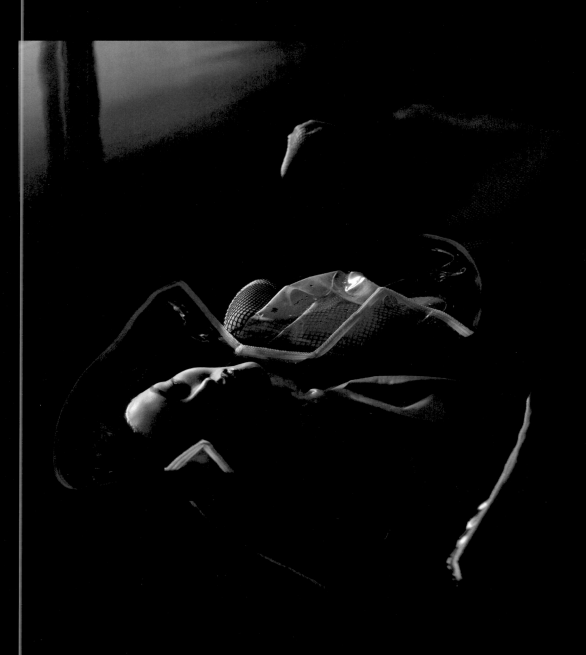

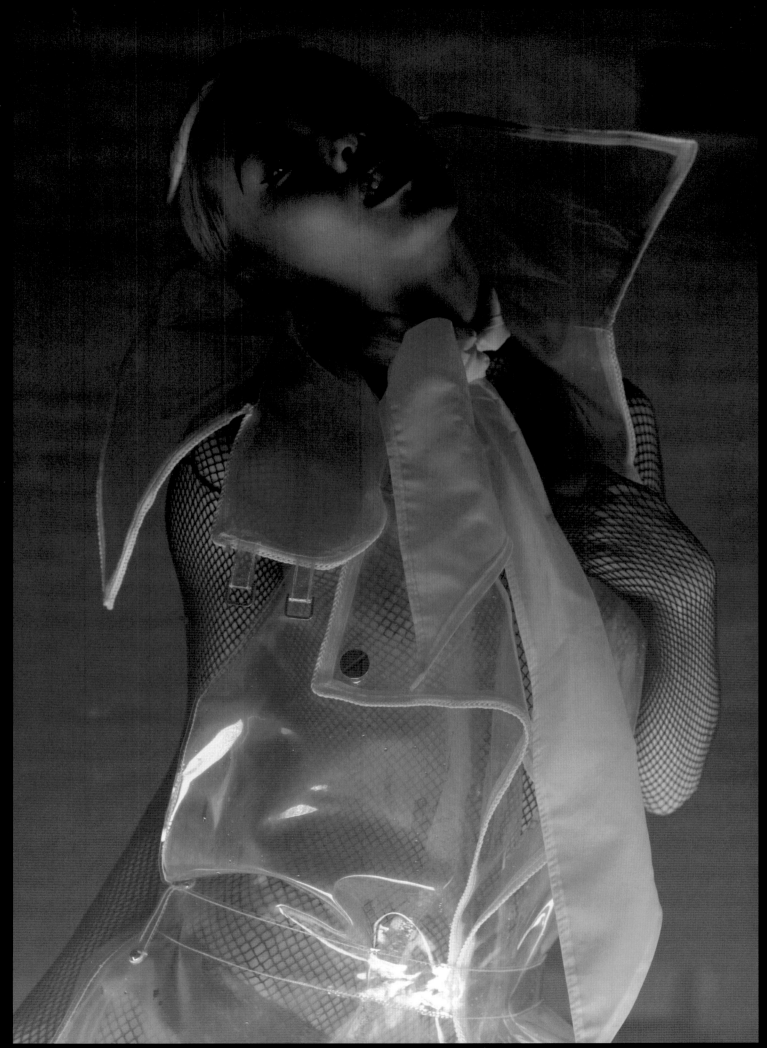

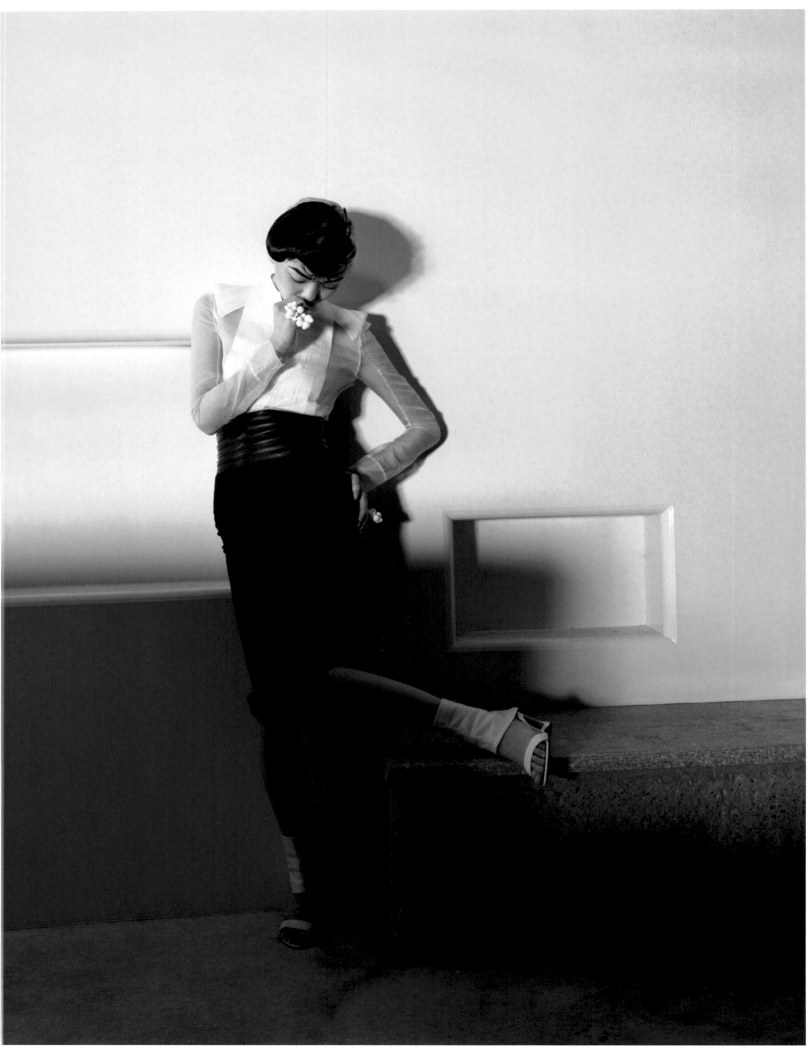

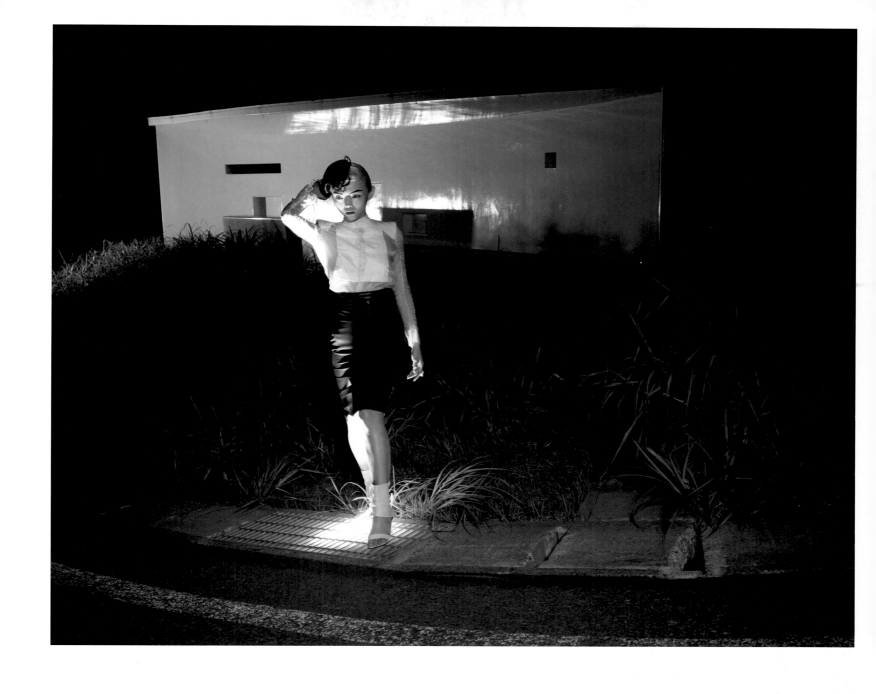

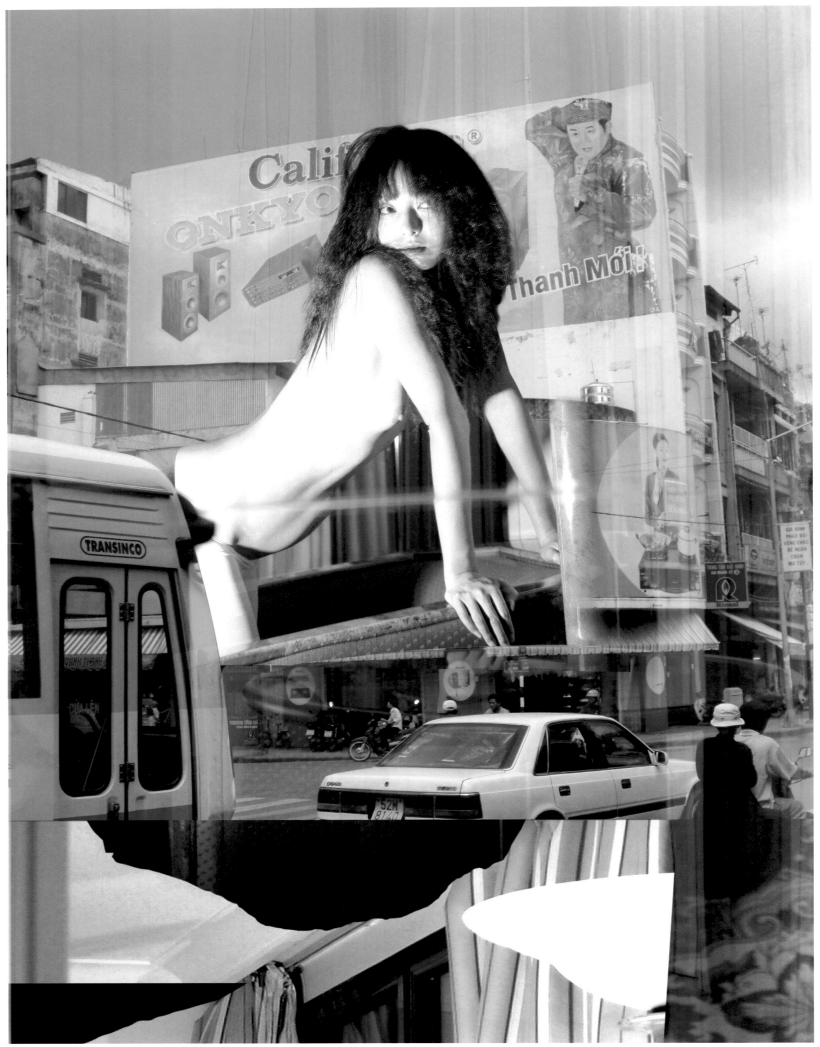

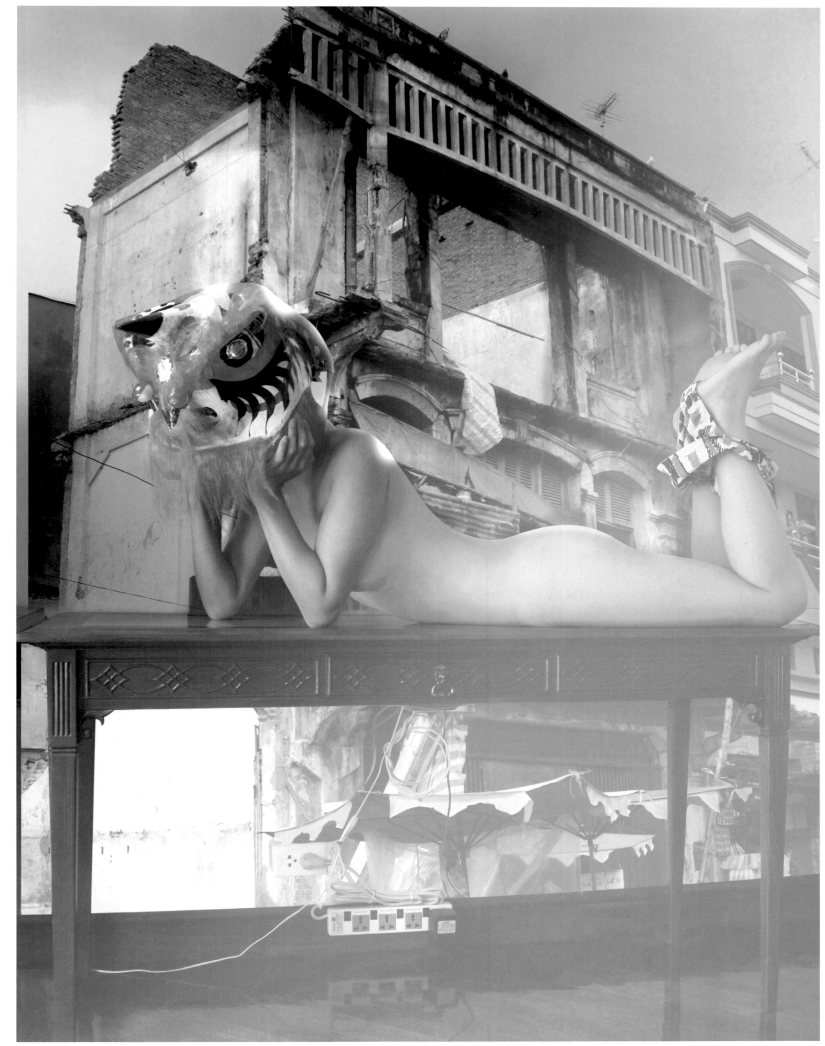

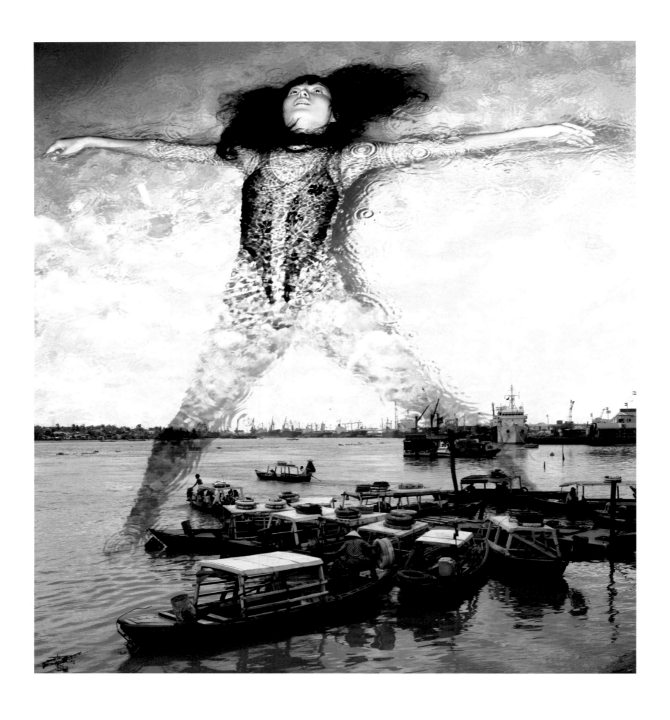

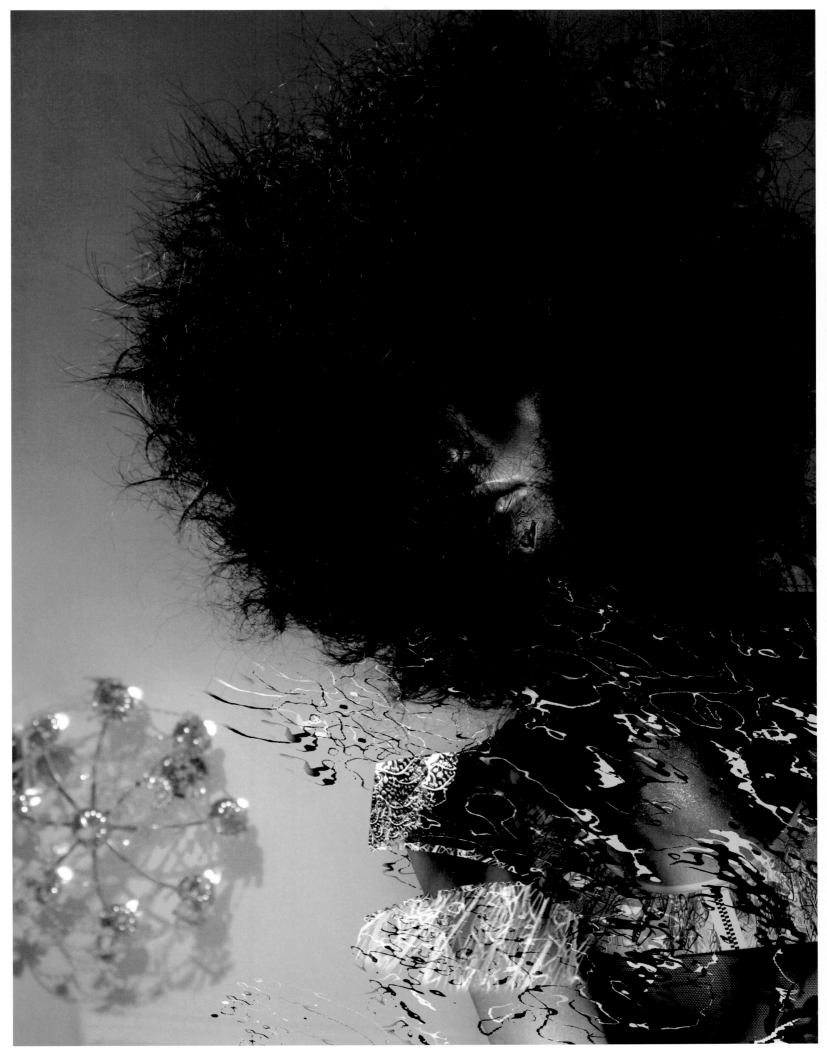

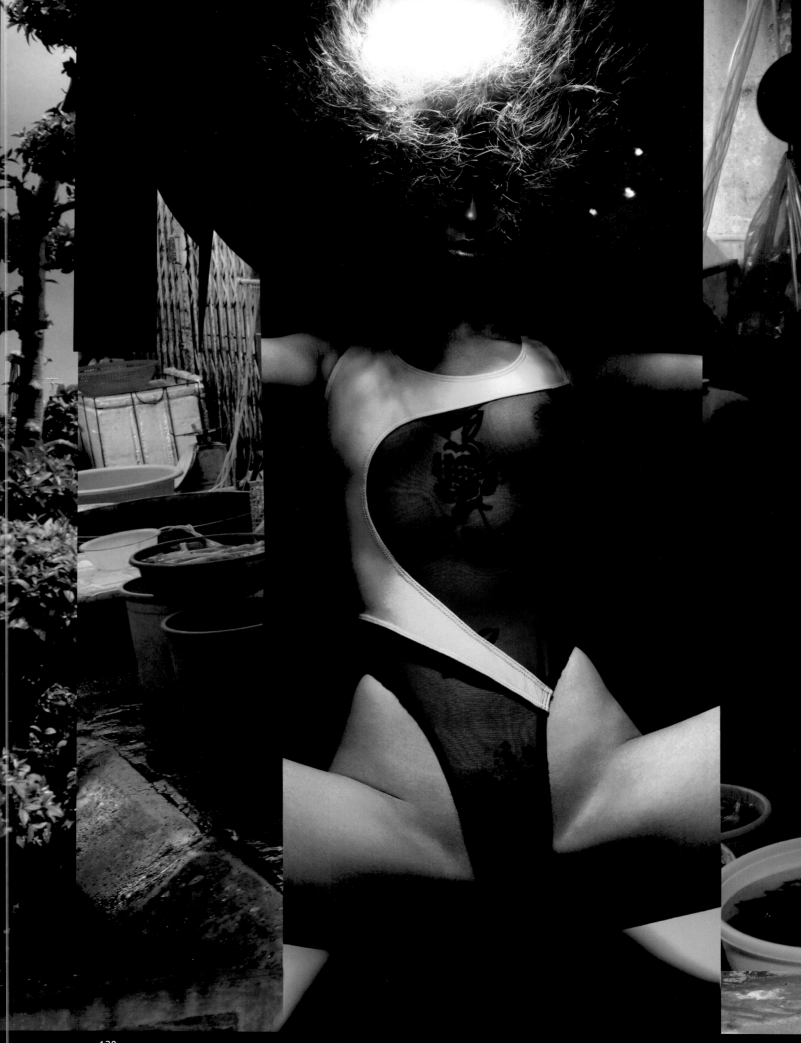

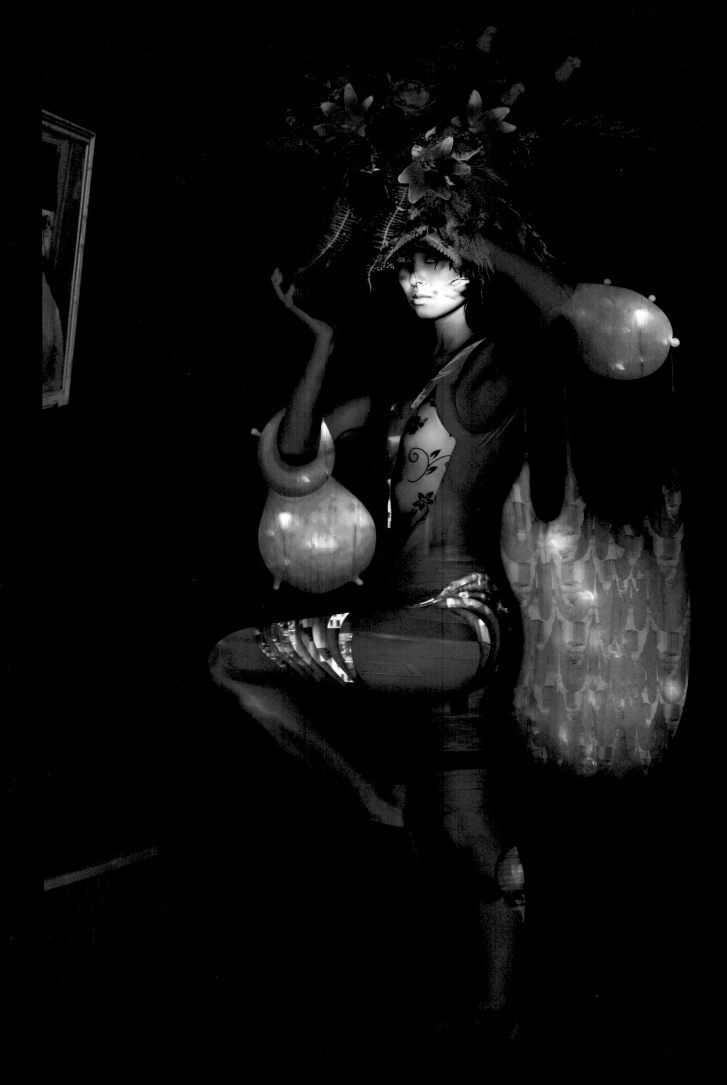

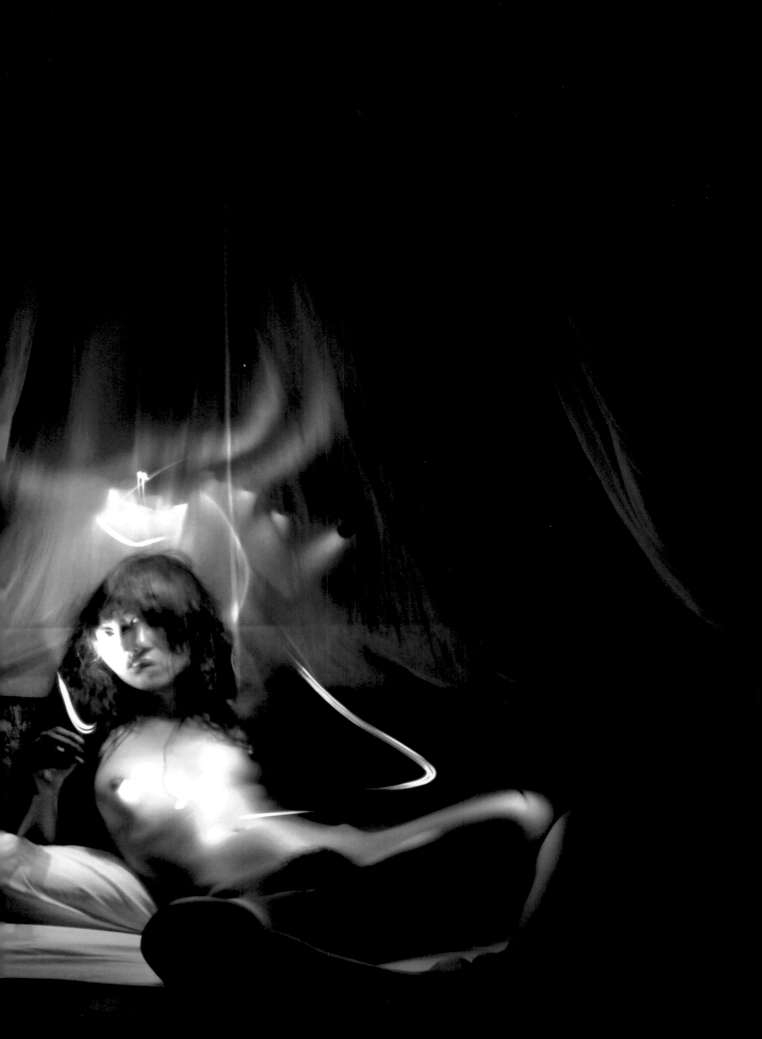

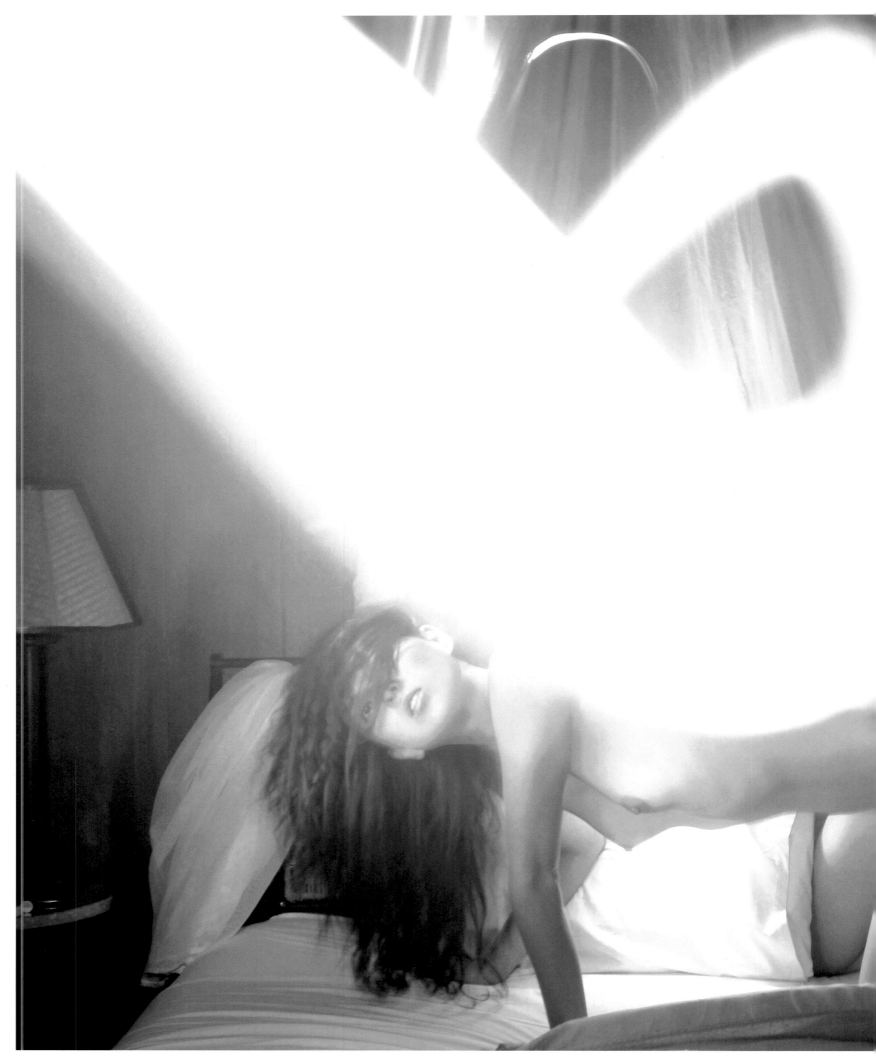

124

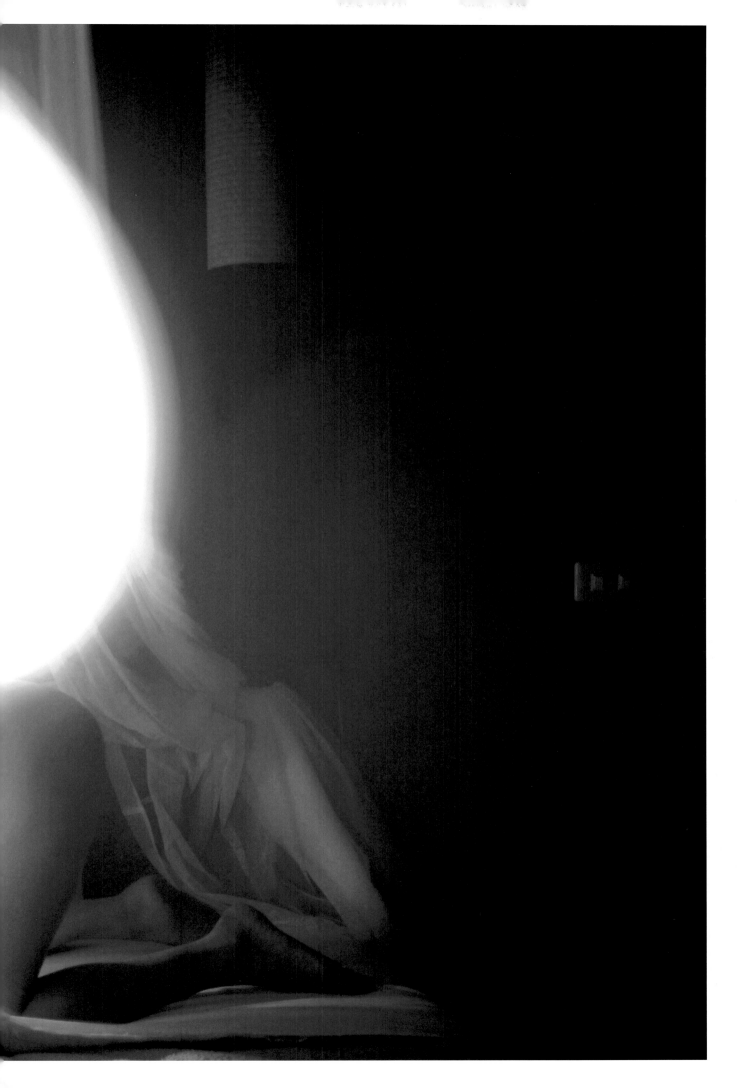

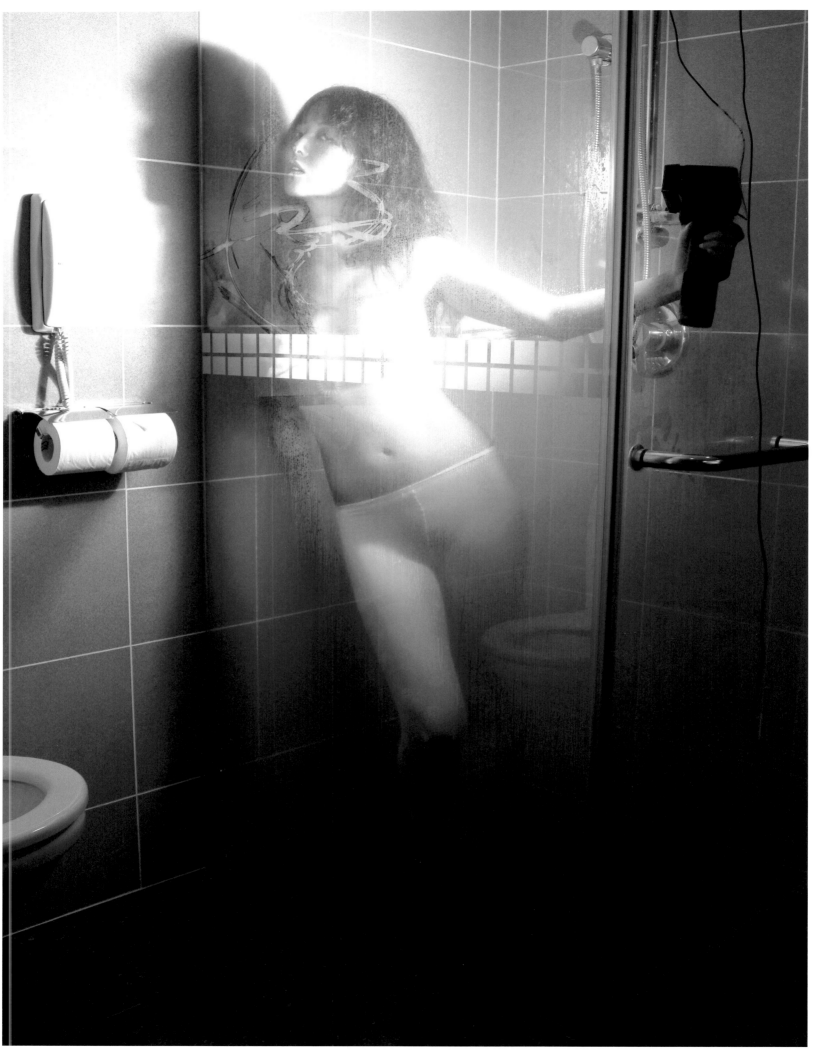

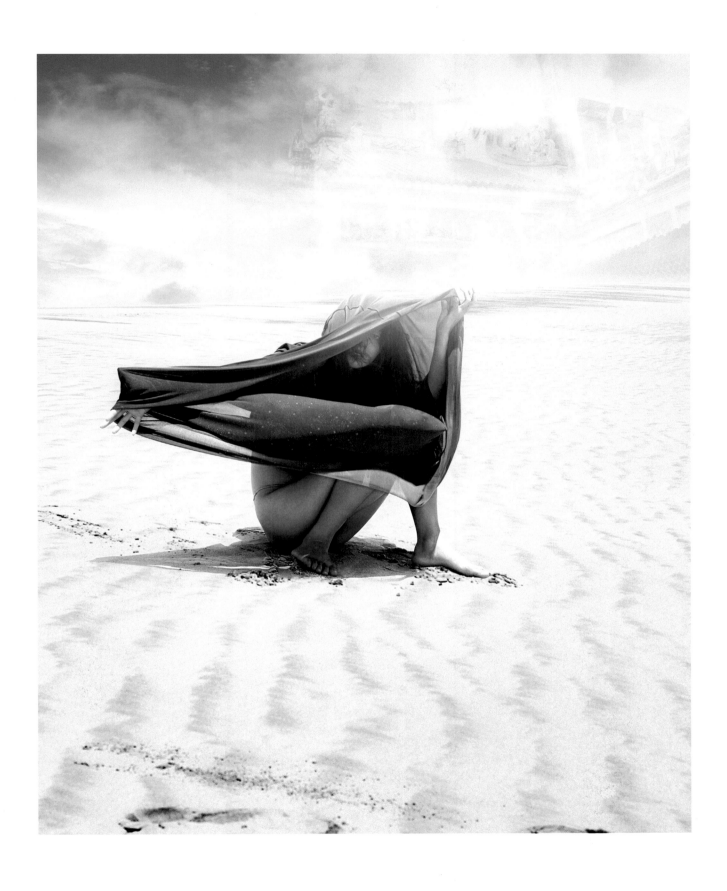

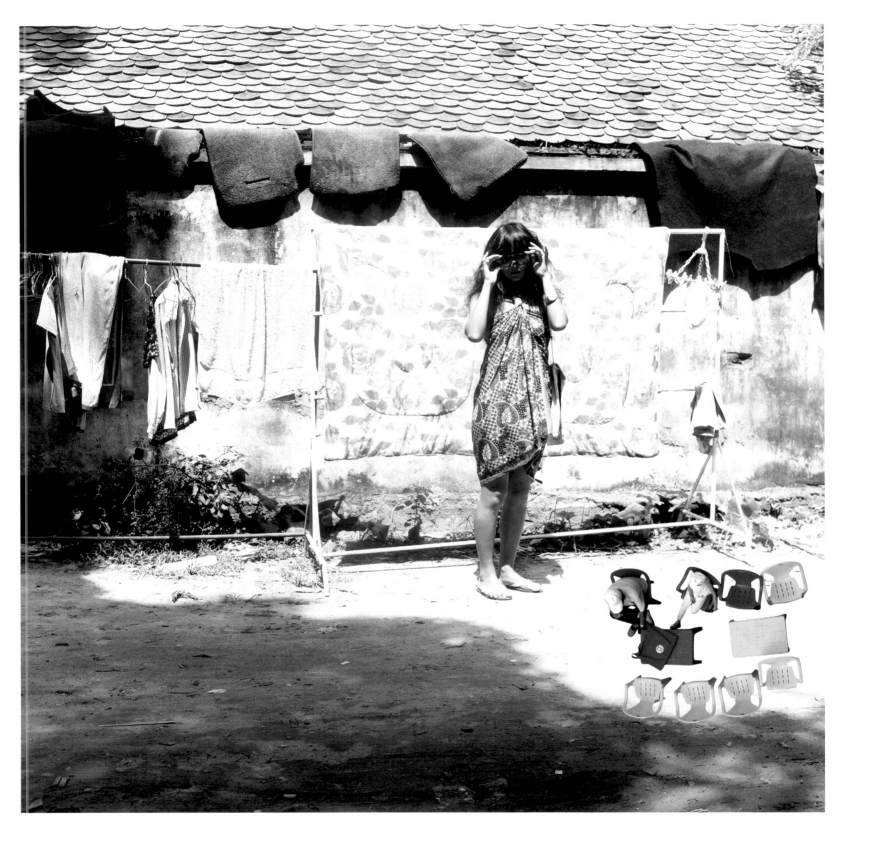

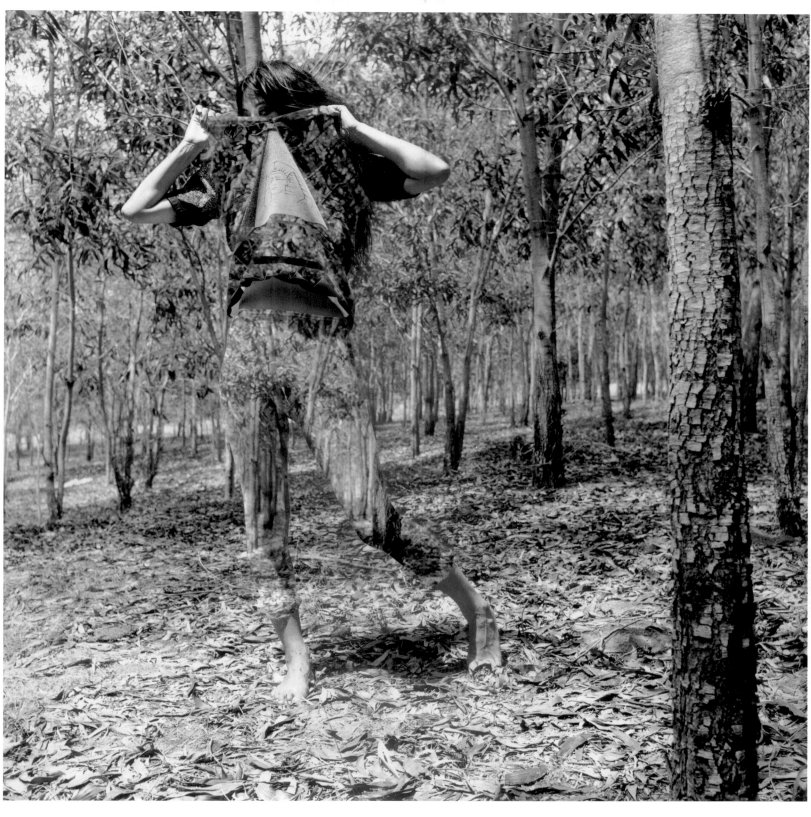

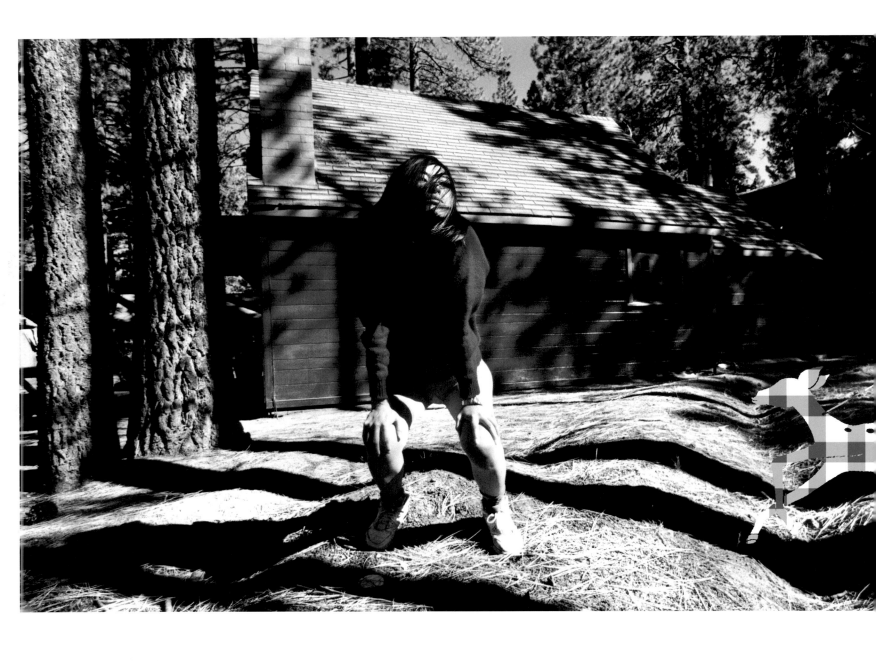

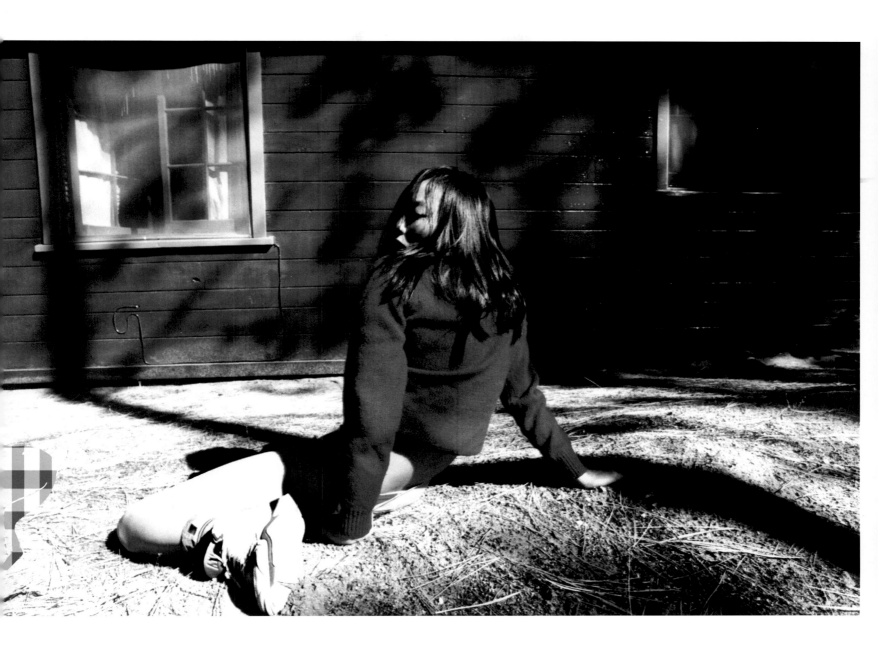

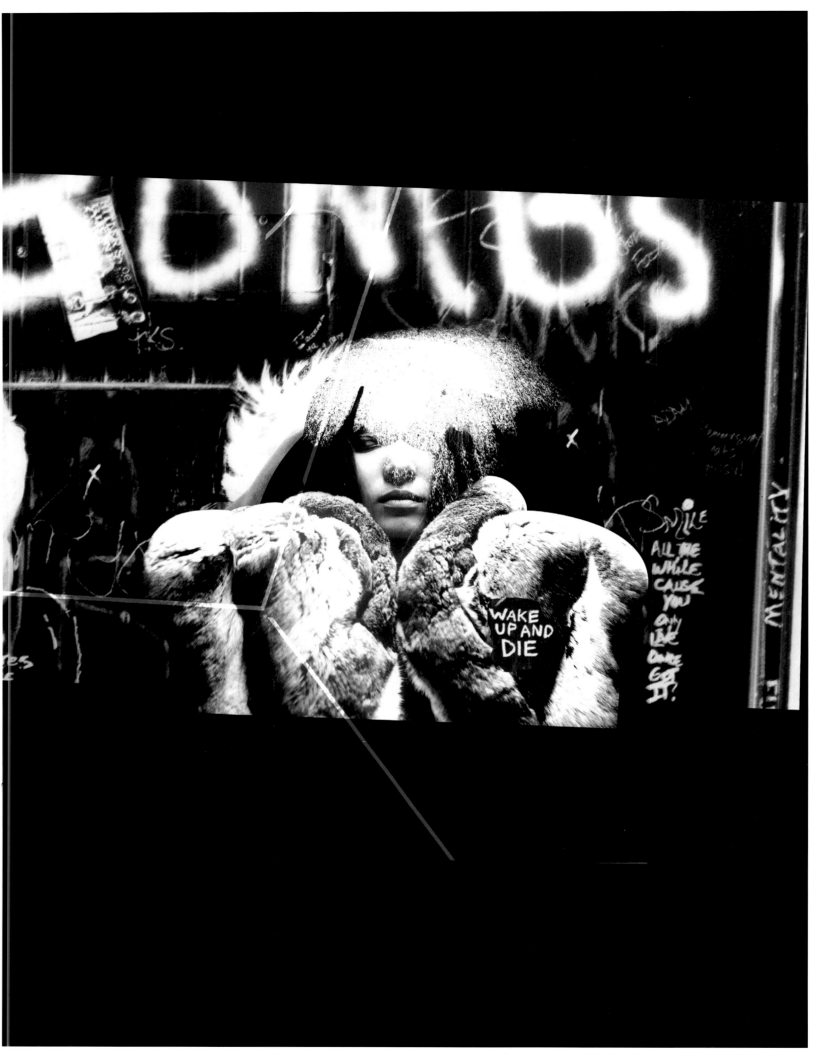

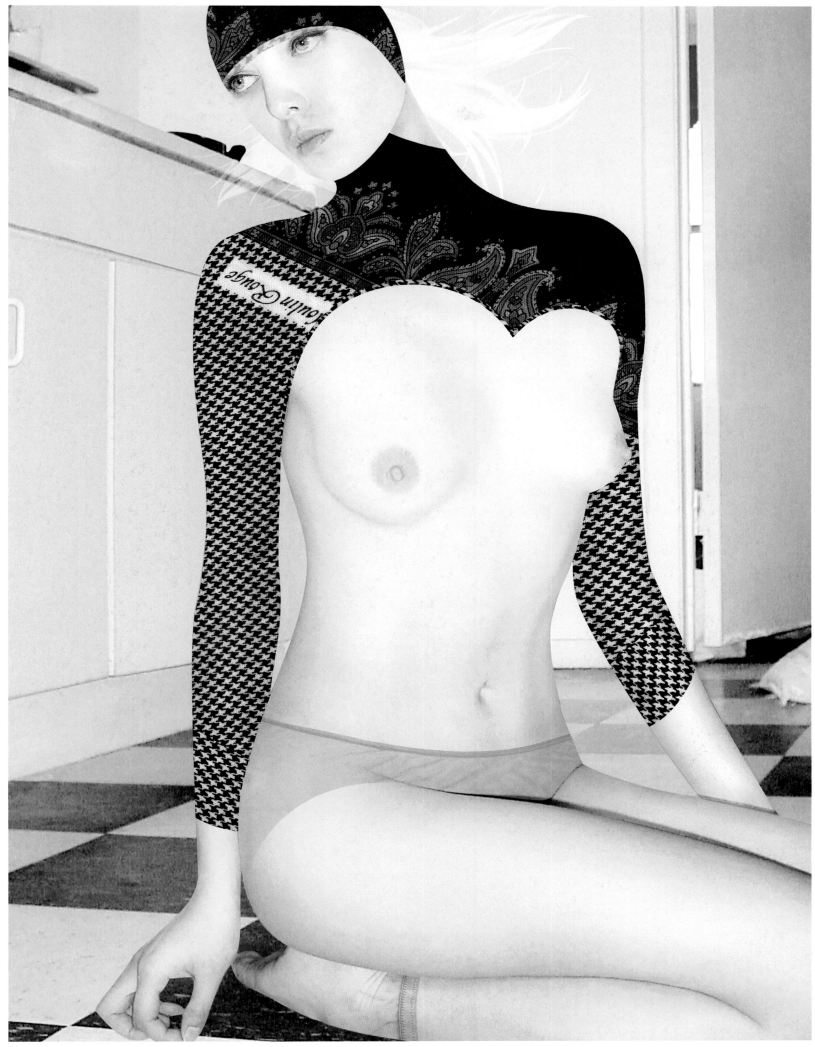

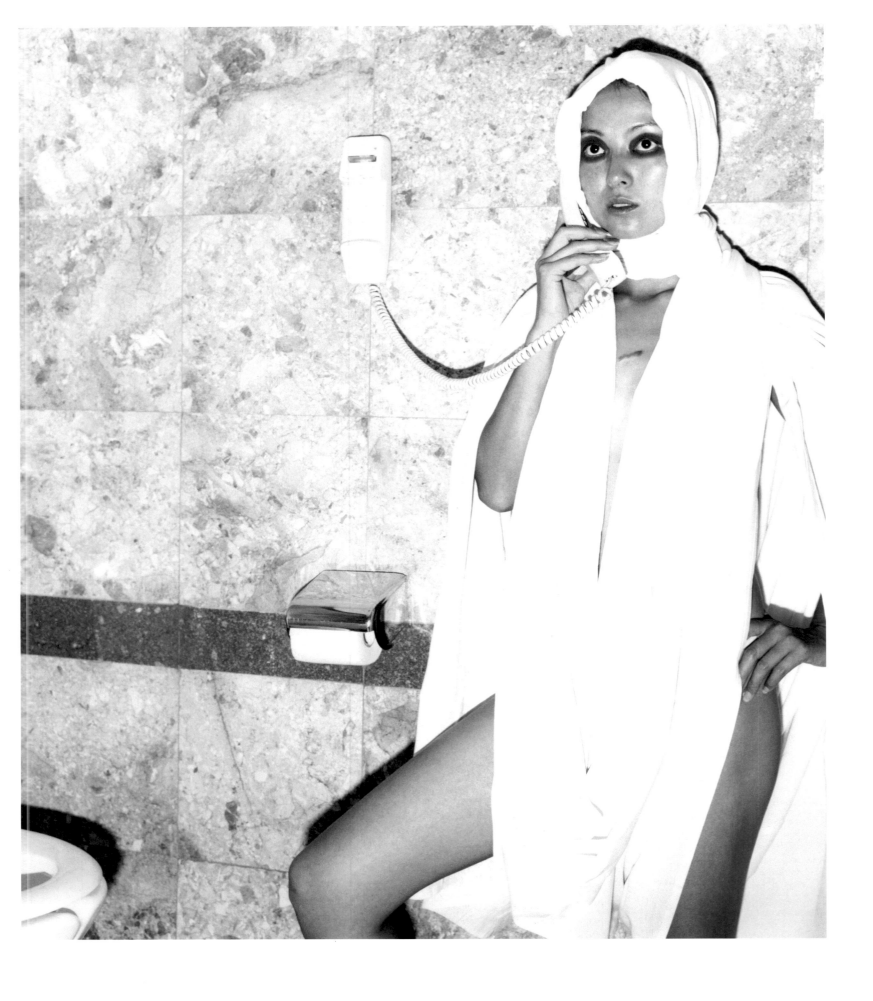

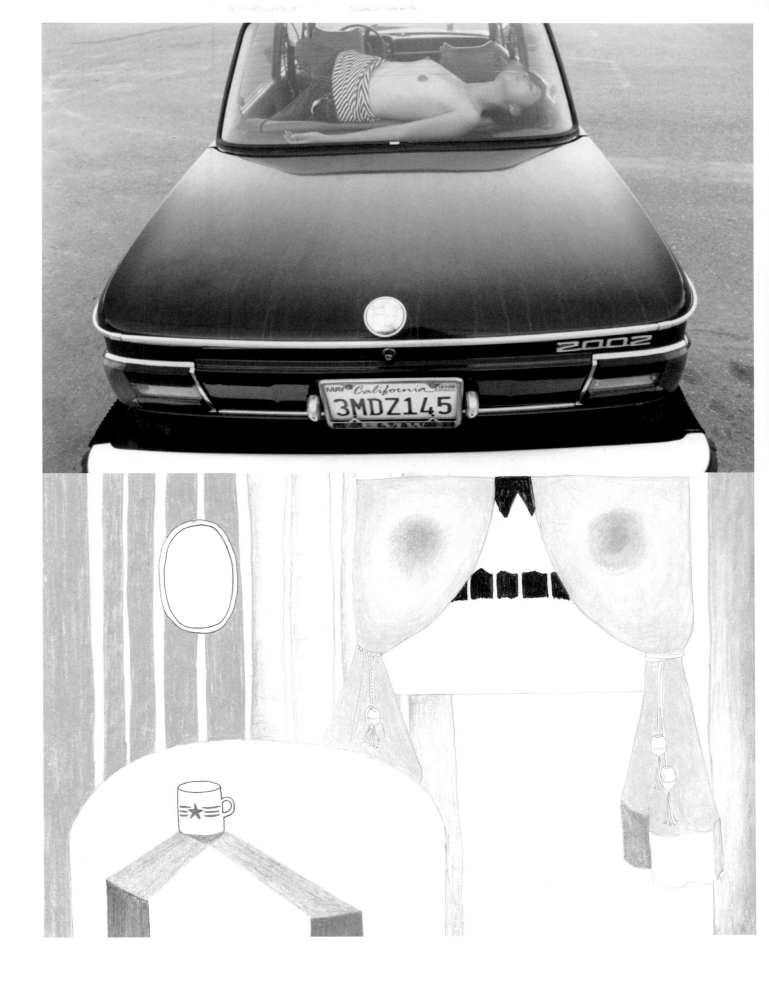

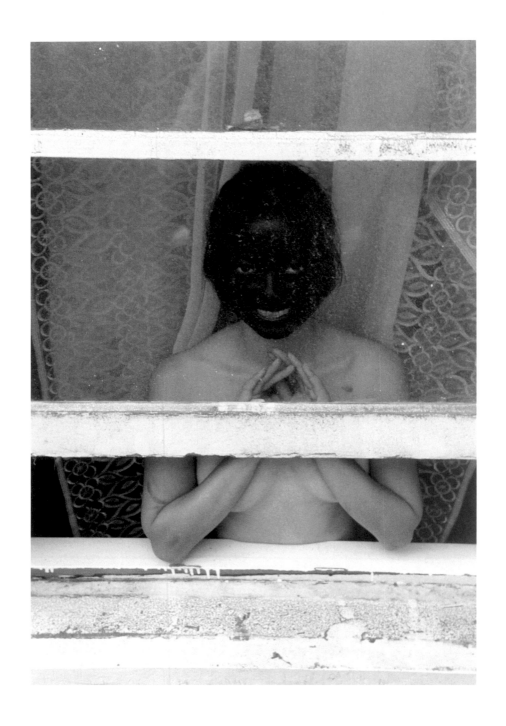

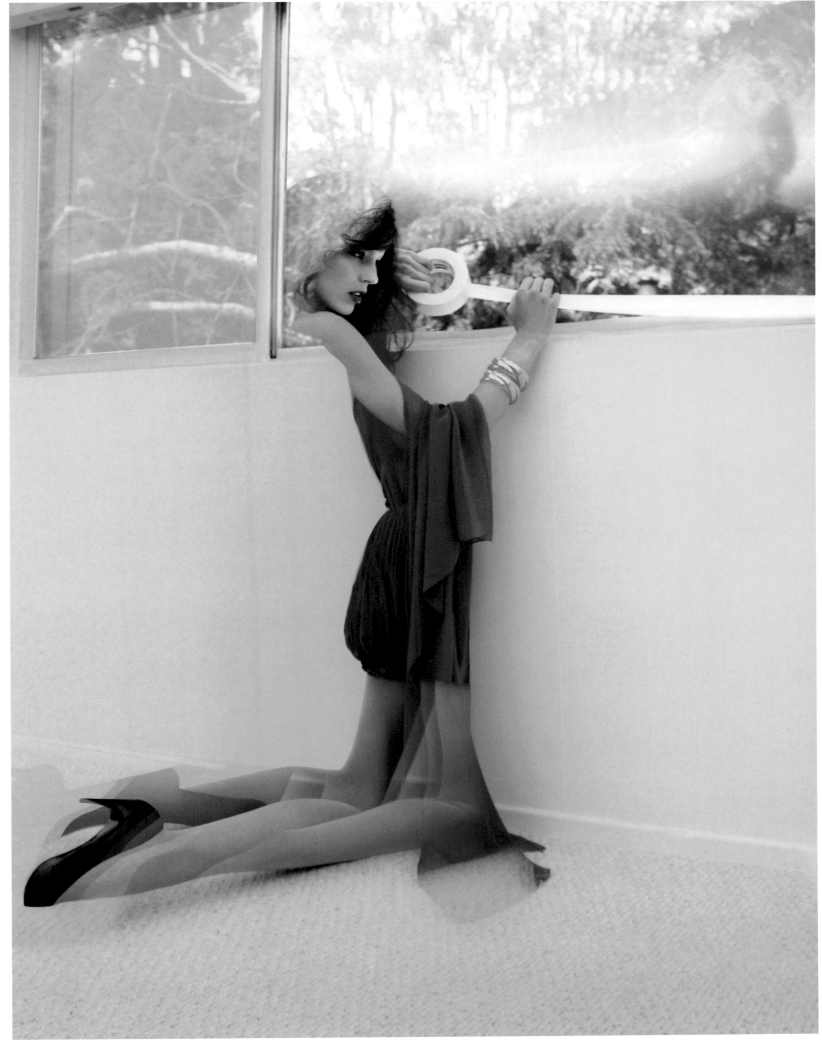

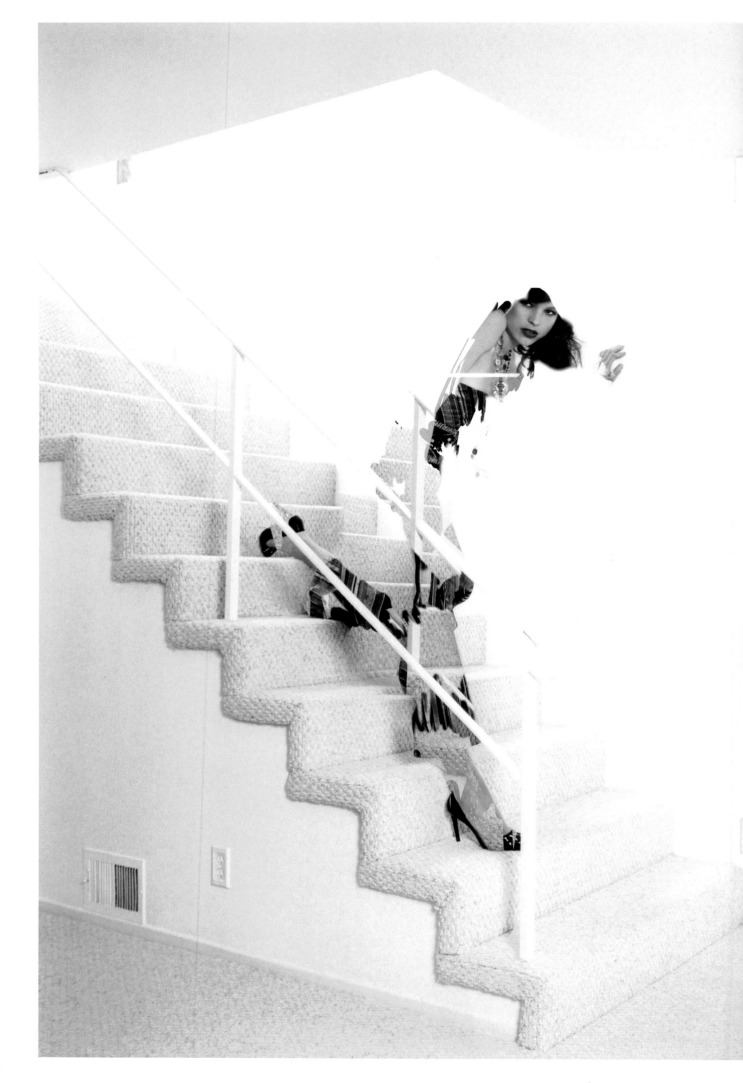

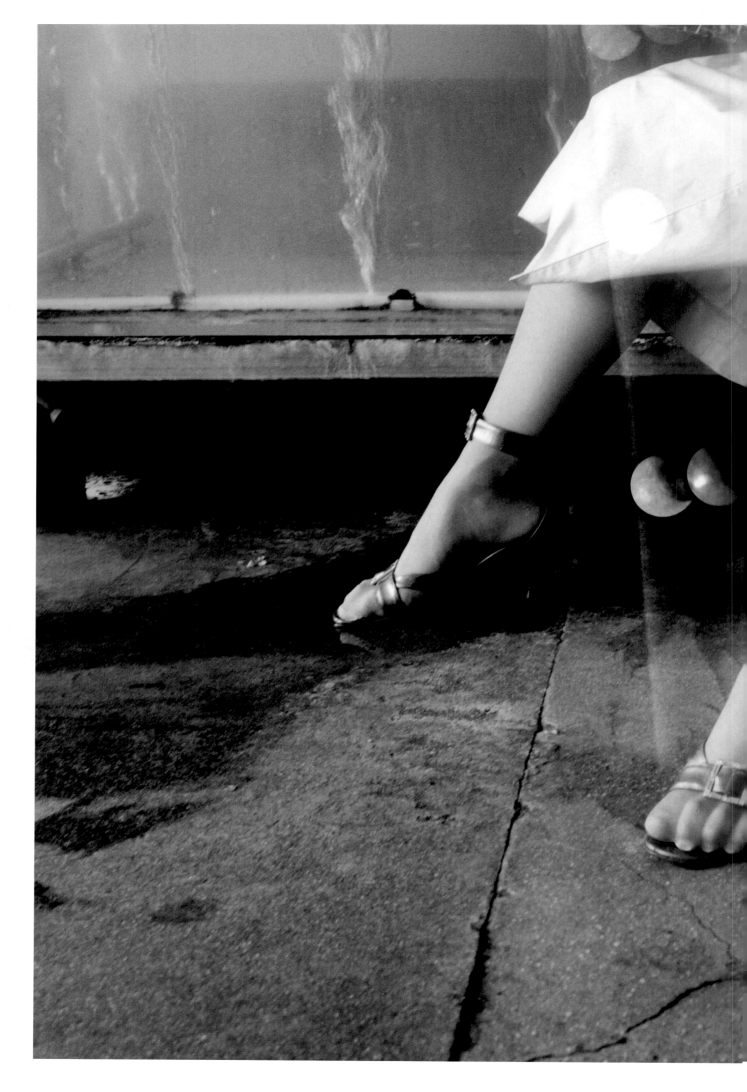

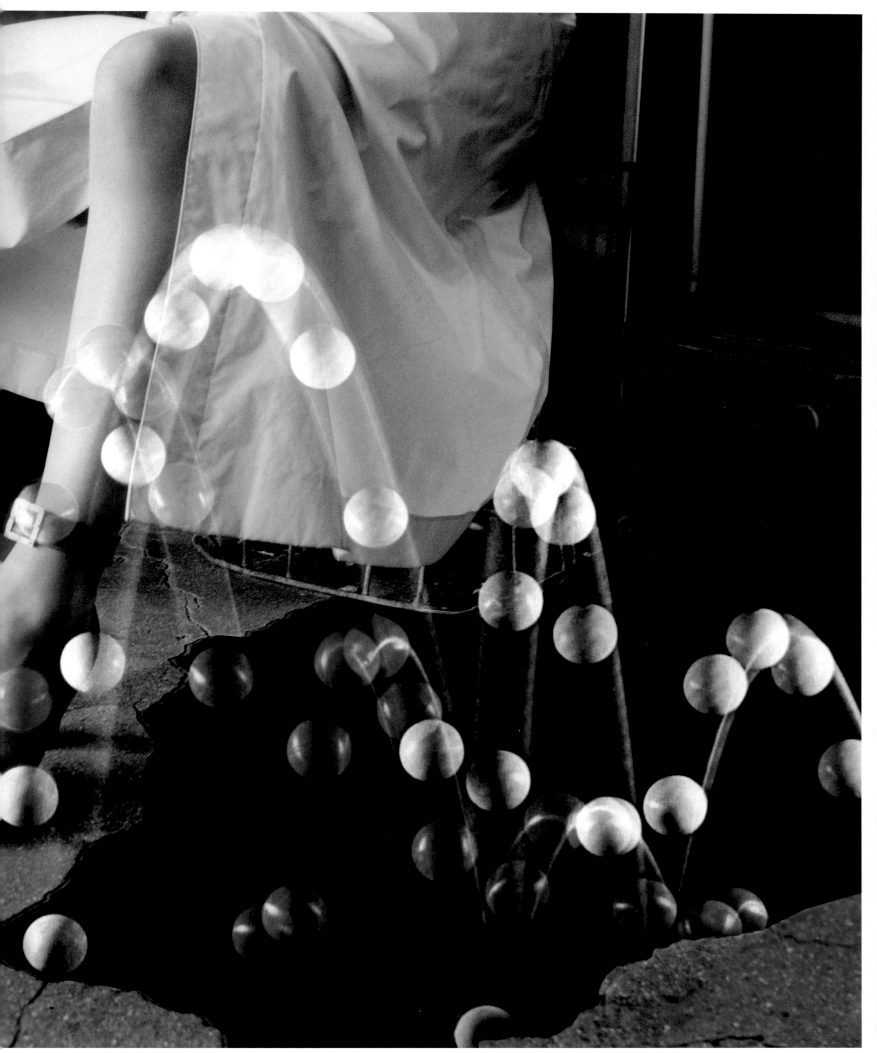

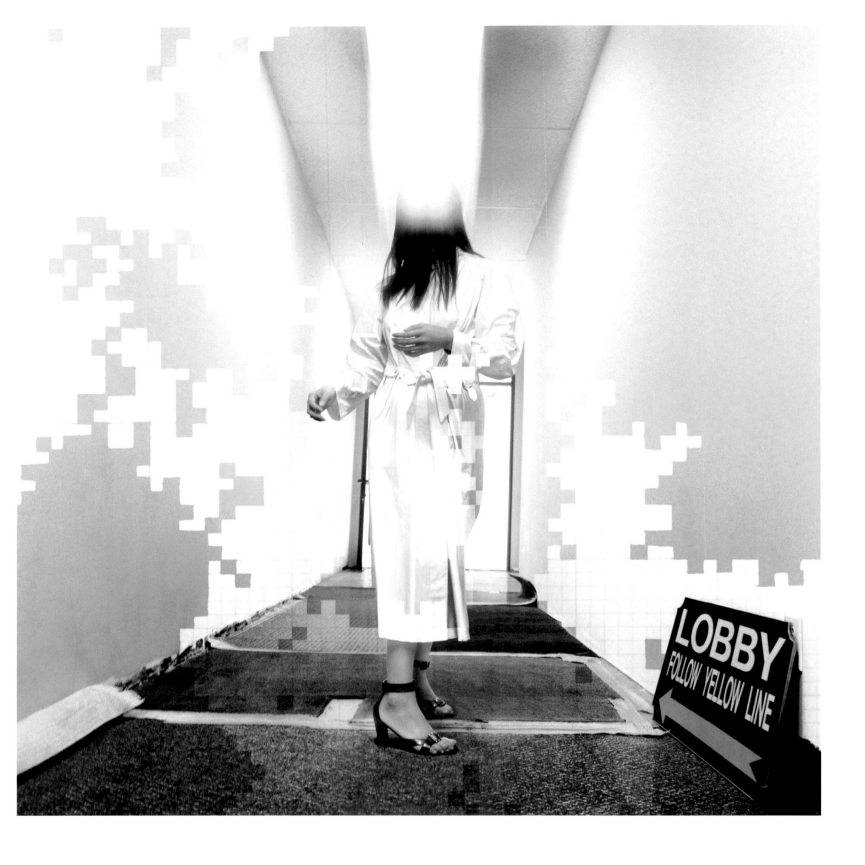

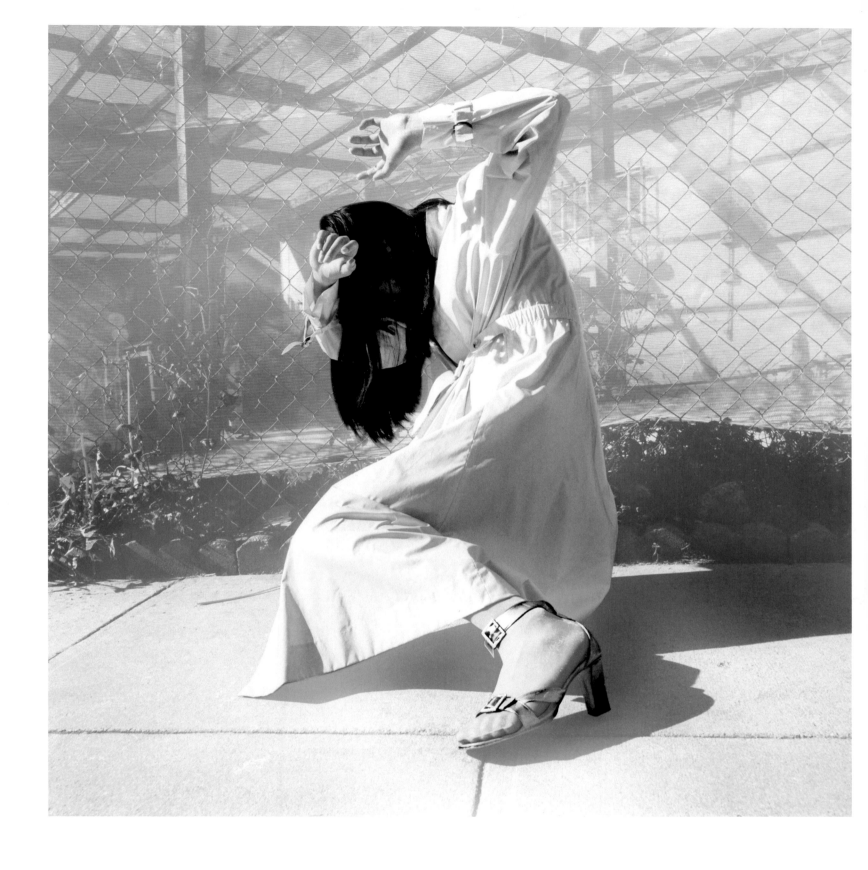

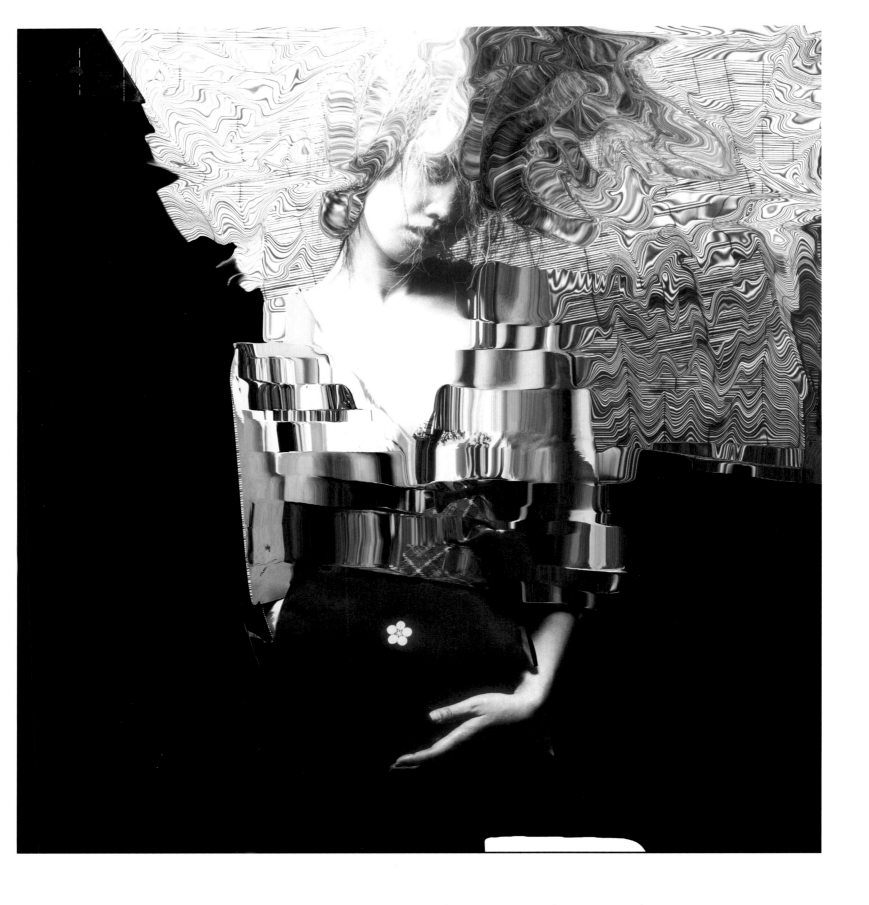

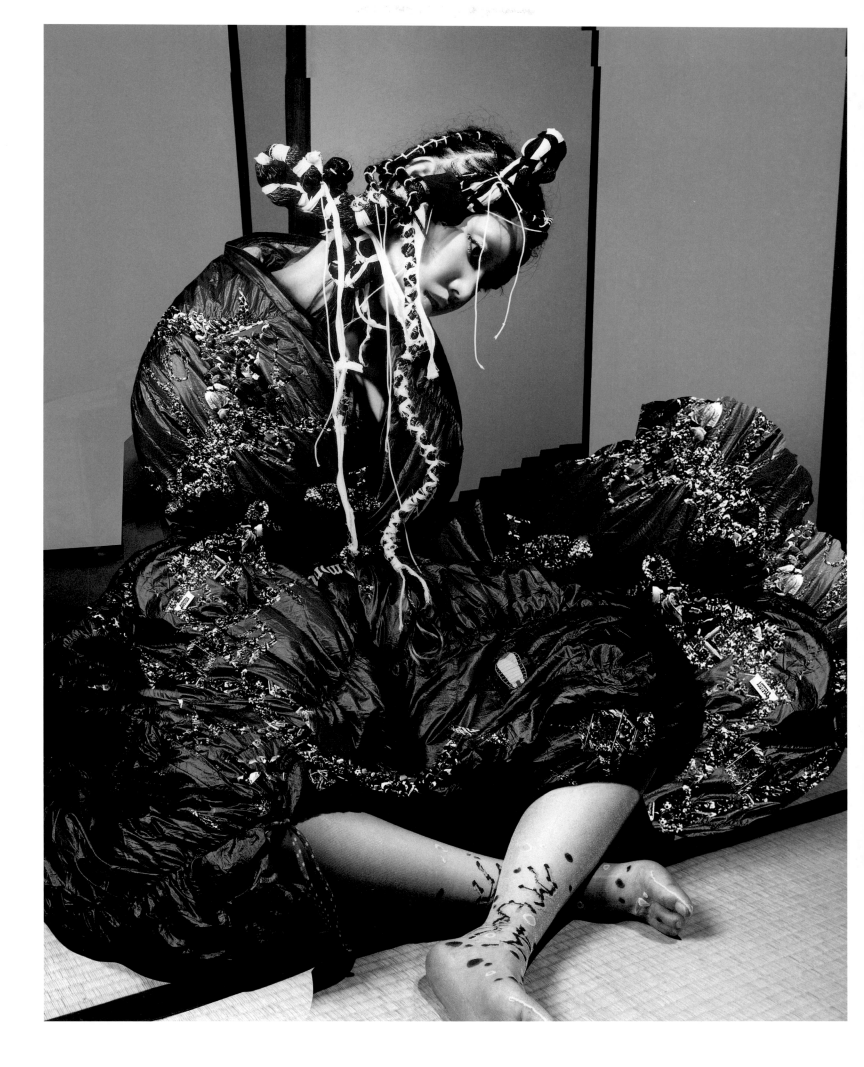

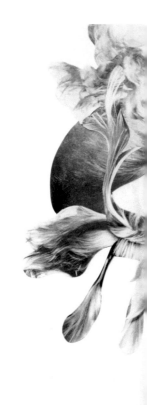

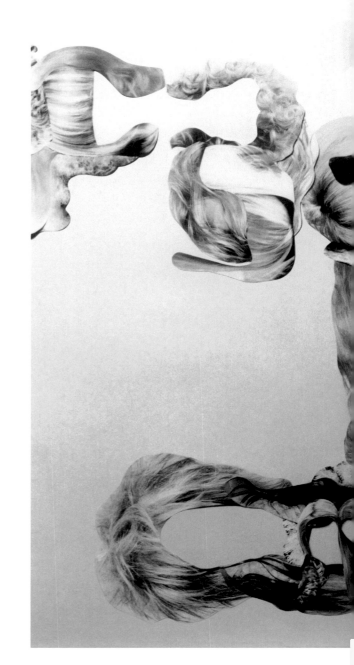

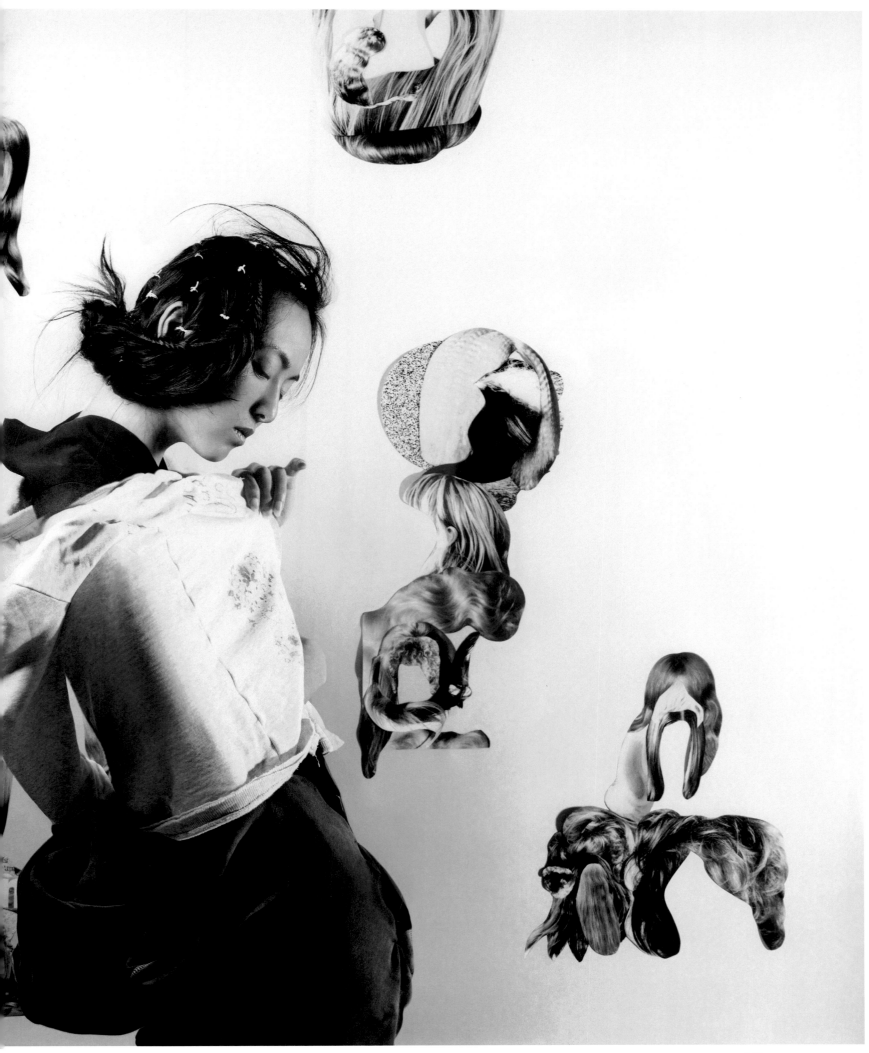

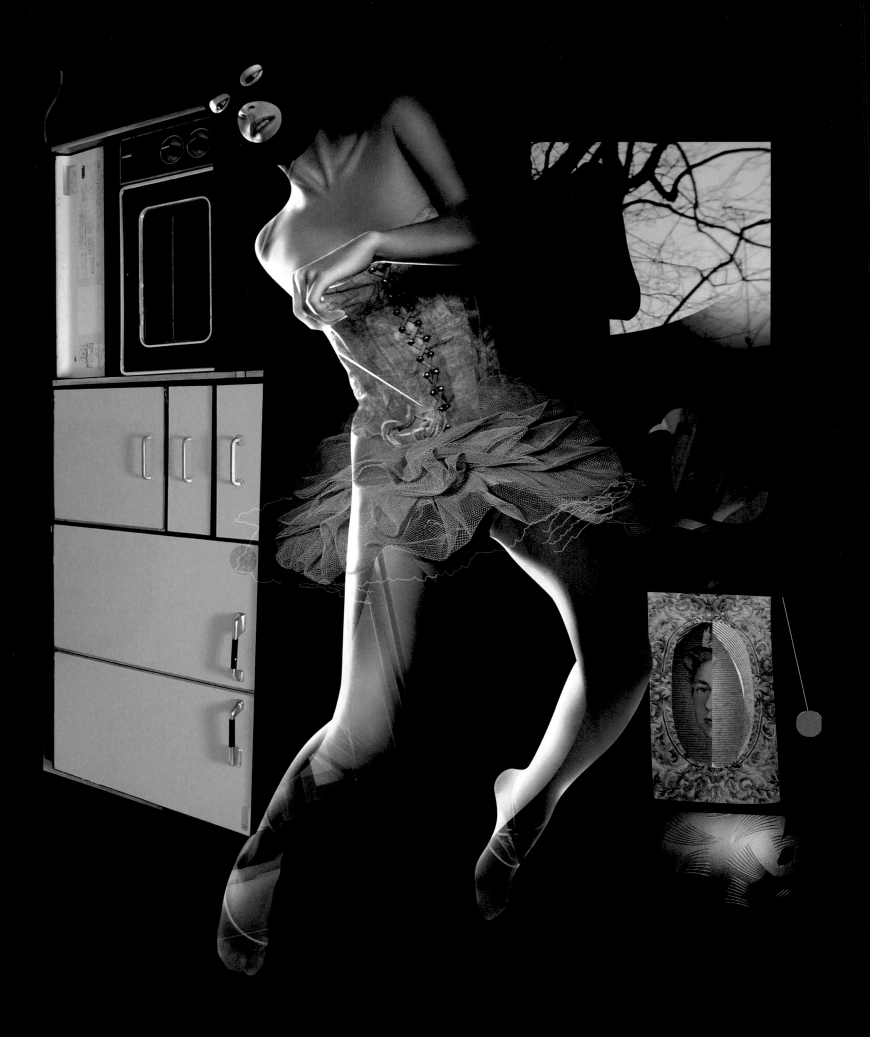

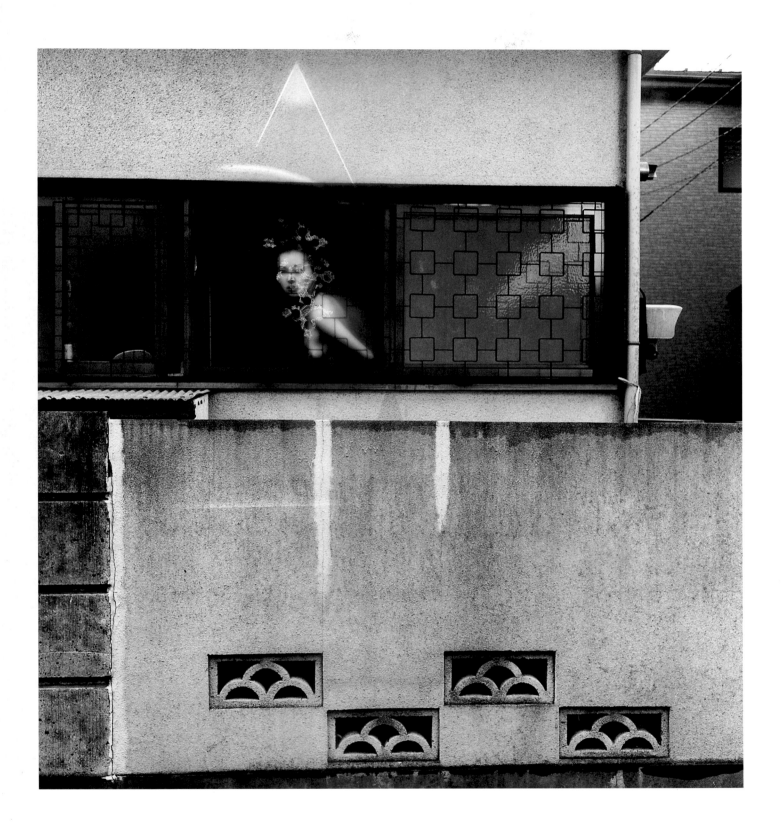

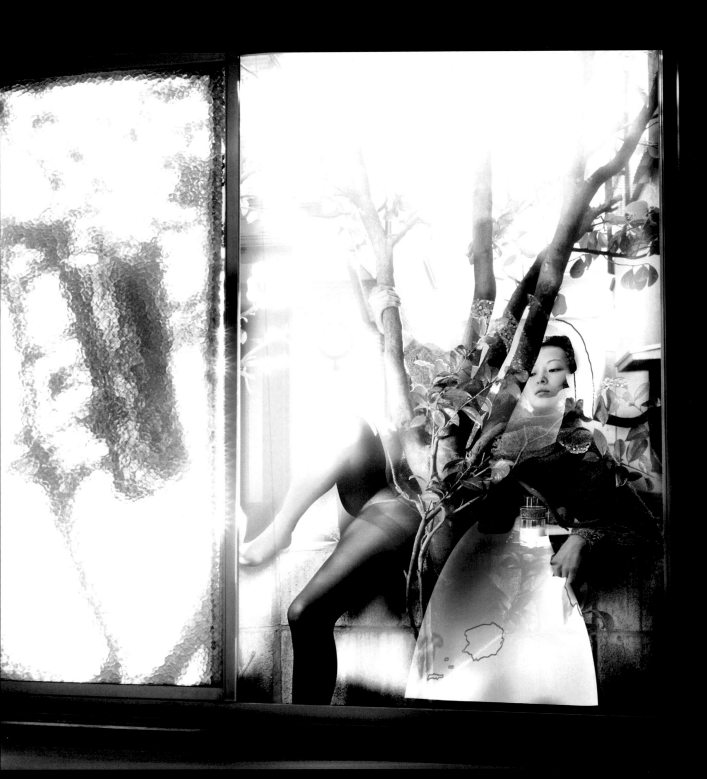

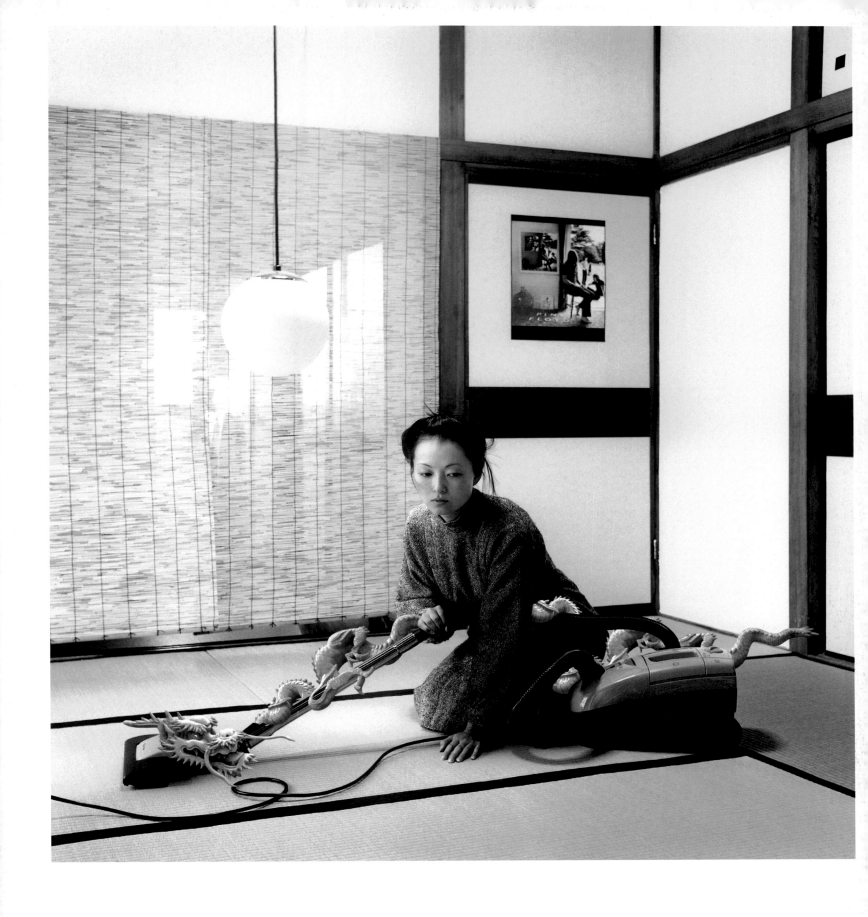

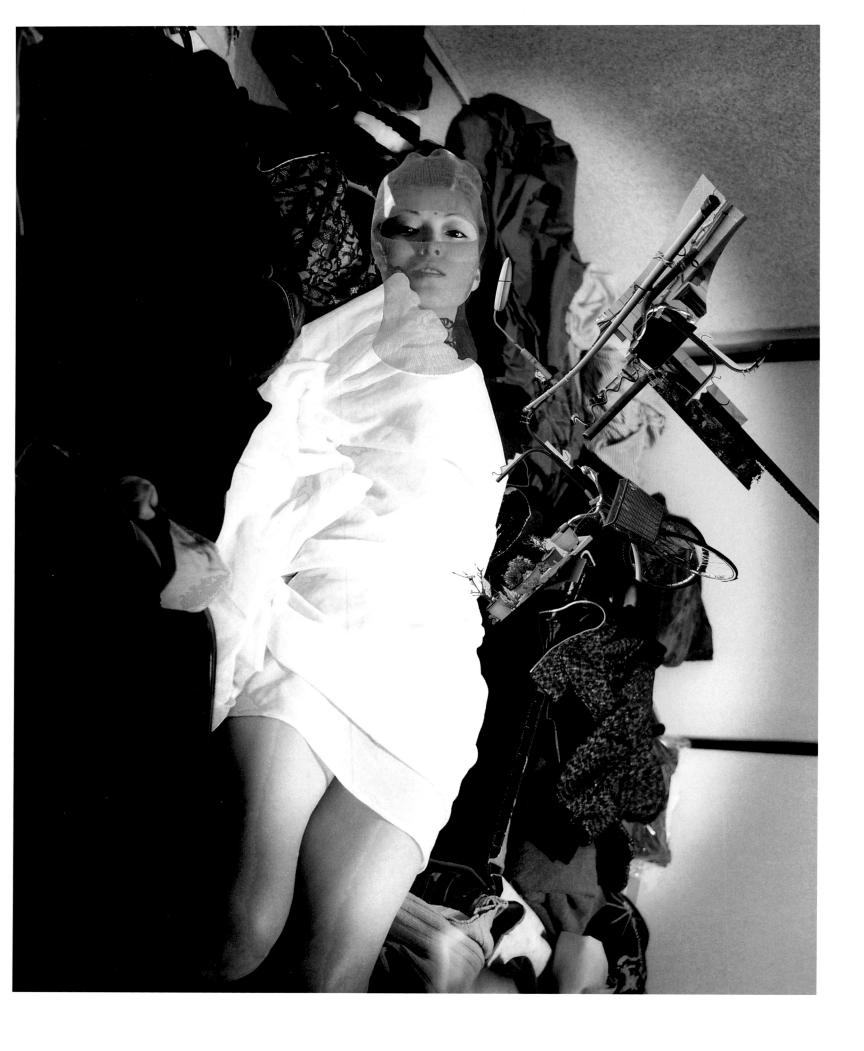

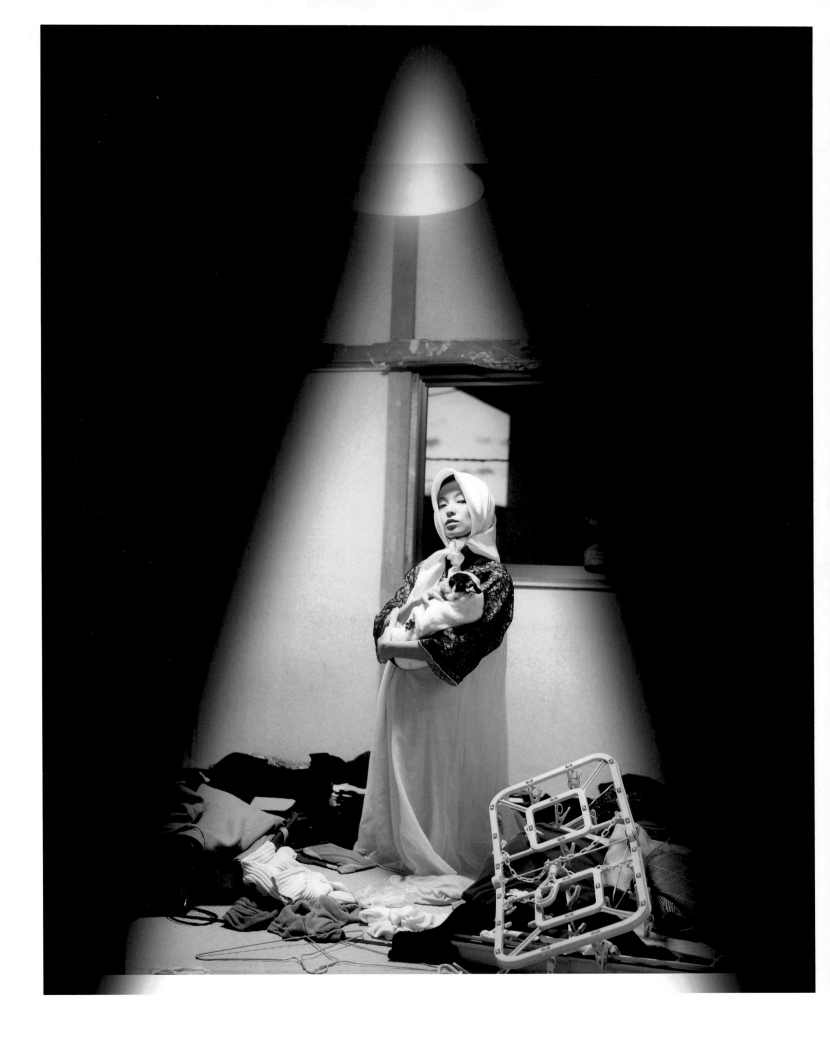

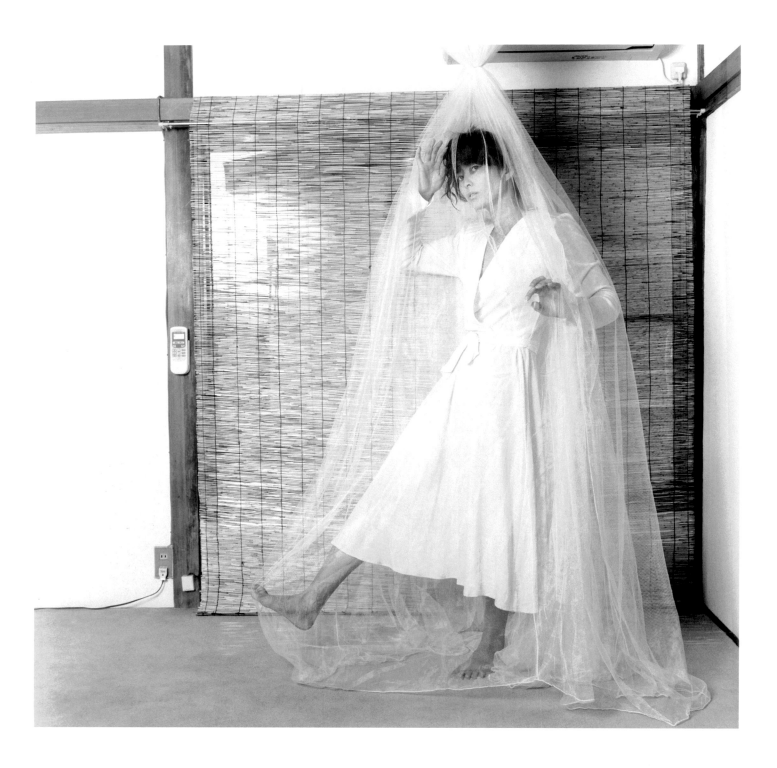

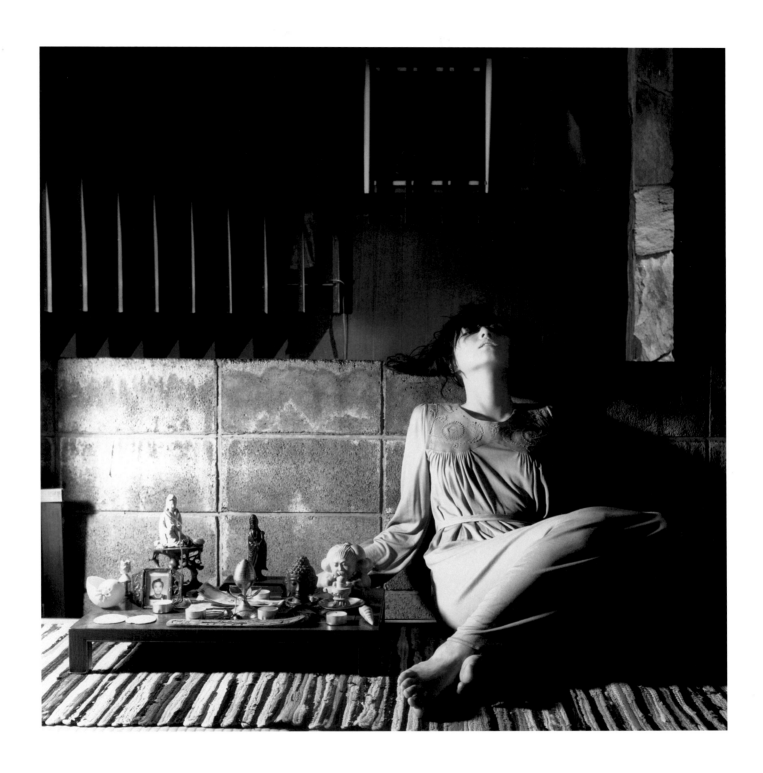

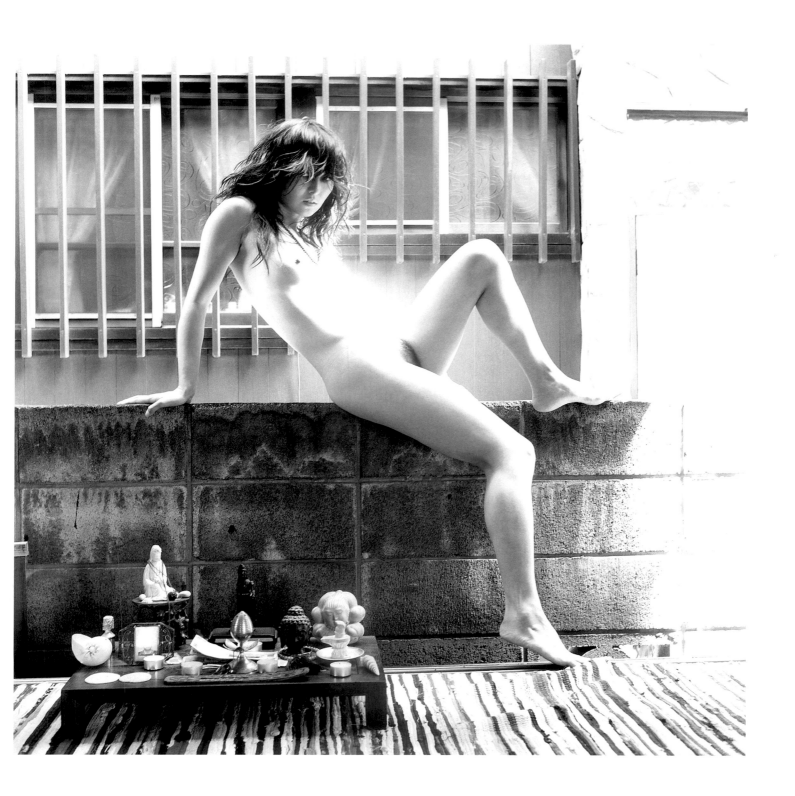

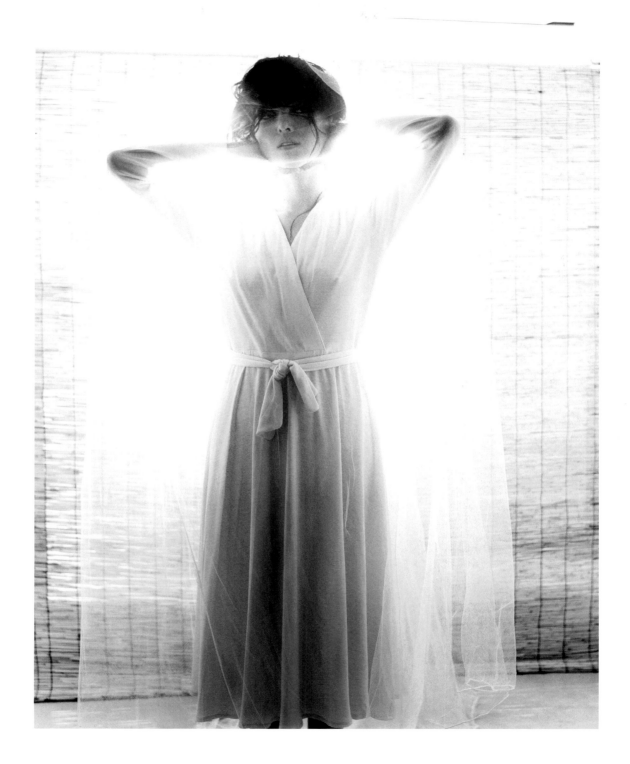

PHOTO ASSISTANTS:
Seiji Kondo and Akira Okimura

OBJECT THAT DREAMS

by Zoren Gold & Minori

Edited by Robert Klanten, Birga Meyer
Production Management by Vinzenz Geppert for dgv

Printed by Engelhardt und Bauer, Karlsruhe

Published by Die Gestalten Verlag, Berlin 2006

ISBN 10: 3-89955-173-7
ISBN 13: 978-3-89955-173-0

Bibliographic information published by the Deutsche Nationalbibliothek
The Deutsche Nationalbibliothek lists this publication in the Deutsche Nationalbibliografie;
detailed bibliographic data is available on the Internet at http://dnb.d-nb.de.

For more information please check: www.die-gestalten.de

Respect copyright, encourage creativity!

Special thanks to our families & friends!

www.mi-zo.com

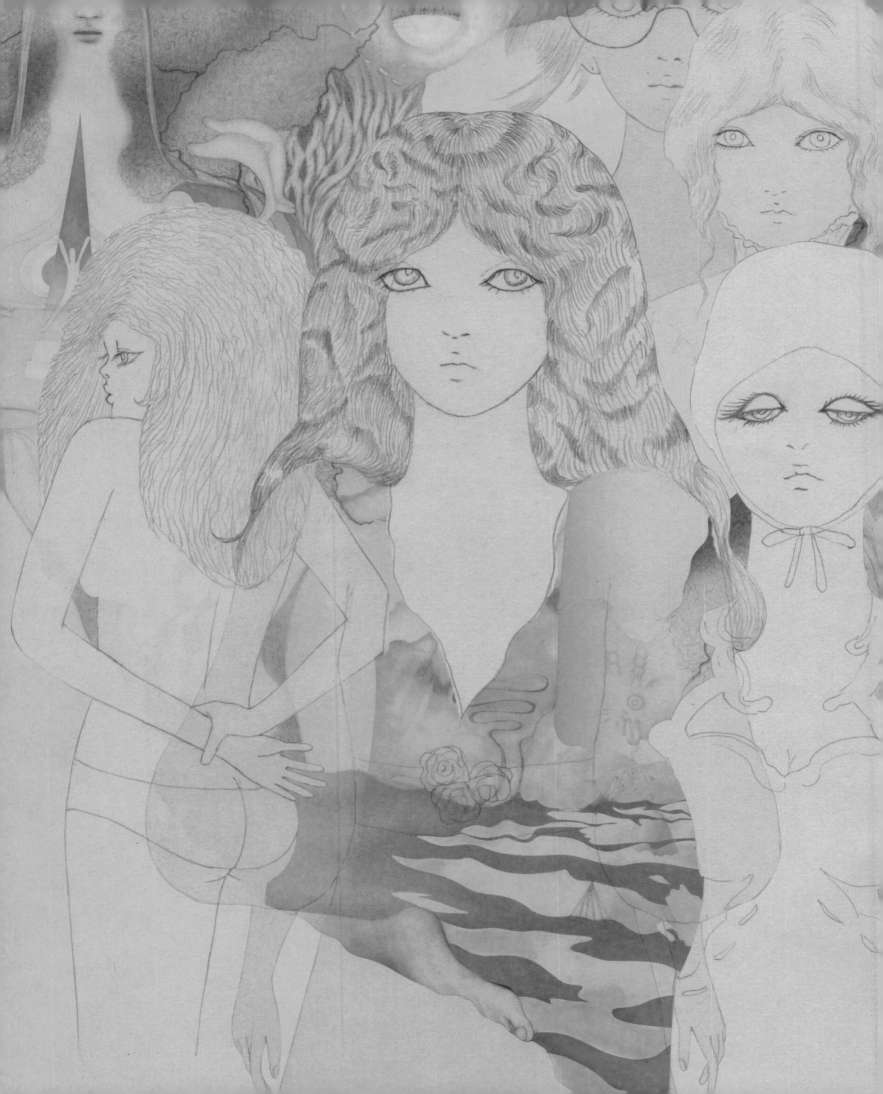